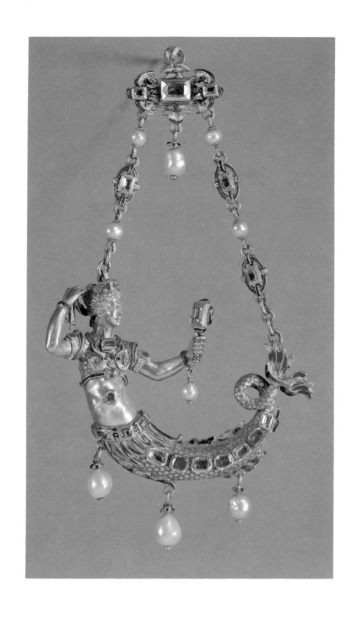

Renaissance

Small Bronze Sculpture

and

Associated Decorative Arts

at the

National Gallery of Art

Carolyn C. Wilson

National Gallery of Art
Washington

This book was produced by the Editors Office, National Gallery of Art, Washington. Printed by Peake Printers inc., Cheverly, Maryland. The type is ITC Garamond Light, set by Hot Type Ltd., Washington, D.C. The text paper is eighty-pound Warren's Cameo dull with matching gloss cover. Edited by Paula M. Smiley. Designed by Melanie B. Ness.

COVER: Leone Battista Alberti, Self-Portrait, c. 1435. National Gallery of Art, Kress Collection.

FRONTISPIECE: South German, Pendant with a Mermaid, c. 1580-1590. National Gallery of Art, Widener Collection.

Library of Congress Cataloging in Publication Data

Wilson, Carolyn C.
 Renaissance small bronze sculpture and associated decorative arts at the National Gallery of Art.
 Bibliography: p.
 1. Bronzes, Renaissance. 2. Decorative arts, Renaissance. 3. Bronzes—Washington (D.C.) 4. Decorative arts—Washington (D.C.) 5. National Gallery of Art (U.S.) I. National Gallery of Art (U.S.) II. Title.
NK7909.3.W57 1983 730'.094'0740153 83-8018
ISBN 0-89468-067-6

Contents

Foreword

SINCE 1957 the National Gallery of Art has been the home of one of the world's greatest collections of Renaissance small bronze sculpture. The gift of the Samuel H. Kress Foundation, the collection comprises free-standing figural sculpture, ornamented utensils, and major reliefs in bronze, as well as the nearly 700 commemorative medals and the more than 450 small reliefs, traditionally called plaquettes, that constitute its largest components. This outstanding collection, the most significant of its type in America, was the result of acquisitions by Samuel H. Kress (1863–1955) and the Kress Foundation (established by him in 1929) and most importantly of the single purchase in 1945 by Rush H. Kress (1877–1963) of a collection of just over 1,300 bronzes from Sir Joseph Duveen. The choicest such collection at that time in private hands, it was assembled through the long-term and discriminating work of the celebrated French nineteenth-century collector of Renaissance art, Gustave Dreyfus (1837–1914). At the time of the acquisition of the Kress small bronzes, the genre was already well represented at the National Gallery by several extremely fine bronze figures and a distinguished group of 127 Renaissance medals and plaquettes in the Widener collection, donated in its entirety in 1942 by Joseph E. Widener (1872–1943) in memory of his father, Peter A.B. Widener (1834–1915). Occasional gifts and purchases continue to enrich these holdings.

The National Gallery is extremely pleased to have the long-awaited opportunity of putting on permanent public display the major part of its remarkable collection of Renaissance small bronze sculpture. As the result of the recent extensive remodeling of the ground floor of the West Building, these works are now exhibited, together with our rich collection of Renaissance decorative arts, and form a key component of a new installation comprising sculpture from the medieval period through the early twentieth century. From the outset Dr. Franklin Murphy, President, Mary Davis, and more recently her successor as Executive Vice-President of the Samuel H. Kress Foundation, Marilyn Perry, have been deeply supportive of this reinstallation. Among the many individuals who contributed to this entire project, we would like to express our appreciation to the National Gallery's sculpture department: Douglas Lewis, Carolyn Wilson, Alison Luchs, and Gladys Clearwaters. We here wish also to thank Carolyn Wilson for her dedicated work on the organization of objects for display and on the preparation of this book.

J. CARTER BROWN
Director

Introduction & Acknowledgments

THE SMALL BRONZE is a subject of integral importance to the study of Italian Renaissance art. Many of the great innovative masters of the period worked in the genre, and their small bronze sculpture stands in direct stylistic relationship to their monumental production in bronze or marble. Indeed, bronze statuettes, utensils, and plaquettes, whether created by a master sculptor or by his workshop, frequently share a repertory of forms and motifs specific to a renowned princely or ecclesiastical large-scale commission. They thus provide an immediate and, because of their size, an intimate appreciation of a great artist's style. Often they closely reflect contemporary paintings or prints as well.

Renaissance medals and plaquettes were, moreover, generally produced in several examples, cast from molds made from wax models. Statuettes were also often replicated, a number of casts—each of which would later be chased with fine chisels and files and then patinated—being taken from a plaster or clay piece-mold formed around a wax or wax-and-clay model. Since the second half of the sixteenth century, medals have most frequently been struck, in large editions, from metal dies. As a multiple medium, then, and one that was easily portable, small bronze sculpture served significantly in the dissemination of stylistic modes, compositional designs, and iconographic innovations among the major artistic centers of Italy and eventually those of northern Europe and Spain.

Small sculpture in bronze not only thus provides us with a many faceted picture of the development of Renaissance art, but in addition small bronzes bespeak the spirit of the Renaissance. An era of fervent scientific exploration and technological innovation as well as dramatic evolution in the history of art, the Renaissance sought its inspiration in the civilization of ancient Greece and Rome. From the editions and translations of classical literature prepared by contemporary humanist scholars, Renaissance artists and patrons learned of the esteem held by erudite Roman collectors for bronze statuettes of their gods and heroes. A parallel taste for such objects, which might be displayed in a courtly collector's cabinet or adorn a humanist writer's study, became manifest during the second half of the fifteenth century in such north Italian centers of classical learning as Padua, Mantua, and Ferrara.

The inspiration for the revival of the small bronze was not exclusively, however, a literary one. Excavations carried out during the Renaissance on Italian soil yielded figurines, engraved gems, and decorated utensils from Hellenistic and Roman times. These were not only prized in themselves, but they motivated the creation of analogous bronze objects in the fifteenth and sixteenth centuries. The discovery of a monumental Roman statue in bronze or marble was an event of such import to the intellectual community of Renaissance Italy that a market grew up for small bronze reproductions of famous classical works. Again, abundant examples of impe-

rial Roman coinage were unearthed and eagerly collected, and these in part underlie the development of the modern medal in the 1430s by the Veronese painter Pisanello.

The proliferation from the fifteenth century on of works of art of any scale in bronze, which was about ten times as expensive as marble, is itself a manifestation of the prevailing interest in classical art and its media. The continual experimentation with and refinement of casting technology, which by the early sixteenth century reached in Italy an unsurpassed mastery, is evidence of the empirical vigor of the age.

The Renaissance devotion to Antiquity is perhaps most apparent in the genre of small bronze sculpture in its subject matter. Gods and goddesses, satyrs and nymphs are again brought to life in the figural bronzes. Lamps, bells, inkwells, and sword pommels share with the plaquettes impassioned scenes inspired by Greek mythology or Roman history. Frequently the legend of one hero is depicted scene by scene on a series of plaquettes, revealing to us their importance as collectors' items to the cultivated Renaissance patron. Also valued as such were the newly introduced portrait medals, which as the bronze figures and plaquettes, were most likely housed together with a collector's treasury of ancient coins, gems, and statuettes. In some examples antique portraiture supplied ideas for the medallist's characterization of his sitter, while ancient texts and relief sculpture provided inspiration for the allegorical content and design of the medal's reverse. Not only in its allusions to antiquity, but especially in its function as a commemoration of the virtues of a distinguished individual, the portrait medal typifies the spirit of Renaissance humanism. For the same reasons, the Renaissance medal, in recording names, faces, and deeds and especially through its inscribed allegorical images, serves us richly as an interpretive key to the period.

From the regions that excelled in bronzes of classical content—often from the same masters and foundries—came bronzes of a religious nature as well. Major reliefs intended for church decoration were produced in bronze, as were plaquettes, bearing Christian themes, for private devotion. The Renaissance tradition of ornamented liturgical objects (often of gilt bronze) and small bronze figurines of saints builds on the legacy of medieval ecclesiastical metalwork. At the same time, it establishes a counterpart to the secular small bronze and, as the whole of Renaissance art, shares with these works its devotion to the formal principles of the art of antiquity.

The new installation on the ground floor of the West Building of a suite of galleries devoted to small sculpture begins with a series of nine rooms housing the finest examples from the Kress Collection of Renaissance bronzes and from the Widener Collection of Renaissance bronzes and decorative arts. These works have not been subdivided by generic categories, but rather arranged according to chronological and geographic considerations. It is hoped that the viewer will thus be afforded an appreciation of the evolution of styles and of the distinctive character of particular artistic centers and will be specifically provided with the opportunity to study interrelationships among, for example, a given bronze figure and a series of plaquettes by the same

artist or to observe readily the recurrence of decorative motifs in various art forms.

The first five galleries display Italian works from the fifteenth and sixteenth centuries (Ground North 4–Ground North 8). German and Netherlandish small bronzes, which in many ways reflect the influence of Renaissance Italy, are housed in the sixth with the collection of north Italian High Renaissance bronzes (GN 9). There follows a small gallery designed for sixteenth-century jewels and rock crystals, produced both in Italy and northern Europe (GN 10). The succeeding gallery represents the art of the Grand Duchy of Tuscany and the Holy Roman Empire in the later sixteenth and seventeenth centuries (GN 11), and the ninth is devoted to the small sculpture and decorative arts of sixteenth and seventeenth-century France (GN 12). This gallery marks the end of the great Kress-Dreyfus collection of Renaissance bronzes; at the same time it constitutes the beginning of a suite of galleries which illustrate the development of French sculpture up through the early twentieth century.

The purpose of the present publication is to serve as a visitor's guide to the new exhibition of Renaissance bronzes and related decorative arts. Each object on display is listed in sequence and identified by author or school, by subject, by dimensions and medium, and by collection and accession number. Inscriptions are given only where they are not visible to the viewer or in instances where an inscription forms part of a pictorial image. Uniface reliefs are designated as such only when exhibited with double-sided reliefs in a transparent vitrine. Many of the objects are briefly discussed, either individually or collectively, in their historical context.

The preparation of the guidebook has provided the opportunity to amplify the attributions, titles, and dates for the works displayed and to bring this information in line with current scholarly opinion. The foundation for this enterprise and its most significant source is Sir John Pope-Hennessy's catalogue of 1965: *Renaissance Bronzes from the Samuel H. Kress Collection: Reliefs, Plaquettes, Statuettes, Utensils and Mortars.* Subsequent contributions which have proved to be extremely useful to the study of this material include the publications of Radcliffe (1966), Weihrauch (1967), Pechstein (1968), Pope-Hennessy (1970), Rossi (1974), Wixom (1975), Weber (1975), Leithe-Jasper (1976), and Draper (1980). The basis for information pertaining to the medals is Graham Pollard's 1967 catalogue *Renaissance Medals from the Samuel H. Kress Collection at the National Gallery of Art,* with its important emendations and additions to Sir George Hill's 1931 catalogue of the Dreyfus collection of medals. Further sources are cited in the bibliography.

Regarding the Renaissance decorative arts from the Widener collection, the recent publications and opinions of Wallen, Mallet, Lessmann, and Shinn on the Italian maiolica have been of great help. Thanks are also owing to Hackenbroch and Distelberger for their current contributions, respectively, to the fields of Renaissance jewelry and rock crystals. Other recent visitors whose observations are much appreciated include Manfred Leithe-Jasper, Leopold and Helen Ettlinger, Jean Owens Schaefer, Ann H. Allison, Stuart Pyhrr, Gary Radke, Carol Pulin, Diana Buitron, and Marianna

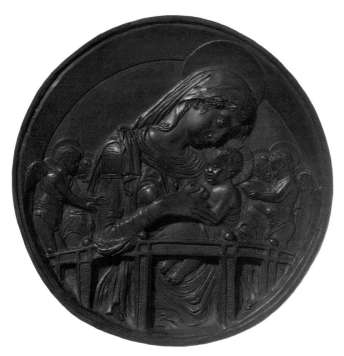

Florentine, after Donatello, Madonna and Child with Four Angels

Shreve Simpson. Among the National Gallery summer interns between 1979 and 1982 who have assisted in the preparatory stages of both the installation and the guide, particular thanks are due to Alison Kurke and Joseph Bliss for their work on the bronzes, Dorothy Limouze for her study of the jewels, and Ronda Kasl for her study of the rock crystals.

The Early Renaissance in Italy (GN 4)

One of the crucial eras in the history of civilization, the fifteenth century saw in Italy the emergence of a new perception of man and his place in the universe. Condemning the near past as a dark and barbaric age, Renaissance man self-consciously sought his model in the ancients, electing the role of reviver of the lost breadth and freedom of thought that he believed to characterize the ancient world. Evident in many branches of learning, this movement was spurred on by a reawakened spirit of discovery, and in Florence, the long prosperous Tuscan metropolis, it was accompanied in the first decades of the quattrocento by a tremendous outburst of creative energy in the fine arts.

In this period the Florentine architect-engineer Filippo Brunelleschi (1377-1446) broke precedent with his Gothic forebears to travel to Rome and decipher from her ruins the principles of grandeur, proportion, and decorative design of Roman architecture. Not only did Brunelleschi's own buildings in Florence establish a new architectural vocabulary rooted in the antique, but they demonstrated advances in technology and a new sensitivity to human scale and purpose as well. Conventionally credited with the invention of linear perspective, Brunelleschi's influence on Florentine painters was vast.

The foremost of these was the short-lived Masaccio (1401-1428), who employed pictorially Brunelleschi's classical architecture and perspectival system to set the stage for his grand and deeply human figures, whose monumentality Masaccio achieved through his pioneering use of light and shade and awareness of classical sculpture.

The greatest of the early fifteenth-century sculptors in Florence was Donatello (1386-1466), who represented the spirit of the age with profound eloquence in the creation of a figural concept at once monumental and humane. With the revolutionary concern for human anatomy and movement shared with his fellow artists, Donatello pursued a wide range of long-dormant classical sculptural forms—the large-scale figure in contrapposto, the free-standing nude, the colossus, the equestrian statue, the portrait—serving to ensure the role of these monumental conventions in the sculpture of succeeding centuries.

A fourth Florentine of critical importance to the development of Renaissance art was Leone Battista Alberti (1404-1472), whose influential treatises on painting, sculpture, and architecture gave verbal expression to the innovative artistic principles of Brunelleschi's and Donatello's generation and thereby provided a vehicle for the dissemination of the new ideas their art represented. A widely traveled aristocrat educated in law, philosophy, and science, Alberti served the arts primarily as a proficient amateur practitioner, as a theorist, and as an advisor to princely patrons in the north of Italy, where he also gave tangible form to the concept of building in the Roman style in his designs for three great churches, the Tempio Malatestiano in Rimini and Sant' Andrea and San Sebastiano in Mantua.

Leone Battista Alberti,

Florentine, 1404-1472
Self-Portrait
c. 1435
Bronze, 20.1 x 13.6 (7 $^{29}/_{32}$ x 5 $^{11}/_{32}$)*
Kress Collection, A-278.1B

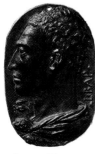

Alberti, Self-Portrait

Alberti's *Self-Portrait,* the earliest and finest of only a very few works in sculpture associated with him, is a remarkable document in the history of this period. The heavy bronze plaque, marked by a casting flaw across the cheek and jaw, is thought to have been made in Florence at the time Alberti was composing his first treatise, *De pictura.* He was a recent arrival in the Tuscan city (his Florentine family having been exiled before his birth), and the impact on him of the artistic innovations that had taken place there during the first three decades of the fifteenth century is attested by his writings. The bronze too bears witness to this impact, as one of the earliest examples in any medium of realistic portraiture, made soon after Masaccio's brilliantly conceived donor portraits, also in profile, in his fresco of the *Trinity* (1428). The incipient interest in lifelike portraiture of Alberti and his contemporaries in Florence developed toward mid-century into the popular conventions of the easel portrait and the three-dimensional portrait bust.

Aware of Pliny's discussion of the reverence held by the Romans for the portraits of their ancestors, Alberti demonstrates in his self-portrait a knowledge of ancient portrait sculpture. The profile image generally recalls Republican and Augustan gems; it is terminated at the neck with classical drapery. In its specific rendering of the subject's physiognomy, the relief merits a key place in the history of Renaissance portraiture. Moreover, it is particularly interesting because of the inclusion of Roman garb and of Alberti's personal device, the hieroglyph of the winged eye, to the left, and of his name, abbreviated in roman capitals and punctuated with eyes, to the right. These indicate Alberti's intent, not merely to record his physical features, but rather to formulate an emblematic statement of his intellectual identity. Alberti's representation of a private individual, himself, in such a manner may well have influenced Pisanello's development of the commemorative medal.

Dimensions are given in centimeters and, in parentheses, in inches.

The Early Influence of Donatello

1. **Florentine,** second quarter
 of the XV century
 Madonna and Child with Two Angels
 Gilt bronze, 16.9 x 11 (6 $^{21}/_{32}$ x 4 $^{11}/_{32}$)
 Kress Collection, A–283.6B

 The gilt bronze plaquette representing the standing Madonna flanked by angels is reminiscent of the figure style of Michelozzo (1396-1472), a Florentine sculptor who worked with Ghiberti, Donatello, and Luca della Robbia. The figures are in high relief, and the casting is unusually heavy.

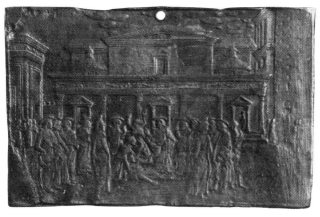

No. 2

2. **Florentine Follower of
 Masaccio and Brunelleschi**
 Christ Healing the Possessed Boy
 c. 1450-1460
 Bronze, 5.8 x 9.3 (2 $^1/_4$ x 3 $^5/_8$)
 Kress Collection, A–334.57B

 The small bronze relief depicting the miracle narrated in Matthew 17 is of great interest to the early development of this genre. It is a contemporary cast of a framed work, now in the Louvre, in silver *répoussé.* Although its author cannot be conclusively identified, the composition clearly reflects major advances in Florentine art of the second quarter of the quattrocento. The figural arrangement, a semicircle receding into space at the center to emphasize the major protagonists, relates closely to Masaccio's great fresco *The Tribute Money* in the Brancacci Chapel. The architecture behind is Brunelleschian in its details, and the ambitious central building may even reflect an unexecuted project designed by that master. The sculptor's use of the figures and architecture to evoke the sense of a large, open civic space in a work of such small dimensions and such slight depth of relief reveals his masterful understanding of the laws of perspective.

3. **Florentine, after Donatello**
Madonna and Child with Four Angels
c. 1456
Bronze, 22.2 (8 $^{23}/_{32}$)
Kress Collection, A–285.8B

This roundel depicting the Madonna and Child behind a balustrade and flanked by pairs of classicizing putti is a close, contemporary copy of a recently rediscovered autograph relief by Donatello, which is now in the Victoria and Albert Museum. The London *Madonna,* bearing a rim and traces of gilding, was given by Donatello in 1456 to Giovanni Chellini, a physician who had successfully treated him for an illness. Chellini recorded this event in his writings, describing the subject and size of Donatello's gift and remarking its most curious feature: a recessed reverse from which could be made a cast in glass that would be identical with the relief on the front. Indeed the occurrence of this highly unusual and technically refined feature confirms the identity of the London roundel (which had been in an English private collection since the mid-eighteenth century) as the Chellini *Madonna.*

The composition shares the motifs of the balustrade and paired putti with the bronze pulpits designed for the Medici church of San Lorenzo in Florence by Donatello in his last years. The perspectival scheme is that appropriate for a devotional relief intended to be placed high on a wall and viewed from below. The roundel and following related bronzes exemplify a convention which, under the influence of Donatello and his contemporary Florentine sculptors, attained great popularity in marble, stucco, and terra cotta, as well as bronze reliefs: the private devotional image of the half-length Madonna and Child.

4. **After Donatello,** mid-XV century
Madonna and Child
Bronze, with traces of gilding, 9.9 x 7.9
(3 $^{29}/_{32}$ x 3 $^{1}/_{8}$)
Widener Collection, A–1585

5. **Follower of Donatello,** mid-XV century
Madonna and Child
Bronze, 9.5 x 8.4 (3 $^{3}/_{4}$ x 3 $^{5}/_{16}$)
Widener Collection, A–1584

6. **Follower of Donatello,** mid-XV century
Madonna and Child
Gilt bronze, 20.3 x 15.2 (8 x 6)
Kress Collection, A–284.7B

This delicately defined and tenderly wistful

Madonna and Child in gilt bronze reflects, in its idiosyncratic and sharply receding architecture and in the repeated gesture of the outstretched right arm, elements of Donatello's work in bronze for the Santo in Padua, the great pilgrimage church where the Franciscan Saint Anthony of Padua is interred. The author of our bronze is most likely a member of the team of craftsmen who worked with Donatello on the decoration of the high altar there (1447-1450).

Medals by Pisanello

Universally held to be the inventor as well as the greatest exponent of modern medallic art, Antonio Pisano was raised in the north Italian city Verona. A brilliant draftsman distinguished for his unusually observant animal studies and for his skill in foreshortening, Pisanello practiced primarily as a painter in the International Gothic style, obtaining major commissions in Verona, Pavia, Venice, Rome, Ferrara, Mantua, and Naples. An awareness of current trends in the art of Burgundy and Florence is also apparent in his work. It was in association with the Este and Gonzaga courts, at the northern Italian cities of Ferrara and Mantua respectively, that Pisanello began creating honorific medals.

The modern medal is a disclike, two-sided object, usually bearing in relief a portrait on one side (obverse) and a design referring to the sitter or to an event on the other (reverse) and bearing also inscriptions on either or both sides. It is thereby a vehicle of commemoration, combining pictorial and literary elements, and one that is both replicable and portable.

The subjects of Pisanello's medals and those of succeeding medallists were generally living persons. The range of subjects represented included not only heads of state but also family members and a wide range of private citizens: scholars, poets, artists, prelates, jurists, generals. These two aspects underlie the special character of the Renaissance medal as a personal monument: a succinct and permanent record of a person's character or biography, a token to be exchanged, awarded, bestowed, or buried beneath foundations for posterity. As an art form, the medal thus speaks for Renaissance man, expressing his sense of individuality, his craving for personal fame, and his admiration of historic greatness.

Pisanello's first medal portrays one of the last Emperors of

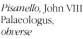

Pisanello, John VIII
Palaeologus,
obverse

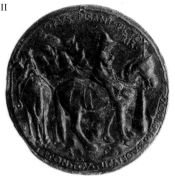

Pisanello, John VIII Palaeologus, *reverse*

Constantinople, John VIII Palaeologus. It is traditionally believed to have been produced at Ferrara when the emperor was there in attendance at the Council of the Greek and Roman Churches held in 1438. In allusion to his Christian mission, he is shown on the reverse riding with a page through a rocky landscape and addressing a wayside cross. The medal's subject is identified in a Greek inscription, its author in a Latin one. The well-preserved example shown here (no. 1) is of lead rather than bronze, an indication that it may have been a trial cast and thus close to the artist's original conception in wax.

The inspiration for Pisanello's Palaeologus medal has been sought in various sources. Perhaps the most obvious is ancient Roman imperial coinage, with its characteristic representation of the emperor's portrait on the obverse, a pictorial commemoration of a military triumph or other great deed on the reverse, and inscriptions proclaiming the emperor's identity, divinity, and achievements. Indeed, Roman imperial coins, which had been a subject of interest in Italy since Petrarch, are known from contemporary literature to have been especially prized by Pisanello's learned Ferrarese patron Leonello d'Este, who treasured them as visual complements to his study of Latin texts on Roman imperial history. But while the Palaeologus medal shares its commemorative program with Roman coins, it bears little relation to them visually. The medal is much larger, it is cast rather than struck, it carries no suggestion of monetary value, and the reverse depiction of two riders in a spacious and carefully detailed landscape is stylistically equivalent to Pisanello's fresco painting and not to any classical prototype.

A second source for the Palaeologus medal has been recognized in a specific pair of two-sided medallions representing, respectively, the Early Christian Emperors Constantine and Heraclius. These were purchased as antiquities in 1402 by the Duc de Berry, who later had them cast in gold versions adorned with gems. These works (examples of which are exhibited in Gallery GN 12) are antique only in subject matter, however. The sitters wear more recent costume, and the inscriptions combine Greek and Latin in a current Byzantine official formula. Stylistically akin to medieval seals, the medallions may have been made by the Parisian artist Michelet Saulmon shortly before their purchase by the duke.

Pisanello's knowledge of these curious pieces is strongly suggested. His familiarity with Burgundian manuscript illumination from the same period is revealed in some of his drawings. The Palaeologus medal is similar to the French

medallions in size and technique and shares with them an image of an emperor on horseback and a combined Greek and Latin inscription. The significant difference is that Pisanello's medal represents a contemporary sitter, whose physiognomy, moreover, is portrayed with penetrating precision, and it makes reference to a current event. Clearly the intent is not to forge an antique artifact, but by reference to antiquity, to create something new. The Palaeologus medal must, as a multiple medium before printing, have succeeded in broadcasting the exact appearance of this esteemed and exotic man as well as in drawing attention to the Council of Ferrara and the religious issues at hand, for Pisanello's portrait of the visiting emperor was copied numerous times in illuminated manuscripts and other media.

The question of why Pisanello made his first medal is still unanswered. However, a crucial element for the artist's invention would seem to have been supplied by his sitter's official status. With John VIII's arrival in Ferrara, Pisanello was suddenly given the opportunity to portray an emperor and, whether by reference to Roman imperial coinage or the French historicizing medallions, he chose a convention that could be recognized as appropriate to his subject's office.

The next and decisive step was the application of this convention to the private individual, with Pisanello's production of medals from 1441 on of his patron Leonello d'Este and other minor rulers in northern Italy. The influence of Alberti, who was at the court of Ferrara in 1441, and his emblematic self-portrait discussed above, may well underlie Pisanello's continued medallic oeuvre. It is not difficult to speculate that Alberti's thinking found favor at once with the cultivated antiquarian Leonello, with the humanist scholars in his circle (who eulogized Pisanello's art), and with the talented Veronese artist, who was beginning at the time to experiment with realistic portraiture in painting. Pisanello's subsequent medals are distinguished throughout not only by excellence of design and execution, which at times achieve an almost magical grace and awesome self-sufficiency of mood, but also by a constant variation in the intercomposition on the circular plane of profile, *impresa,* and inscription.

1. **Antonio Pisano,** called **Pisanello,**
Veronese, c. 1395-1455
John VIII Palaeologus, 1390-1448, Emperor of Constantinople 1425. Reverse: emperor riding to right, passing wayside cross; on left, mounted page seen from behind.
1438
Lead, 10.3 (4 1/16)
Kress Collection, A–737.1A

2. **Pisanello**
Filippo Maria Visconti, 1392-1447, Duke of Milan 1412. Reverse: duke riding to left; on right, mounted page seen from behind; between them armed horseman to front; mountainous landscape with tops of buildings in background.
c. 1441

Bronze, 10.4 (4 3/32)
Kress Collection, A–739.3A

3. **Pisanello**
Francesco I Sforza, 1401-1466, Duke of Milan 1450. Reverse: bust of charger to left; three closed books and sword.
c. 1441
Bronze, 8.8 (3 15/32)
Kress Collection, A–741.5A

4. **Pisanello**
Niccolò Piccinino, c. 1386-1444, *condottiere.* Reverse: she-griffin of Perugia suckling two infants, Braccio de Montone and Piccinino.
c. 1441
Bronze, 9.0 (3 17/32)
Kress Collection, A–740.4A

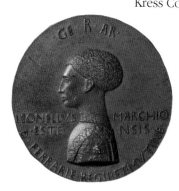 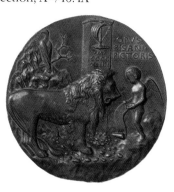

No. 5, obverse *No. 5, reverse*

5. **Pisanello**
Leonello d'Este, 1407-1450, Marquess of Ferrara 1441. Reverse: Cupid teaching a lion (Leonello) to sing; in background, pillar on which a mast and inflated sail, the Este *impresa,* and date MCCCCXLIIII; Este eagle on rocks at left.
1444
Bronze, 10.3 (4 1/16)
Kress Collection, A–746.10A

6. **Pisanello**
Leonello d'Este, 1407-1450, Marquess of Ferrara 1441. Reverse: head with three infantile faces (Allegory of Prudence); on either side a knee piece suspended from an olive branch.
c. 1440-1444
Bronze, 6.8 (2 11/16)
Kress Collection, A–742.6A

7. **Pisanello**
Leonello d'Este, 1407-1450, Marquess of Ferrara 1441. Reverse: blindfolded lynx seated to left on cushion.
c. 1441-1444

Bronze, 6.9 (2 23/$_{32}$)
Kress Collection, A–744.8A

8. **Pisanello**
 Leonello d'Este, 1407-1450, Marquess of
 Ferrara 1441. Reverse: two nude men each
 carrying a basket filled with olive branches;
 in background, two vessels on which rain
 drops from clouds.
 c. 1443
 Bronze, 6.8 (2 11/$_{16}$)
 Kress Collection, A–743.7A

9. **Pisanello**
 Leonello d'Este, 1407-1450, Marquess of
 Ferrara 1441. Reverse: nude youth lying to
 right before rock on which is a vase con-
 taining olive branches, ends of which
 pierce sides of vase; attached to each
 handle, an anchor, that on right being
 broken.
 Bronze, 7.0 (2 3/$_{4}$)
 Kress Collection, A–745.9A

The early medals, which include the series
devoted to Leonello d'Este, are generally char-
acterized by the truncation of the bust near the
neck or parallel to the medal's rim and by the
circular placement of the inscription at the
rim. The carefully devised reverse imagery
often combines heraldic and allegorical ele-
ments to create a consciously erudite state-
ment on the sitter's identity. In Leonello's large
marriage-commemoration medal of 1444 (no.
5), which reveals its meaning in the reverse
image of the canting lion instructed by Cupid
to sing, Pisanello experiments with a horizon-
tal placement of the inscription and with a low
straight truncation of the portrait bust. The
latter convention was to become standard for
Italian fifteenth-century portrait busts in the
round.

10. **Pisanello**
 Vittorino Ramboldoni da Feltre, 1379-
 1446, humanist. Reverse: pelican in her
 piety.
 c. 1446
 Bronze, 6.7 (2 5/$_{8}$)
 Kress Collection, A–754.18A

Pisanello's medal of Vittorino, the influential
teacher associated with the Gonzaga court,
was probably produced as a memorial shortly
after his death. It is of great interest as an early
medal honoring an untitled individual.

11. **Pisanello**
 Sigismondo Pandolfo Malatesta, 1417-

1468, Lord of Rimini 1432, shown as Captain General of the Roman Church. Reverse: Sigismondo on charger to left before fortress, on walls of which the date MCCCCXLV and his shield of arms.
1445
Lead, 10.4 (4 ³/₃₂)
Kress Collection, A–749.13A

12. **Pisanello**

Sigismondo Pandolfo Malatesta, 1417-1468, Lord of Rimini 1432. Reverse: Sigismondo standing, fully armed, holding sword; on left, on heraldic rose tree, his casque, crowned, and elephant's-head crest; on right, his shield.
c. 1445
Bronze, 9.0 (3 ¹⁷/₃₂)
Kress Collection, A–748.12A

No. 13, obverse

13. **Pisanello**

Domenico Novello Malatesta, 1418-1465, Lord of Cesena 1429. Reverse: Domenico in full armor, kneeling right, clasping feet of Crucifix; on left, his horse seen from behind.
c. 1445
Bronze, 8.5 (3 ¹¹/₃₂)
Kress Collection, A–751.15A

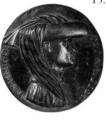

No. 13, reverse

14. **Pisanello**

Alfonso V of Aragon, 1394-1458, King of Naples and Sicily 1442. Reverse: in rocky landscape, eagle on tree stump above dead fawn, surrounded by lesser birds of prey.
1449
Lead, 11 (4 ⁵/₁₆)
Kress Collection, A–755.19A

In 1448 Pisanello was called to the court of Naples by Alfonso of Aragon, whose rugged medallic portrait is boldly balanced by triumphal devices in a new composition. The inscriptions link Alfonso to the Caesars, while the imagery of the mighty eagle permitting lesser birds to feast on its leavings is a medieval symbol of royal magnanimity.

15. **Pisanello**

Don Iñigo d'Avalos, Grand Chamberlain of Naples from 1442. Reverse: sphere representing earth between starry heavens and sea above, shield of arms of Avalos.
c. 1448-1449
Bronze, 7.9 (3 ¹/₈)
Kress Collection, A–758.22A

No. 15, obverse

This exquisitely delicate portrait in low relief of Alfonso's Chamberlain bears comparison, in its rhythmic balance of curves and its harmony of features, with early examples of Florentine painted portraiture; the National Gallery's *Matteo Olivieri* has often been compared with the Iñigo medal. The cosmic device on its reverse is derived from Homer's description of the shield of Achilles.

16. **Pisanello**
Gianfrancesco I Gonzaga, 1395-1444, 1st Marquess of Mantua 1433. Reverse: Gianfrancesco riding to left; on right, mounted page seen from behind.
c. 1439
Lead, 10.0 (3 $^{15}/_{16}$)
Kress Collection, A-738.2A

Probably one of Pisanello's early medals, that of the Marquess of Mantua is strongly reminiscent in its portrait and reverse of the artist's courtly paintings. Pisanello worked for the Gonzaga periodically over a number of years and designed for their palace an extensive fresco cycle of Arthurian legends. The outline of Gianfrancesco's fanned hat is echoed in the curve that terminates the bust.

17. **Pisanello**
Cecilia Gonzaga, 1424?-1451?, daughter of Gianfrancesco I. Reverse: in rocky moonlit landscape, figure of maiden and unicorn; on right, square column with date MCCCCXLVII.
1447
Lead, 8.6 (3 $^3/_8$)
Kress Collection, A-753.17A

No. 17, reverse

The only remaining medal by Pisanello of a female subject, that of Gianfrancesco's daughter who took the veil, bears one of the artist's most beautiful reverses, complementing a traditional image of virginity with a lyrical evocation of evening and moonlight in an airy landscape.

18. **Pisanello**
Lodovico III Gonzaga, 1414-1478, son of Gianfrancesco I and 2nd Marquess of Mantua 1444. Reverse: Lodovico in full armor, with globular crest to his helmet, riding right; in field above, sun and sunflower.
c. 1447-1448
Bronze, 10.2 (4)
Kress Collection, A-752.16A

Fittingly, the founder of medallic art was himself commemorated in the work of these two followers:

19. **Antonio Marescotti,** known active
 1444-1462 at Ferrara
 Antonio Pisano, called Pisanello, the painter and medallist. Reverse: Latin initials of the seven Virtues in laurel wreath.
 c. 1440-1443
 Bronze, 5.8 (2 $^9/_{32}$)
 Kress Collection, A–768.32A

20. **Nicholaus,** known active
 c. 1440-1454 at Ferrara
 Antonio Pisano, called Pisanello, the painter and medallist. Without reverse.
 c. 1445-1450
 Bronze, 3.4 (1 $^{11}/_{32}$)
 Kress Collection, A–766.30A

Medals by Matteo de' Pasti

Pisanello's most gifted early follower in the production of honorific medals was Matteo de' Pasti, who practiced as an illuminator, architect, and medallist in his native Verona and at Rimini on the Adriatic coast. There he was employed by Sigismondo Pandolfo Malatesta, Lord of Rimini, who was vigorously engaged in expanding his territorial domain and in the enlightened embellishing of his city. In his office as Captain General of the Church, Sigismondo is represented in one of Pisanello's medals seen nearby.

Matteo de' Pasti's medallic style differs from Pisanello's in the more pliant handling of relief surfaces and the more decorative outlines. Matteo's oeuvre includes numerous medals devoted to Sigismondo and his mistress, Isotta. At Rimini, Matteo also worked under Alberti's direction on the rebuilding of the Franciscan church which was to serve as the mausoleum of Sigismondo, Isotta, and the humanist scholars Sigismondo had summoned to his court. Known as the Tempio Malatestiano, this structure is a signal monument in the history of Renaissance adaptation of Roman architecture for Christian worship.

1. **Matteo de' Pasti,** known active
 by 1441, died 1467/68
 Leone Battista Alberti, 1404-1472, architect and writer on art and science. Reverse: within laurel wreath, a winged eye terminating in thunderbolts, and motto QVID TVM.
 1446-1450
 Bronze, 9.3 (3 $^{21}/_{32}$)
 Kress Collection, A–792.56A

The winged eye appearing on Alberti's *Self-Portrait* recurs with the popular humanist motto *Quid Tum* on the reverse of Matteo's medal honoring him.

2. **Matteo de' Pasti**
 Guarino da Verona, 1374-1460, humanist.
 Reverse: within laurel wreath, a fountain
 surmounted by nude male figure with
 mace and shield; all in a flowery meadow.
 c. 1446
 Bronze, 9.4 (3 $^{11}/_{16}$)
 Kress Collection, A–791.55A

In a medal contemporaneous with Pisanello's
Vittorino da Feltre, Matteo here represents in a
superbly supple portrait the great humanist
who served the court of Ferrara and was Leon-
ello d'Este's teacher. Alone among Matteo's
subjects, the classical scholar is represented in
antique garb reminiscent of Alberti's *Self-
Portrait.* Guarino was one of the humanist
writers who extolled Pisanello's art.

3. **Matteo de' Pasti**
 Jesus Christ. Reverse: half-figure of dead
 Christ supported by winged putto; on left
 weeping putto; behind, the Cross.
 1446-1450
 Bronze, 9.3 (3 $^{21}/_{32}$)
 Kress Collection A–793.57A

This medal represents an early and unusual
application of the medallic convention for
devotional meditation. A second departure
occurring not long after is the representation
in medals of historic personages.

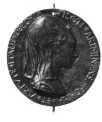

4. **Matteo de' Pasti**
 Isotta degli Atti of Rimini, mistress, then
 wife in 1456, of Sigismondo Pandolfo
 Malatesta; d. 1470. Reverse: elephant in
 flowery meadow, flanked by heraldic rose
 trees. Signed and dated MCCCCXLVI.
 1446
 Bronze, 8.4 (3 $^5/_{16}$)
 Widener Collection, A–1487

5. **Matteo de' Pasti**
 Isotta degli Atti. Reverse: elephant in flow-
 ery meadow; below, MCCCCXLVI.
 1446
 Bronze, 8.3 (3 $^1/_4$)
 Kress Collection, A–799.63A

6. **Matteo de' Pasti**
 Isotta degli Atti. Reverse: closed book;
 around, ELEGIAE.
 c. 1446
 Bronze, 4 (1 $^9/_{16}$)
 Kress Collection, A–800.64A

7. Matteo de' Pasti

Isotta degli Atti. Reverse: same as preceding, but inscription reworked and increased in size.
1446
Bronze, 4.2 (1 $^{21}/_{32}$)
Kress Collection, A–801.65A

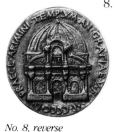

No. 8, reverse

8. After Matteo de' Pasti

Sigismondo Pandolfo Malatesta, 1417-1468, Lord of Rimini 1432. Reverse: front view of San Francesco at Rimini, according to Alberti's proposed reconstruction, and MCCCCL.
1450
Bronze, 4 (1 $^{9}/_{16}$)
Kress Collection, A–802.66A

This work is of particular interest in its commemoration of the launching of an architectural project, a convention frequently encountered subsequently. Moreover, the reverse depiction of the Tempio Malatestiano is of great historical importance in that it records Alberti's innovative architectural design. The façade, which is articulated as a Roman triple-bayed triumphal arch, was never brought to completion, and the hemispherical Pantheon-like dome shown in the medal was never built.

9. Matteo de' Pasti

Sigismondo Pandolfo Malatesta, 1417-1468, Lord of Rimini 1432. Reverse: arms of Sigismondo (shield, helmet, elephant-crest, and mantling).
1446
Bronze, 4.3 (1 $^{11}/_{16}$)
Kress Collection, A–794.58A

10. Matteo de' Pasti

Sigismondo Pandolfo Malatesta, 1417-1468, Lord of Rimini 1432. Reverse: the castle of Rimini and date, MCCCCXLVI.
1446
Bronze, 8.3 (3 $^{1}/_{4}$)
Kress Collection, A–796.60A

11. Matteo de' Pasti

Sigismondo Pandolfo Malatesta, 1417-1468, Lord of Rimini 1432. Reverse: Fortitude, holding broken column, seated on a throne, sides of which are formed by foreparts of Malatesta elephants; below, MCCCCXLVI.
1446
Bronze, 8.2 (3 $^{7}/_{32}$)
Kress Collection, A–797.61A

Central Italy, 1450-1500 (GN 5)

The second room is devoted to bronze sculpture produced during the second half of the fifteenth century by central Italian artists. These include masters working in the great Tuscan cities of Florence and Siena, where the achievements of Donatello and his generation continued to inspire a lively sculptural tradition, as well as artists active at Rome, which, under the impetus of enlightened papal patronage, began during this period to emerge as an artistic center.

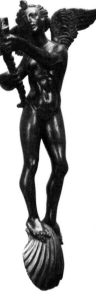

Vecchietta, Winged Figure Holding a Torch

Lorenzo di Pietro, called **Vecchietta,**
Sienese, c. 1412-1480
Winged Figure Holding a Torch
Bronze, 45.6 x 17.7 x 21
(17 7/8 x 6 7/8 x 8 1/4)
Kress Collection, A–1653

Long considered to be one of the most notable small bronzes surviving from the fifteenth century, the free-standing nude figure, in the niche to the right, was attributed in the early twentieth century to Donatello. Although it was later assigned by some scholars to Francesco di Giorgio, Pope-Hennessy recognized it as the work of Vecchietta, a Sienese fresco painter and woodcarver, who fell under the influence of Donatello during the late 1450s, when the great Florentine master was engaged on major commissions in bronze for the Cathedral of Siena. At this point Vecchietta embraced bronze as a sculptural medium and adopted a hauntingly mystical style akin to Donatello's late oeuvre. A companion piece to the *Winged Female Figure,* a male figure likewise standing on a shell, exists in a private collection in Paris. That statuette supports in his upraised hands a disc fixed with a pricket, suggesting that the two bronzes originally constituted a pair of sconces.

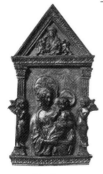

No. 1

1. **Florentine,** second half XV century
 Madonna and Child with Two Angels
 Gilt bronze, 19.4 x 11.5 (7 5/8 x 4 1/2)
 Kress Collection, A–546.268B

2. **Italian,** XV or early XVI century
 Saint Sebastian
 Gilt-bronze appliqué, 12.4 x 3.1
 (4 7/8 x 1 3/16)
 Kress Collection, A-556.278B

These two religious objects demonstrate the continuing taste for gilding observed earlier in the Madonnas associated with Donatello. On the pax (no. 1) here one can see that the

Madonna and Child relief was cast separately and then mounted on its tabernacle frame and ornamental background. The similarly silhouetted *Saint Sebastian* would also originally have been applied to a separate surface.

1. **Roman,** second half XV century
 The Redeemer
 Gilt-bronze appliqué, 20.2 x 9.0
 (7 $^{15}/_{16}$ x 3 $^{9}/_{16}$)
 Kress Collection, A–725.447B

Another gilt and silhouetted appliqué, the *Redeemer* almost certainly originally adorned the door of a tabernacle designed to house the consecrated wine and host. Several similar reliefs dating from the second half of the fifteenth century and from the early sixteenth century are still to be found so situated in churches in and around Florence and Rome. The iconic image showing the blood of Christ streaming from the Savior's wound directly into the chalice was particularly current in the fifteenth century; it was of course eminently appropriate for the decoration of the eucharistic tabernacle.

No. 2

2. **Francesco Marti,** Lucchese, known active 1489-1516
 Saint Catherine
 Gilt bronze, 8.5 x 7.8 (3 $^{11}/_{12}$ x 3 $^{1}/_{16}$)
 Kress Collection, A–563.285B

3. **Francesco Marti**
 Saint John the Evangelist
 Gilt bronze, 8.2 x 5.9 (3 $^{7}/_{32}$ x 2 $^{11}/_{32}$)
 Kress Collection, A–564.286B

4. **Francesco Marti**
 Male Saint
 Gilt bronze, 8.4 x 6.2 (3 $^{9}/_{32}$ x 2 $^{7}/_{16}$)
 Kress Collection, A–565.287B

5. **Francesco Marti**
 Saint Mary Magdalen
 Gilt bronze, 7.9 x 5.3 (3 $^{3}/_{32}$ x 2 $^{3}/_{32}$)
 Kress Collection, A–566.288B

These four silhouetted, half-length saints are also gilt-bronze appliqués; holes for attachments are still visible. Other casts of the saints occur in varying combinations on three crucifixes—still extant in churches in Italy—made by the Lucchese silversmith Marti. This assures the attribution to him of our works and also suggests their original function. A plaquette of classical subject matter, a *Nymph on a Dol-*

The following small plaquettes (in the wall case to the left of
the window), many of them oval and slightly concave, are of
special interest not only for their Antique subject matter but
also because they were either adopted from designs of Hel-
lenistic and Roman gems or actually cast from molds taken
from ancient specimens. Many such pieces relate to specific
gems known to have been in the collection of the great
Florentine banking family, the Medici. Such pieces would
have been cast in Florence. Others may have been produced
in northern Italy or in Rome, inspired by the Antique gems
collected by Pope Paul II, whose portrait medal is seen in the
case extending from this wall. Further examples of the genre
appear in the wall case on the opposite side of the window.

No. 1

1. **Italian,** after the Antique,
 XV or XVI century
 Minerva in a Chariot
 Bronze, 3.5 x 4.3 (1 ³/₈ x 1 ¹¹/₁₆)
 Kress Collection, A–305.28B

2. **Florentine,** after the Antique, XV century
 Augustus
 Bronze, 4.6 x 3.2 (1 ¹³/₁₆ x 1 ¹/₄)
 Kress Collection, A–328.51B

3. **Italian,** after the Antique,
 last quarter of the XV century
 Mars and Diana
 Bronze, 4.9 x 6.4 (1 ¹⁵/₁₆ x 2 ¹/₂)
 Kress Collection, A–320.43B

4. **Italian,** after the Antique, c. 1500
 Diana
 Bronze, 4.9 x 3.4 (1 ²⁹/₃₂ x 1 ⁵/₁₆)
 Kress Collection, A–321.44B

No. 5

5. **Italian,** after the Antique, XV century
 Diomedes and the Palladium
 Bronze, 5.1 x 4.1 (2 x 1 ⁵/₈)
 Kress Collection, A–314.37B

6. **Italian,** after the Antique, XV century
 Pompey
 Bronze, 6.1 x 4.1 (2 ³/₈ x 1 ⁵/₈)
 Kress Collection, A–331.54B

7. **Italian,** after the Antique, XVI century
 Minerva
 Bronze, 4.0 x 3.1 (1 ⁹/₁₆ x 1 ⁷/₃₂)
 Kress Collection, A–316.39B

8. **Italian,** after the Antique,
 early XVI century
 Julius Caesar

Bronze, 4.1 (1 ⁵/₈)
Kress Collection, A–329.52B

9. **Italian,** after the Antique,
XV or XVI century
A Roman Emperor
Bronze, 4.4 x 3.5 (1 ³/₄ x 1 ³/₈)
Kress Collection, A–330.53B

10. **Florentine,** mid-XV century
Noah entering the Ark
Bronze, 4.3 x 5.5 (1 ¹¹/₁₆ x 2 ³/₁₆)
Kress Collection, A–300.23B

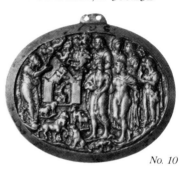

No. 10

This delicately beautiful work relates to the plaquettes derived from gems in its scale, manufacture, and origins. It was cast from a fifteenth-century onyx cameo, now in the British Museum. The cameo is known to have belonged to Piero de' Medici and is inscribed with the name of his son Lorenzo, the foremost Florentine artistic patron and arbiter of taste during the second half of the fifteenth century.

In the case to the right of the window, further examples of plaquettes based on ancient gems are juxtaposed with contemporary plaquettes of classical themes. The intricate narrative scenes are the work of a recognizable but unknown artist conventionally called the Master of the Orpheus Legend from his three plaquettes devoted to that subject, two of which are shown here. It is not known whether this skillful adapter of Roman motifs worked in northern or central Italy; the seried depiction *all'antica* of heroic myths is frequently encountered in both regions, from the late fifteenth through the mid-sixteenth centuries.

1. **Francesco Marti,** Lucchese,
known active 1489-1516
Nymph on a Dolphin
Bronze, 4.5 (1 ²⁵/₃₂)
Kress Collection, A–716.438B

2. **Florentine,** after the Antique, XV century
Centaur
Bronze 4.9 x 4.1 (1 ⁷/₈ x 1 ⁹/₁₆)
Widener Collection, A–1525

3. **Master of the Orpheus Legend,**
 Florentine or North Italian,
 last quarter XV century
 Achilles Taking Leave of Thetis
 Bronze, 5.6 (2 $^3/_{16}$)
 Kress Collection, A–385.108B

4. **Master of the Orpheus Legend**
 Orpheus Playing to the Animals
 Bronze, 5.6 (2 $^3/_{16}$)
 Kress Collection, A–387.110B

No. 4

5. **Florentine,** after the Antique, XV century
 Apollo and Marsyas
 Bronze, 4.2 x 3.4 (1 $^5/_8$ x 1 $^5/_{16}$)
 Kress Collection, A–301.24B

6. **Italian,** after the Antique, XV century
 Hercules and the Nemean Lion
 Bronze, 3.6 x 2.5 (1 $^7/_{16}$ x 1)
 Kress Collection, A–309.32B

7. **Master of the Orpheus Legend**
 Aeneas Descending to the Underworld
 Bronze, 5.9 (2 $^5/_{16}$)
 Kress Collection, A–389.112B

8. **Master of the Orpheus Legend**
 *Orpheus and Eurydice before Pluto
 and Proserpine*
 Bronze, 5.5 (2 $^5/_{32}$)
 Kress Collection, A–386.109B

9. **Master of the Orpheus Legend**
 Meleager Hunting the Calydonian Boar
 Bronze, 6.4 (2 $^1/_2$)
 Kress Collection, A–392.115B

Central Italian, possibly Roman,
late XV or early XVI century
*The She-Wolf Suckling Romulus
and Remus*
Bronze, 38 x 64.2 x 15.9
(14 $^7/_8$ x 25 $^1/_4$ x 6 $^1/_4$)
Kress Collection, A–155

This extraordinary bronze is one of the most distinquished examples anywhere of a Renaissance copy after an Antique statue. Its model is the famous *Capitoline Wolf* in Rome, an Etruscan work which was preserved along with the second-century equestrian statue of Marcus Aurelius and other revered antiquities through the Middle Ages under the aegis of the papacy. In the piazza of Saint John Lateran, the ferocious *She-Wolf* presided for centuries over the punishment of criminals, accruing almost totemic status as an emblem of law. In 1471

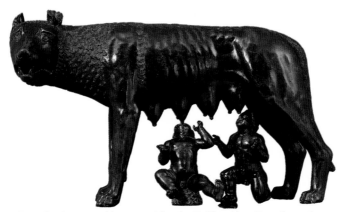

Central Italian, possibly Roman, The She-Wolf Suckling Romulus and Remus

Pope Sixtus IV, not only manifesting the enthusiasm of his time for classical civilization but specifically seeking to glorify papal Rome through analogy to ancient Rome, ordered the removal of the *She-Wolf* and various other Antique statues to the Capitoline Hill. That site, already imbued with historical importance as the symbolic heart of ancient Rome, was eventually transformed into a grandiose complex of municipal buildings by Michelangelo in the mid-sixteenth century.

At some point after 1471 and before 1510, the figures of Romulus and Remus were added to the Etruscan beast, in allusion to the origins of Rome. Numerous small-scale reproductions of the *Capitoline Wolf* with the twins were made during the Renaissance. The present piece is exceptional for its large size (almost exactly half that of the original) and for the high quality of casting and finish. It is indeed possible that the Kress piece was produced by and served as a demonstration model for the Renaissance artist who was commissioned to add the pair of suckling infants. That artist has recently been proposed by Meller to be the Milanese sculptor Christoforo Solari, active in Rome in 1500.

Antique Revivals in Rome

Many of the following works demonstrate the increasing enthusiasm for the revival of Antique forms manifest at Rome itself during the period. The enormous popularity achieved in central Italy at this time by Pisanello's invention, the commemorative portrait medal, is reflected in the Roman and Florentine medals seen here and in the transparent case opposite.

1. **Attributed to Cristoforo di Geremia,**
 known active 1456-1476 in Rome
 Fortune Bestowing Fame. Without reverse.
 Bronze, 8.9 (3 ½)
 Kress Collection, A–333.56B

2. **Cristoforo di Geremia**
 Paolo Dotti of Padua (?), General of Militia in Vicenza 1289. Reverse: nude female figure of Constancy, resting left arm on fluted column, right on tall staff, and holding long scarf.
 Bronze, 6.1 (2 $^{13}/_{32}$)
 Kress Collection, A–952.214A

3. **Cristoforo di Geremia**
 An Emperor and Concord.
 Without reverse.
 Bronze, 7.1 x 7.0 (2 $^{25}/_{32}$ x 2 $^{3}/_{4}$)
 Kress Collection, A–332.55B

A Mantuan, Cristoforo di Geremia worked in Rome after 1456, entering the service of the papacy in 1465. Two classically inspired allegorical plaquettes associated with his name are shown with one of the artist's authenticated medals portraying not a contemporary but a historical personage.

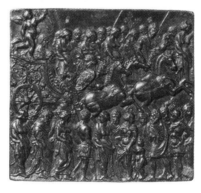

No. 4

4. **Italian, possibly Roman,**
 second half XV century
 Triumph of Cupid. Without reverse.
 Bronze, 10.7 x 12.0 (4 $^{3}/_{16}$ x 4 $^{11}/_{16}$)
 Kress Collection, A–296.19B

This superb and unique relief, based on the iconography of the ancient Roman triumph, may also have been produced in modern Rome. The composition suggests the artist's first-hand knowledge of Trajan's Column.

5. **After Giuliano di Scipione,**
 known active 1464-1471
 Paul II (Pietro Barbo, 1417/1418-1471), Pope 1464. Reverse: the same.
 c. 1470
 Bronze, 8.1 x 4.4 (3 $^{7}/_{32}$ x 1 $^{3}/_{4}$)
 Widener Collection, A–1479

6. **Medallist of the Roman Emperors,**
 possibly Lombard, known active last quarter of XV century
 Marcus Croto. Reverse: Croto riding to

left, carrying standard; below, helmet and shield.
Bronze, 6.0 (2 $^3/_8$)
Kress Collection, A-942.205A

7. **Medallist of the Roman Emperors**
Nero. Reverse: Nero, laureate, seated to right under palm tree holding a patera; facing him a nude man, also laureate, standing behind a large vase.
Bronze, 11.4 (4 $^{15}/_{32}$)
Kress Collection, A-939.202A

8. **Italian,** late XV or early XVI century
The She-Wolf Suckling Romulus and Remus. Without reverse.
Bronze, 8.4 (3 $^5/_{16}$)
Kress Collection, A-297.20B

9. **Roman**
Domenico Grimani, 1463-1523, Cardinal 1493. Reverse: Theology, standing before a palm tree, points to a radiant cloud and takes by the hand Philosophy, who is seated reading a book under a tree.
c. 1493
Bronze, 5.3 (2 $^3/_{32}$)
Kress Collection, A-974.236A

10. **Lysippus Junior,** known active c. 1471-1484 in Rome
Giovanni Alvise Toscani, c. 1450-1478, Milanese jurisconsult, consistorial advocate, and auditor general under Pope Sixtus IV. Reverse: Neptune in sea car to front.
Bronze, 4.0 (1 $^9/_{16}$)
Kress Collection, A-958.220A

11. **Lysippus Junior**
Giovanni Alvise Toscani, c. 1450-1478, Milanese jurisconsult, consistorial advocate, and auditor general under Pope Sixtus IV. Reverse: inscription within laurel wreath.
Bronze, 7.3 (2 $^{55}/_{64}$)
Widener Collection, A-1483

12. **Florentine,** late XV century
Gianfrancesco Pallavicino. Without reverse.
Lead, 5.1 (2)
Kress Collection, A-1040.302A

13. **Andrea Guacialoti,**
Florentine, 1435-1495
Sixtus IV (Francesco della Rovere, 1414-1484), Pope 1471. Reverse: nude standing figure of Constancy, resting left arm on

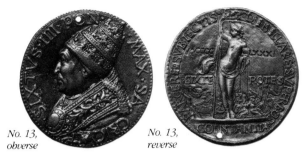

No. 13, obverse

No. 13, reverse

fluted column, right on tall staff, and holding long scarf; at her feet, Turkish captives, arms, banners; galleys in harbor.
1481
Bronze, 6.0 (2 ³/₈)
Kress Collection, A–947.209A

This group, predominantly Roman works, includes portrait medals of Paul II and Sixtus IV (nos. 5 and 13), who were both outstanding patrons of the arts and instrumental in bringing to papal Rome artists from advanced cultural centers elsewhere in Italy. Members of the papal court are also represented, notably in the two examples (nos. 10 and 11) by the very refined medallist Lysippus Junior, who is mentioned as a nephew of Cristoforo di Geremia and is known only by the pseudonym which likens him to the renowned Greek sculptor of the fourth century B.C. The taste for historicizing medals is again evident in the *Nero* (no. 7) by the Master of the Roman Emperors, who may have worked in northern Italy and was particularly influenced by Roman coins. Interest in Roman history is also evident in the currently popular motif of the She-Wolf with Romulus and Remus (no. 8; here derived from Roman coins) which we see represented on plaquettes as well as in statuettes.

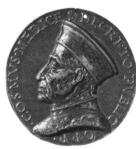
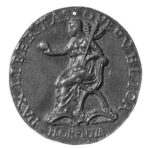

No. 14, obverse No. 14, reverse

14. **Florentine**
Cosimo de' Medici, 1389-1464, *Pater Patriae.* Reverse: Florence seated, holding orb and triple olive branch.
c. 1465-1469
Bronze, 7.8 (3 ¹/₁₆)
Kress Collection, A–984.246A

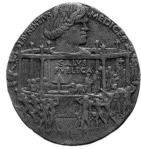
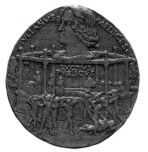

No. 15, obverse *No. 15, reverse*

15. **Bertoldo di Giovanni,**
 Florentine, c. 1420-1491
 The Pazzi Conspiracy. Obverse: bust of
 Lorenzo de' Medici, 1449-1492, nearly in
 profile to right, placed above choir of the
 duomo, Florence; within, priests celebrat-
 ing Mass; outside, conspirators attacking
 Lorenzo; below SALVS PVBLICA. Reverse:
 bust of Giuliano de' Medici, 1453-1478,
 nearly in profile, to left, over the choir of
 the duomo, where Mass is being cele-
 brated; outside it, his murder; below,
 LVCTVS PVBLICVS.
 1478
 Bronze, 6.6 (2 $^{19}/_{32}$)
 Kress Collection, A–990.252A

16. **Florentine,** third quarter XV century
 Giovanni di Cosimo de' Medici, 1421-1463.
 Without reverse.
 c. 1465-1469
 Bronze, 9.8 (3 $^{7}/_{8}$)
 Widener Collection, A–1477

17. **Italian,** late XV or early XVI century
 Mathias Corvinus, King of Hungary 1458-
 1490. Without reverse.
 Bronze, 8.6 (3 $^{3}/_{8}$)
 Kress Collection, A–1230.492A

18. **Florentine,** late XV century
 Mathias Corvinus, King of Hungary 1458-
 1490. Reverse: cavalry battle between Hun-
 garians and Turks; in foreground, statue
 on column.
 Bronze, 5.2 (2 $^{1}/_{16}$)
 Kress Collection, A–993.255A

19. **Bertoldo di Giovanni**
 Mohammad II, 1430-1481, Sultan of the
 Turks 1451. Reverse: triumphal car drawn
 by two horses, led by Mars; on car, stand-
 ing man carrying small figure in left hand,
 with right holding cord which binds three
 crowned nude women representing
 Greece, Trebizond, and Asia; on side of
 car, scene of siege; below, reclining fig-

ures of Sea and Earth.
Bronze, 9.4 (3 $^{11}/_{16}$)
Kress Collection, A-986.248A

Largely Florentine, this group of medals includes representations of two of the Medici who, without official title, ruled fifteenth-century Florence: Cosimo il Vecchio, called Pater Patriae, and his grandson Lorenzo, called Il Magnifico (nos. 14 and 15). We note also the roughly finished but vigorously three-dimensional portrait of Cosimo's second son Giovanni (no. 16), which bears comparison with the contemporaneous portrait busts by the Florentine sculptor Benedetto da Maiano (1442-1497).

Of great historic interest is the partly narrative, partly emblematic Pazzi Conspiracy medal (no. 15), which commemorates the defeat of a plot by the Pazzi and other Florentine houses to overthrow the domination of the Medici by assassinating Lorenzo and his brother Giuliano. The portraits of Lorenzo and Giuliano, who was in fact fatally wounded while attending Mass in the cathedral, may have been based on paintings by Botticelli; they bear comparison with the two portrait busts ascribed to Verrocchio and the Botticelli *Giuliano* in the National Gallery's collection. The profile of Lorenzo also recalls Trajanic coins.

The Pazzi Conspiracy medal is the work of the sculptor Bertoldo, who was intimately connected with the Medici circle. A pupil of Donatello, he assisted the older master on the bronze pulpits in the Medici church of San Lorenzo; like Antonio Pollaiuolo (1431/32-1498), Bertoldo was one of the earliest Florentines to make bronze statuettes of heroes from ancient mythology. He was also one of Michelangelo's teachers.

Francesco di Giorgio

1. **Francesco di Giorgio Martini,**
 Sienese, 1439-1501/02
 Judgment of Paris
 c. 1475-1485
 Bronze, 13.7 x 13.2 (5 $^3/_8$ x 5 $^5/_{32}$)
 Kress Collection, A-293.16B

2. **Francesco di Giorgio**
 Saint John the Baptist
 c. 1475-1485
 Bronze, 19.8 (7 $^3/_4$)
 Kress Collection, A-401.124B

No. 3

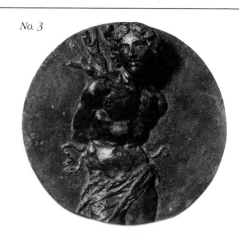

No. 4

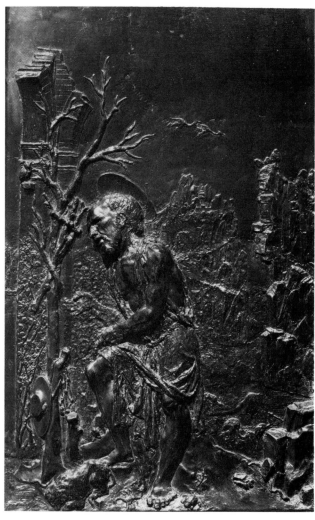

3. **Francesco di Giorgio**
 Saint Sebastian
 c. 1475-1485
 Bronze, 20.3 (8)
 Kress Collection, A–400.123B

4. **Francesco di Giorgio**
 Saint Jerome
 c. 1475-1485
 Bronze, 55 x 37.3 (21 5/8 x 14 3/4)
 Kress Collection, A–165.2C

A pupil of Vecchietta, Francesco di Giorgio is the most outstanding Sienese artist of the second half of the quattrocento. He was not only a talented sculptor, painter, and architect, but also a distinguished theoretician and military and civil engineer.

His sculptural style, in some ways analogous to the "activism" of his Florentine contemporary Andrea Verrocchio (1435-1488), is characterized by the nervous internal agitation of the figures he portrays. This quality is in large part achieved through the complex and constant varying of the relief surfaces and the resulting effect of flickering light. Francesco di Giorgio's style, which is so richly represented here, is one supremely suited to the realization of both the plastic potential of the process of modeling in wax and the light-reflecting properties of bronze. These four reliefs may all have been produced during the decade 1475-1485, when the artist was employed at the court of Urbino on the construction of Federigo da Montefeltro's Ducal Palace. Their juxtaposition affords an appreciation not only of the artist's mastery of the bronze technique but also of the range of his application: the very low relief of the small, sketchlike, and classicizing *Judgment of Paris,* the unusual and dramatically high relief of the two three-quarter-length saints against a neutral relief plane, and the extraordinary pictorial character of the multifacetted *Saint Jerome,* with its acute attention to natural detail. The two roundels form part of a series, of which two more examples are known; they probably originally functioned as church decoration. Undoubtedly a major commission, the depiction of the tormented saint repentant in the wilderness is perhaps the artist's most poignant work.

Niccolò Fiorentino and His School

1. **Adriano de' Maestri,** called **Adriano Fiorentino,** active 1488-1499 or later
 Giovanni Gioviano Pontano, 1426-1503, poet. Reverse: Urania walking to right, holding globe and lyre; before her, an ivy plant.
 Bronze, 8.4 (3 5/16)
 Kress Collection, A–843.106A

Adriano de' Maestri, called Fiorentino, was greatly influenced by his sometime collaborator Bertoldo. He appears to have worked in Rome, Naples, Urbino, and in Germany. In its portrayal of a poet, this medal is reminiscent of the humanist medals encountered before.

2. **Niccolò di Forzore Spinelli,** called **Niccolò Fiorentino,** 1430-1514
Alfonso I d'Este, 1476-1534, Duke of Ferrara 1505. Reverse: Alfonso (?) in armor, seated right on triumphal car, drawn by four rearing horses.
1492
Bronze, 7.1 (2 ²⁵/₃₂)
Kress Collection, A-994.256A

3. **Manner of Niccolò Fiorentino**
Ercole I d'Este 1431-1505, Duke of Ferrara and Modena 1471. Reverse: Minerva standing to front, resting on spear and shield.
c. 1490-1495
Bronze, 5.1 (2)
Kress Collection, A-1005.267A

4. **Attributed to Niccolò Fiorentino**
Innocent VIII (Giovanni Battista Cibo, 1432-1492), Pope 1484. Reverse: female figures of Justice, left, holding sword and scales; Peace, center, laureate, holding branch and cornucopia; Abundance, right, laureate, holding two ears of corn and cornucopia.
c. 1480-1486
Bronze, 5.4 (2 ¹/₈)
Kress Collection, A-996.258A

5. **Manner of Niccolò Fiorentino**
Marsilio Ficino, 1433-1499, Florentine humanist. Reverse: PLATONE (Plato) across field.
c. 1499
Bronze, 5.5 (2 ⁵/₃₂)
Kress Collection, A-1006.268A

6. **Manner of Niccolò Fiorentino**
Roberto di Ruggiero de' Macinghi. Reverse: nude female figure with scarf about her, standing, holding round conical shield in right hand, and peacock by its neck in left hand; above, VIGILANTIA.
1495
Bronze, 3.3 (1 ⁹/₃₂)
Kress Collection, A-1008.270A

7. **Manner of Niccolò Fiorentino**
Lorenzo de' Medici, 1449-1492. Without reverse.
c. 1485-1500
Bronze, 3.5 (1 ³/₈)
Kress Collection, A-1009.271A

8. **Manner of Niccolò Fiorentino**
Maria de' Mucini. Reverse: eagle displayed, on armillary sphere, resting on a

blazing framework; across, on a scroll, EXPECTO; below, a dog with scroll ASSIDVVS and a lamb with scroll MITIS ESTO; behind, a pomegranate; the field *semé* with plumes.

c. 1485-1500

Bronze, 9.0 (3 $^{17}/_{32}$)

Kress Collection, A–1010.272A

9. **Manner of Niccolò Fiorentino**

Costanza Rucellai, possibly daughter of Girolamo Rucellai who married Francesco Dini 1471. Reverse: female figure of Virginity fastening nude, winged Love to tree; at his feet, a bow and quiver; between them, unicorn lying on the ground.

c. 1485-1490

Bronze, 5.5 (2 $^5/_{32}$)

Kress Collection A–1019.281A

10. **Manner of Niccolò Fiorentino**

Ruberto Nasi, born 1479, prior of liberty 1513. Reverse: the same allegory of Chastity as the preceding example.

c. 1495

Bronze, 5.5 (2 $^5/_{32}$)

Kress Collection, A–1011.273A

11. **Manner of Niccolò Fiorentino**

Antonio Pizzamani, 1462-1512, Venetian scholar and apostolic protonotary, Bishop of Feltre 1504. Reverse: half figures of Felicity, carrying a peacock; Virtue, holding palm branch; Fame, helmeted, with trumpet.

c. 1490

Bronze, 6.1 (2 $^{13}/_{32}$)

Kress Collection, A–1016.278A

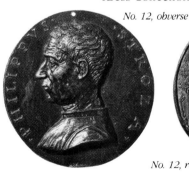
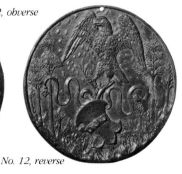

No. 12, obverse

No. 12, reverse

12. **Manner of Niccolò Fiorentino**

Filippo Strozzi, 1426-1491, Florentine merchant-prince. Reverse: eagle displayed, on stump to which is tied shield of the Strozzi arms; landscape with pine trees in meadow; field *semé* with plumes.

1489

Bronze, 9.8 (3 $^7/_8$)

Kress Collection, A–1024.286A

13. **Manner of Niccolò Fiorentino**
Girolamo Savonarola, 1452-1498, Dominican preacher. Reverse: map of Italy, showing chief cities marked with initials; above, hand of God issuing from cloud, holding dagger.
c. 1497
Bronze, 9.5 (3 ¾)
Kress Collection, A–1020.282A

14. **Manner of Niccolò Fiorentino**
Alessandro di Gino Vecchietti, 1472-1532. Reverse: nude female figure of Fortune, holding sail, advancing over waves on a dolphin; sun's face reflected in water; on rock at right, an ermine holding a scroll inscribed PRIVS MORI QVA[M] TVRPARI.
c. 1498
Bronze, 8.0 (3 ⁵/₃₂)
Kress Collection, A–1028.290A

No. 15, obverse

15. **Manner of Niccolò Fiorentino**
Giovanna Albizzi, wife of Lorenzo Tornabuoni. Reverse: the Three Graces.
c. 1486
Bronze, 7.8 (3 ¹/₁₆)
Kress Collection, A–1026.288A

No. 15, reverse

16. **Manner of Niccolò Fiorentino**
Lorenzo di Giovanni Tornabuoni, 1466-1497. Reverse: Mercury, walking to right, armed with sword and carrying caduceus.
Bronze, 7.8 (3 ¹/₁₆)
Kress Collection, A–1034.296A

The work of Niccolò Fiorentino and his prolific followers constitutes the finest series of medallic portraits from the second half of the quattrocento. Boldly rendered in high relief, sharply silhouetted against the flat plane, and grandly extended to fill the relief surface vertically, these portraits are excellent character studies as well. The sitters include two Este rulers (nos. 2 and 3), the heirs of Pisanello's patrons; Pope Innocent VIII (no. 4), the successor of Sixtus IV and also a patron of major artists; and numerous prominent Florentines, including the influential Neoplatonic philosopher Ficino (no. 5) and the popular Dominican preacher Savonarola (no. 13), whose fanatical vision of the destruction of Italy at the close of the century is depicted on his medal's reverse. Again represented is Lorenzo de' Medici (no. 7), who is known to have possessed by 1492 a collection of 1,844 bronze medals, a sure indication of the vitality of the new art form by the end of the fifteenth century.

Northern Italy, 1450-1500 (GN 6)

The second half of the quattrocento witnessed the spread of the modern Florentine aesthetic into the north of Italy. Here the dominant financial and political centers were the Lombard capital Milan, ruled by the Sforza dukes, and republican Venice; each pursued during the fifteenth century an aggressive policy of territorial expansion.

Like the Visconti whom they displaced at mid-century, the Sforza proved to be lavish patrons of the arts, and they were often—as demonstrated by Leonardo da Vinci's lengthy residence at Milan—receptive to Tuscan innovations. Concurrently in Venice, the fertile and opulent native tradition of Byzanto-Gothic art came increasingly to incorporate principles of Florentine rationalism. During the second quarter of the century Venice had employed such forward-looking Florentine painters as Paolo Uccello and Andrea del Castagno, and the Venetian Jacopo Bellini traveled to Florence. He was to become an indefatigable transcriber of ancient sculptural and architectural monuments and an ingenious master of the laws of linear perspective. With Jacopo's outstanding son Giovanni Bellini, the guiding artistic force of the second half of the century, dawned the golden age of Venetian painting.

The arts of the neighboring university city of Padua continued to be influenced by Donatello's presence there at mid-century; the strong tradition of bronze casting, fostered by the production of the high altar in the Santo and the Gattamelata equestrian monument, evolved by the end of the century into the remarkably active sculptural school represented in the next gallery. The art of the medal and the small bronze also prospered in northern Italy under the regional princely families and flourished most notably at the culturally vital courts of Ferrara, Mantua, Rimini, Urbino, and Pesaro.

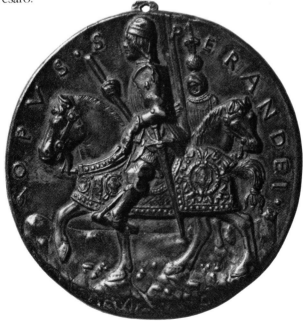

Sperandio, Giovanni II Bentivoglio, *reverse*

Princes and Popes

The first case presents medals, by artists of various origins, portraying heads of state. Below is exhibited the Kress collection of Renaissance coins, which also represent a variety of regions within Italy. The coins, actual units of currency, are of particular interest in the relationships they bear to contemporary medals. While medieval European coinage was primarily heraldic and abstract in design, the Renaissance revived the Roman and Byzantine imperial convention of representing the ruler's portrait on the obverse.

1. **Clemente da Urbino,**
 known active 1468 at Urbino
 Federigo da Montefeltro, 1422-1482, Count of Urbino 1444, and Duke 1474. Reverse: eagle on torse supporting with spread wings a plate on which are cuirass, shield, sword, globe, and brush with olive branch; above, radiant planets of Jupiter, Mars, and Venus.
 1468
 Bronze, 9.4 (3 $^{11}/_{16}$)
 Kress Collection, A–837.100A

 Little is known of the bronze caster and medallist who signed and dated this impressive medal of Federigo da Montefeltro, who governed Urbino and was extolled by his contemporaries as a model of princely virtue. The medal commemorates Federigo's military achievements by reference to the Romans in its inscription, in the classical breastplate the sitter wears, and in the reverse imagery, which symbolizes astrologically the balance of Mars and Venus (War and Peace) under Jupiter. Federigo's role as patron of the arts has been mentioned regarding Francesco di Giorgio.

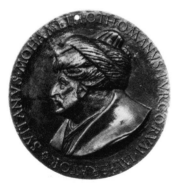 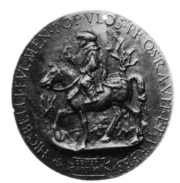

No. 2, obverse *No. 2, reverse*

2. **Costanzo da Ferrara,** known active 1481
 Mohammad II, 1430-1481, Sultan of the Turks 1451. Reverse: Sultan riding to left, with trees and buildings in background.
 c. 1481
 Bronze, 12.3 (4 $^{25}/_{32}$)
 Kress Collection, A–839.102A

Repeatedly hailed as the most outstanding medal in the Kress Collection, this piece with its robust portrait and harmonious composition, is a unique cast. Presumably a native of Ferrara, Costanzo was active as a medallist and painter in Naples. He was called to Constantinople to paint the sultan's portrait and probably returned in 1481 after the latter's death. The portrayal on the medal's reverse of the sultan on horseback in a landscape recalls Pisanello's medallic designs, while the design of the horse itself reflects Donatello's influential equestrian monument in Padua, the Gattamelata.

3. **Francesco Laurana,**
 Dalmatian, c. 1430-1502
 René d'Anjou, 1409-1480, King of Naples 1435-1442, and *Jeanne de Laval,* his second wife in 1454, died 1498. Reverse: Peace standing, holding olive branch; on right, olive tree; on left, cuirass; in field, M CCCC LXIII.
 1463
 Lead, 9.0 (3 $^{17}/_{32}$)
 Kress Collection, A-760.24A

4. **Francesco Laurana**
 Jean d'Anjou, 1427-1470, Duke of Calabria. Reverse: circular temple surmounted by Archangel Michael; across field, M CCCC LXIIII.
 1464
 Bronze, 8.5 (3 $^{11}/_{32}$)
 Kress Collection, A-762.26A

A distinguished marble carver, Laurana was born in La Vrana near Zadar and trained in the Adriatic tradition. He worked primarily in Naples and Sicily and in Provence, where he produced the medals shown here. The convention of representing a pair of sitters jugate, as in the first, is known from Roman coins. The sense of plasticity achieved in the double image reminds us of Francesco's masterful portrait busts in marble.

5. **Milan**
 Lodovico Maria Sforza, 1451-1508, called Il Moro, 7th Duke of Milan 1494-1500. Reverse: Beatrice d'Este, 1475-1497, his wife.
 1497
 Copper proof for a testoon, 2.7 (1 $^{1}/_{16}$)
 Kress Collection, A-1394.654A

6. **Milan**
 Francesco I Sforza, 1401-1466, 4th Duke of Milan 1450. Reverse: duke in armor on horseback, wielding sword.
 Gold ducat, 2.2 ($^{27}/_{32}$)
 Kress Collection, A–1387.647A

7. **Milan**
 Giangaleazzo Maria Sforza, 1469-1494, 6th Duke of Milan 1476; titular duke in association with his uncle Lodovico il Moro 1480-1494. Reverse: shield with two crests.
 Silver testoon, 2.9 (1 $^{1}/_{8}$)
 Kress Collection, A–1390.650A

8. **Milan**
 Giangaleazzo Maria Sforza, 1469-1494, 6th Duke of Milan 1476; titular duke 1480-1494. Reverse: shield with two crests.
 Silver testoon, 2.9 (1 $^{1}/_{8}$)
 Kress Collection, A–1391.651A

9. **Milan**
 Giangaleazzo Maria Sforza, 1469-1494, 6th Duke of Milan 1476; titular duke 1480-1494. Reverse: Lodovico Maria Sforza, 1451-1508, called Il Moro, regent 1480-1494, to right in cuirass.
 Silver testoon, 2.9 (1 $^{1}/_{8}$)
 Kress Collection, A–1392.652A

10. **Milan**
 Giangaleazzo Maria Sforza, 1469-1494, 6th Duke of Milan 1476; titular duke 1480-1494. Reverse: shield with two crests.
 Gold double testoon, 2.9 (1 $^{1}/_{8}$)
 Kress Collection, A–1389.649A

11. **Milan**
 Galeazzo Maria Sforza, 1444-1476, 5th Duke of Milan 1466. Reverse: shield, casque and crest, flanked by brands with buckets.
 Silver testoon, 2.8 (1 $^{3}/_{32}$)
 Kress Collection, A–1388.648A

12. **Milan**
 Lodovico Maria Sforza, 1451-1508, called Il Moro, 7th Duke of Milan 1494-1500. Reverse: crowned shield flanked by brands with buckets.
 Silver testoon, 2.7 (1 $^{1}/_{16}$)
 Kress Collection, A–1393.653A

13. **Naples**
 Ferdinando I of Aragon, 1431-1494, King of Naples 1458. Reverse: Saint Michael

spearing the dragon.
Silver coronato, 2.7 (1 $^1/_{16}$)
Kress Collection, A–1405.665A

14. **Bologna**
Giovanni II Bentivoglio, 1443-1509, Lord of Bologna 1462-1506. Reverse: shield surmounted by eagle.
Gold ducat, 2.3 ($^{29}/_{32}$)
Kress Collection, A–1399.659A

15. **Rome**
Sixtus IV (Francesco della Rovere, 1414-1484), Pope 1471. Reverse: shield with the della Rovere arms, surmounted by crossed keys and tiara.
Silver grosso, 2.4 ($^{15}/_{16}$)
Kress Collection, A–1404.664A

16. **Bologna**
Julius II (Guiliano della Rovere, 1443-1513), Pope 1503. Reverse: San Petronio seated, holding model of Bologna and a crozier; below, arms of Cardinal Alidosi.
Silver giulio, 2.8 (1 $^3/_{32}$)
Kress Collection, A–1400.660A

17. **Bologna**
Leo X (Giovanni de' Medici, 1475-1521), Pope 1513. Reverse: lion rampant, holding banner; to left above, shield with arms of Cardinal Giulio de' Medici.
Silver bianco, 2.7 (1 $^1/_{16}$)
Kress Collection, A–1401.661A

18. **Pesaro**
Giovanni Sforza, 1466-1510, Lord of Pesaro 1489. Reverse: inscription: PVBLICAE COMMODITATI.
Copper denaro, 1.9 ($^3/_4$)
Kress Collection, A–1402.662A

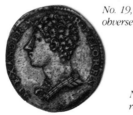
No. 19, obverse

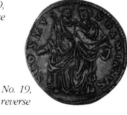
No. 19, reverse

19. **Benvenuto Cellini,**
Florentine, 1500-1571
Alessandro I de' Medici, 1510-1537, 1st Duke of Florence 1531. Reverse: Saints Cosmas and Damian.
Silver testoon, 2.8 (1 $^3/_{32}$)
Kress Collection, A–1403.663A

In his autobiography, the famous Florentine sculptor mentions the making of this coin.

20. **Turin**
 Filiberto II, 1480-1504, 8th Duke of Savoy
 1497. Reverse: shield of Savoy, casque,
 crest and lambrequins, with two Savoy
 knots in the field.
 Silver half-testoon, 2.7 (1 $^{1}/_{16}$)
 Kress Collection, A-1381.641A

21. **Turin**
 Carlo II, 1489-1496, 6th Duke of Savoy
 1490. Reverse: crowned shield; across
 field, FE RT.
 Silver testoon, 2.9 (1 $^{1}/_{8}$)
 Kress Collection, A-1382.642A

22. **Carmagnola**
 Lodovico II, Marquess of Saluzzo, 1475-
 1504. Reverse: crowned shield inclined,
 with eagle crest, between L M.
 Gold ducat, 2.4 ($^{15}/_{16}$)
 Kress Collection, A-1383.643A

23. **Mantua**
 Francesco II Gonzaga, 1466-1519, 4th
 Marquess of Mantua 1484. Reverse: pyxis
 of the Blood of Christ.
 Silver testoon, 2.5 ($^{31}/_{32}$)
 Kress Collection, A-1384.644A

24. **Mantua**
 Francesco II Gonzaga, 1466-1519, 4th
 Marquess of Mantua 1484. Reverse: pyxis
 of the Blood of Christ.
 Silver half-testoon, 2.5 ($^{31}/_{32}$)
 Kress Collection, A-1385.645A

25. **Mantua**
 Francesco III Gonzaga, 1533-1550, 2nd
 Marquess of Monferrat and 2nd Duke of
 Mantua 1450. Reverse: Tobias guided by
 the Angel.
 Silver testoon, 3.0 (1 $^{3}/_{16}$)
 Kress Collection, A-1386.646A

26. **Spain**
 Ferdinando II of Aragon, 1452-1516, mar-
 ried 1469 Isabella of Castile and Leon,
 1451-1504; joint monarchs of Spain (as
 Ferdinand V and Isabella I) 1474. Reverse:
 eagle displayed, charged with crowned
 shield of Castile and Leon quartering
 Aragon and Sicily; in field to right, T; to
 left, five pellets.
 Gold excelente, 2.9 (1 $^{1}/_{8}$)
 Kress Collection, A-1407.667A

27. **Nancy**
 Antoine, 1489-1544, Duke of Lorraine
 1508. Reverse: crowned shield.
 1523
 Silver testoon, 3.0 (1 $^3/_{16}$)
 Kress Collection, A-1406.666A

28. **Milan**
 Louis XII, 1462-1515 (King of France 1498),
 as Duke of Milan 1499-1512. Reverse: Saint
 Ambrose on horseback, wielding scourge;
 below, crowned shield of France.
 Silver testoon, 2.8 (1 $^3/_{32}$)
 Kress Collection, A-1395.655A

29. **Ferrara**
 Alfonso I d'Este, 1476-1534, 3rd Duke of
 Ferrara 1505. Reverse: helmeted nude
 figure seated, holding lion's head from
 which issue bees.
 Cast of a silver testoon, 2.8 (1 $^3/_{32}$)
 Kress Collection, A-1398.658A

30. **Ferrara**
 Ercole I d'Este, 1431-1505, 2nd Duke of
 Ferrara 1471. Reverse: Christ rising from
 the tomb, holding banner.
 Gold ducat, 2.4 ($^{15}/_{16}$)
 Kress Collection, A-1396.656A

31. **Ferrara**
 Ercole I d'Este, 1431-1505, 2nd Duke of
 Ferrara 1471. Reverse: nude man on horse-
 back to right.
 Copper proof for a testoon, 2.8 (1 $^3/_{32}$)
 Kress Collection, A-1397.657A

Milanese, early XVI century
The Man of Sorrows
Marble relief, 29.5 x 25.4 (11 $^5/_8$ x 10)
Kress Collection, A-66

Comparable in scale to many of the bronze
devotional reliefs, this delicately carved image
of Christ in the tomb attended by angels was
made by one of the Lombard sculptors work-
ing at the Certosa (Charterhouse) at Pavia
during the first few years of the sixteenth cen-
tury. The dynastic mausoleum, inherited by
Francesco Sforza, Duke of Milan (whom we
have seen portrayed by Pisanello and on a
Milanese gold ducat), from his Visconti pre-
decessors, was throughout this period the
foremost arena of sculptural activity in Lom-

bardy. Reconstruction of the buildings began in 1451 when Francesco brought in as supervisor the Florentine sculptor, architect, and theorist Antonio Filarete (c. 1400-1469), who also was a pioneer in the art of the small bronze. The program of sculptural decoration at the Certosa continued into the sixteenth century and was strongly influenced by the style of the Pavian sculptor Antonio Amadeo (1447-1522). Amadeo's style is reflected here in the deep undercutting and in the liturgically garbed adolescent angels.

Milanese, The Man of Sorrows

Mantua and Ferrara

1. **Bartolommeo Melioli,**
 Mantuan, 1448-1514
 Chiara Gonzaga, wife 1481 of Gilbert de Bourbon (Comte de Montpensier and Dauphin d'Auvergne), died 1503. Cast hollow, and decorated with cast impressions of goldsmiths' ornaments.
 c. 1481
 Bronze, 5.8 (2 $^9/_{32}$)
 Kress Collection, A–806.70A

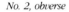

No. 2, obverse

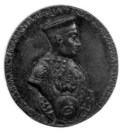

2. **Bartolommeo Melioli**
 Lodovico III Gonzaga, 1414-1478, 2nd Marquess of Mantua 1444. Reverse: Lodovico seated to right on throne adorned with Gonzaga hounds; before him Faith and Minerva standing.
 1475
 Bronze, 7.9 (3 $^1/_8$)
 Kress Collection, A–804.68A

3. **Bartolommeo Melioli**
 Francesco II Gonzaga, 1466-1519, 4th Marquess of Mantua 1484. Reverse: figure of Health standing between a sea and a fire, resting on staff, holding ears of corn and basket with inscribed scroll.
 1484?
 Bronze, 7.1 (2 $^{25}/_{32}$)
 Kress Collection, A–805.69A

4. **Gianfrancesco Ruberti,**
 known active 1483-1526 at Mantua
 Francesco II Gonzaga, 1466-1519, 4th Marquess of Mantua 1484. Reverse: battle scene.
 After 1484
 Bronze, 5.0 (1 $^{31}/_{32}$)
 Kress Collection, A–807.71A

Melioli worked in Mantua as a medallist, coin engraver, and goldsmith. His skill in metalworking is revealed in the ornate armor of the Gonzaga rulers here portrayed. Melioli appears to have been succeeded as master of the Mantuan mint in 1500 by Ruberti. The latter was also active as a goldsmith and die engraver and may have served the Gonzaga court as an armorer.

5. **Giancristoforo Romano,** c. 1465-1512
 Isabella d'Este, 1474-1539, wife 1490 of Francesco II Gonzaga of Mantua. Reverse: Astrology, winged, with wand; before her, serpent rearing; above, sign of Sagittarius.
 Bronze, 3.9 (1 $^{17}/_{32}$)
 Kress Collection, A–813.76A

6. **Circle of Giancristoforo Romano**
 Lucrezia Borgia, 1480-1519, wife 1502 of Alfonso d'Este of Ferrara. Without reverse.
 1502?
 Bronze, 6.0 (2 $^3/_8$)
 Kress Collection, A–815.78A

No. 6

Giancristoforo, son of the sculptor Isaia da Pisa, was born in Rome. Trained as a metalworker, he was also a marble sculptor and architect. He worked in several Italian cities on major projects, including the decoration of the Certosa of Pavia. From 1497 to 1505 Giancristoforo worked in Mantua for Isabella d'Este, who presided over the cultural society of the Gonzaga court for nearly half a century. She was one of the most determined collectors of antiquities in her day and was an avid and fastidious patron of the fine and applied arts. Isabella's rival and sister-in-law, the notorious and beautiful Lucrezia Borgia, is represented

in a medal which may have been made to commemorate her third and last marriage, to the heir to the Duchy of Ferrara.

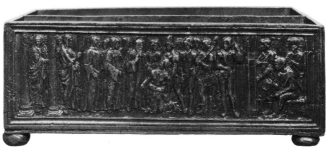

No. 8

7. & 8. **North Italian, possibly Mantuan**
Writing Casket with Scenes from the Life of Saint Simeon of Podirolo
c. 1500
Bronze, 7.6 x 18.9 x 13.8
(2 $^{31}/_{32}$ x 7 $^{7}/_{16}$ x 5 $^{7}/_{16}$)
Kress Collection, A–213.54C

The subjects of the reliefs decorating the box and that of the single plaquette have been recognized by Middeldorf as scenes from the life of a tenth-century saint whose cult is localized to the region around Mantua. Probably produced there, the narrative reliefs bear analogies with the medals of Melioli.

9. **Bartolommeo di Sperandio Savelli,**
c. 1425/30-c. 1504
The Flagellation. Without reverse.
c. 1480
Bronze, 12.3 x 13.4 (4 $^{27}/_{32}$ x 5 $^{1}/_{4}$)
Kress Collection, A–363.86B

10. **Sperandio**
Bartolommeo Pendaglia, merchant of Ferrara. Reverse: nude male figure seated on cuirass, holding globe and spear, his left foot on bag from which money flows; behind, two shields.
c. 1462
Bronze, 8.4 (3 $^{5}/_{16}$)
Kress Collection, A–849.112

11. **Sperandio**
Antonio Sarzanella de' Manfredi of Faenza, Este diplomat. Reverse: double-headed figure of Prudence seated on throne formed by two hounds, holding shield with Manfredi arms, a pair of compasses, and a mirror.
c. 1463
Bronze, 7.3 (2 $^{7}/_{8}$)
Kress Collection, A–850.113A

12. **Sperandio**

Lodovico Carbone of Ferrara, c. 1436-1482, poet. Reverse: Lodovico receiving wreath from seated Calliope; in background, fountain.

c. 1462-1463

Bronze, 7.0 (2 3/4)

Kress Collection, A–851.114A

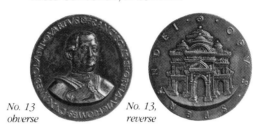

No. 13 obverse No. 13, reverse

13. **Sperandio**

Francesco I Sforza, 1401-1466, 4th Duke of Milan 1450. Reverse: elevation of five-domed centralized church.

c. 1466

Bronze, 8.6 (3 3/8)

Kress Collection, A–852.115A

14. **Sperandio**

Francesco II Gonzaga, 1466-1519, 4th Marquess of Mantua 1484. Reverse: Francesco on horseback, accompanied by horsemen and foot soldiers.

c. 1495

Bronze, 9.5 (3 3/4)

Kress Collection, A–868.131A

15. **Sperandio**

Niccolò da Correggio, 1450-1508, Count of Brescello 1480. Reverse: Niccolò, fully armed and riding to left, reaches his hand to a bearded, cowled friar; on either side, a leafless tree.

c. 1480

Lead, 7.9 (3 1/8)

Kress Collection, A–863.126A

16. **Sperandio**

Alessandro Tartagni of Imola, 1424-1477, jurisconsult. Reverse: on summit of Parnassus, Mercury seated on dragon.

c. 1478

Bronze, 9.0 (3 17/32)

Kress Collection, A–861.124A

17. **Sperandio**

Giovanni II Bentivoglio, 1443-1509, Lord of Bologna 1462-1506. Reverse: Giovanni in armor riding left, the caparison adorned

with Bentivoglio arms; behind, a mounted squire seen from the front.
c. 1478-1482
Bronze, 9.8 (3 $^{27}/_{32}$)
Widener Collection, A-1494

18. **Sperandio**
Pietro Bono Avogario of Ferrara, died 1506, physician and astrologer. Reverse: Aesculapius standing on dragon, holding phial and branch; Urania on globe with Asia, Europe, and Africa labeled, holding astrolabe and book containing astrological diagrams.
c. 1472
Bronze, 9.0 (3 $^{17}/_{32}$)
Kress Collection, A-856.119A

The son of a Mantuan goldsmith, Sperandio was the most prolific medallist of the period. He worked at Ferrara from 1463 to 1477, as indicated by several of the medals here, and from 1478 to 1490 in Bologna, where he executed the tomb of Pope Alexander V. The *Flagellation* plaquette (no. 9), a signed version of which exists in Paris, dates probably from Sperandio's years in Bologna.

19. **Amadio da Milano,** known active 1437-c. 1483 at Ferrara
Borso d'Este, 1413-1471, Marquess of Este 1450; Duke of Modena and Reggio 1452; and 1st Duke of Ferrara 1471. Reverse: marigold with two long leaves; hanging from rosette, a door knocker with bar ending in dragon's head.
c. 1441
Bronze, 5.1 (2)
Kress Collection, A-764.28A

20. **Jacopo Lixignolo,** known active c. 1460
Borso d'Este, 1413-1471, Marquess of Este 1450; Duke of Modena and Reggio 1452; and 1st Duke of Ferrara 1471. Reverse: in a mountainous landscape, a unicorn dipping its horn into a stream; above, sun shining.
1460
Lead, 8.2 (3 $^{7}/_{32}$)
Kress Collection, A-771.35A

21. **Petrecino of Florence,**
known active in 1460 at Ferrara
Borso d'Este, 1413-1471, Marquess of Este 1450; Duke of Modena and Reggio 1452; and 1st Duke of Ferrara 1471. Reverse: in a rocky landscape, Este device of a hexagonal font with open lid, showing a ring

No. 24

No. 23

within; crosses on sides of font; above, sun shining.
1460
Lead, 9.6 (3 $^{25}/_{32}$)
Kress Collection, A–772.36A

22. **Ferrarese,** last quarter XV century
Acarino d'Este, legendary ancestor of the Estensi. Without reverse.
Lead, 8.3 x 6.6 (3 $^{1}/_{4}$ x 2 $^{19}/_{32}$)
Kress Collection, A–775.39A

23. **Italian, possibly Ferrarese**
Madonna and Child with Angels. Without reverse.
c. 1475
Bronze, 13.5 x 8.9 (5 $^{5}/_{16}$ x 3 $^{1}/_{2}$)
Kress Collection, A–518.240B

A Ferrarese origin is suggested for this frequently encountered plaquette in the characteristics it shares with contemporary Ferrarese painting. The attenuated figures, exaggerated contrapposto, and fantastic architecture recall the dynamic compositions of Cosimo Tura.

24. **North Italian, possibly Ferrarese,**
late XV or early XVI century
Saint George
Bronze, 13.2 x 6.75 x 5.5
(5 $^{3}/_{16}$ x 2 $^{15}/_{16}$ x 2 $^{1}/_{8}$)
Kress Collection, A–169.7C

A unique cast, this statuette of a classically garbed warrior saint, traditionally interpreted as Saint George, is also reminiscent of Tura's style. The position of the right hand suggests that the saint may originally have held a balance, rather than a lance, and thus been intended to represent a triumphant, albeit wingless, Saint Michael.

Venice and Padua

1. **Vettor di Antonio Gambello,**
 called **Camelio,** c. 1455/60-1537
 Self-Portrait. Reverse: sacrificial scene
 with seven figures, the altar with remains
 of victim and a wreath on the side; beside
 it, two goats.
 1508
 Struck bronze, 3.7 (1 $^{15}/_{32}$)
 Kress Collection, A–885.148A

2. **Camelio**
 Sixtus IV (Francesco della Rovere, 1414-
 1481), Pope 1471. Reverse: the pope in
 audience, assisted by two cardinals.
 1482?
 Bronze, 5.1 (2)
 Kress Collection, A–882.145A

3. **Camelio**
 A Lion. Without reverse.
 Bronze, 5.4 (2 $^1/_8$)
 Kress Collection, A–399.122B

4. **Camelio**
 Giovanni Bellini, c. 1430-1516, Venetian
 painter. Reverse: owl perched left on
 fragment of branch.
 Bronze, 5.5 (2 $^5/_{32}$)
 Kress Collection, A–883.146A

5. **Camelio**
 Gentile Bellini, 1429-1507, Venetian paint-
 er. Reverse: inscription.
 c. 1500
 Bronze, 6.4 (2 $^{17}/_{32}$)
 Kress Collection, A–884.147A

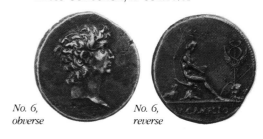

No. 6,
obverse No. 6,
reverse

6. **Camelio**
 "Augustus" (Self-Portrait?). Reverse: nude
 male figure seated right in attitude of the
 Ludovisi Mars; before him, winged cadu-
 ceus rising out of cuirass, with spear,
 helmet, and shield leaning against it;
 behind him, sapling and owl(?).
 Struck bronze, 2.9 (1 $^1/_8$)
 Kress Collection, A–887.150A

7. **Camelio**
 Classical subjects. Obverse: nude male figure carrying dead stag; behind him, Pan seated, two other satyrs in background; on left two putti playing and seated female(?) figure. Reverse: flaming tripod on square altar; on right wineskin at foot of a tree; on left ram tied to altar, and goat; branch, axe, torch, sword, and helmet on ground.
 Bronze, 3.0 (1 $^3/_{16}$)
 Kress Collection, A–886.149A

8. **Manner of Camelio**
 Marco Barbarigo, c. 1413-1486, Doge of Venice 1485. Reverse: inscription in ivy wreath.
 Bronze, 7.8 (3 $^1/_{16}$)
 Kress Collection, A–888.151A

Camelio was master of the dies for the Venetian mint from 1484 until 1510 and worked also as a medallist, jeweler, and armorer. He served the papal mint between 1513 and 1516 but returned to work in Venice until his death. Two impressive, large-scale bronze reliefs, signed by Camelio and depicting nude warriors in battle, are preserved in Venice.

The smaller medals shown here are characterized by a brilliantly crisp and incisive line and reflect a close study of the most refined examples of Roman coinage. The *Self-Portrait* and *"Augustus"* are the results of Camelio's experimentation with striking medals from dies. The medal of Giovanni Bellini, with its shrewd portrait of the greatest painter of fifteenth-century Venice, and that of his brother Gentile are late casts.

9. **North Italian or Florentine,**
 late XV century
 Neptune. Without reverse.
 Bronze, 4.2 x 5.1 (1 $^5/_8$ x 2)
 Kress Collection, A–308.31B

10. **Antonio Gambello,** known active
 1458-1479 or later in Venice
 Francesco Foscari, c. 1374-1457, Doge of Venice 1423. Reverse: Venetia seated, holding sword and shield, two Furies at her feet.
 Bronze, 4.7 (1 $^{27}/_{32}$)
 Kress Collection, A–873.136A

Primarily an architect, Antonio Gambello here portrays Francesco Foscari, who as Doge actively promoted the territorial expansion of the Venetian Republic on the mainland while initiating significant sculptural and architec-

tural projects in Venice itself. The medal's reverse reproduces the relief personifying Venice that adorns the façade of the Doge's Palace.

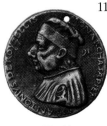

No. 11

11. **Bartolommeo Bellano,**
Paduan, c. 1434-1496/97
Antonio Roselli of Arezzo, 1380-1466, jurist. Reverse: seated male allegorical figure.
1460-1466(?)
Bronze, 4.7 (1 $^{27}/_{32}$)
Kress Collection, A–909.172A

Bellano, whose oeuvre is marked by a crudeness noted by his contemporaries, was nevertheless the foremost Paduan sculptor of the period. The son of a goldsmith, he was trained under Donatello, first during the decade spent in Padua by the Florentine master and later in Florence. Bellano worked predominantly in bronze, exploring the material's use for statuettes and utensils as well as large-scale works. He is best known as the author of a series of ten reliefs for the choir of the Santo in Padua and as the teacher of Andrea Riccio, the greatest Paduan sculptor of the next generation.

12. **Gianfrancesco Enzola,**
Parmesan, known active 1455-1478
Francesco I Sforza, 1401-1466, 4th Duke of Milan 1450. Reverse: greyhound seated under tree, touched by hand issuing from radiant cloud; bridle on ground tied to tree by chain.
1456
Bronze, 4.2 (1 $^{21}/_{32}$)
Kress Collection, A–829.92A

13. **Gianfrancesco Enzola**
Costanzo Sforza, 1447-1483, Lord of Pesaro 1473. Reverse: Alessandro Sforza, 1409-1468, Lord of Pesaro 1445, Costanzo's father, in plate armor over mail.
1475
Bronze, 8 (3 $^{5}/_{32}$)
Kress Collection, A–833.96A

A goldsmith, medallist, and die engraver, Enzola worked in his native Parma, in Ferrara, and in the papal vicariate of Pesaro on the Adriatic coast. Like Camelio, he experimented with striking medals from dies. Plaquettes by Enzola are displayed in the wall case nearby.

14. **Marco Guidizani,**
 active c. 1454-1462 at Venice
 Bartolommeo Colleone of Bergamo, 1400-
 1475, *condottiere.* Reverse: laureate nude
 male figure seated on cuirass, holding
 above his head end of plummet line
 which passes through ring, the plummet
 by his knee; with right hand he points to
 vertical line.
 1454 or later
 Lead, 8.3 (3 ¼)
 Kress Collection, A–875.138A

Colleone served Venice as *condottiere* (mer-
cenary general) and was there immortalized
in Verrocchio's over-life-sized bronze eques-
trian monument (begun in 1479 and com-
pleted in 1496), the heir to Donatello's
Gattamelata in nearby Padua and the most
important extant sculpture made by a Floren-
tine artist in northern Italy during the later
fifteenth century. Colleone's tomb in Bergamo
is a significant example of the Lombard
Amadeo's work.

15. **Gentile Bellini,** Venetian, 1429-1507
 Mohammad II, 1430-1481, Sultan of the
 Turks 1451. Reverse: three crowns of Con-
 stantinople, Iconium, and Trebizond.
 c. 1480
 Bronze, 9.2 (3 ⅝)
 Kress Collection, A–881.144A

As did Costanzo da Ferrara during the same
period, the Venetian painter Gentile Bellini
traveled to Constantinople (in 1479 and 1480)
to portray Mohammad II. One of Gentile's
painted portraits of the sultan is preserved in
the National Gallery, London.

16. **Pietro da Fano,** active c. 1452-1464
 Pasquale Malipiero, 1385-1462, Doge of
 Venice 1457. Reverse: Giovanna Dandolo,
 his wife, in flat cap and veil; below, a
 crown.
 Bronze, 9.3 (3 ²¹/₃₂)
 Kress Collection, A–872.135A

17. **Giovanni Boldù,**
 Venetian, known active 1454-1473
 Self-Portrait. Reverse: Boldù seated, pen-
 sive, between Faith, angel holding up
 chalice, and Penitence, as old woman,
 who scourges him.
 1458
 Bronze, 8.7 (3 ⁷/₁₆)
 Kress Collection, A–878.141A

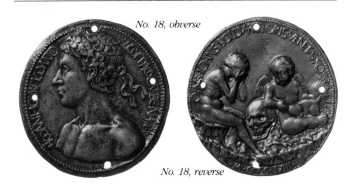

No. 18, obverse

No. 18, reverse

18. **Giovanni Boldù**
 Self-Portrait. Reverse: Boldù seated, head in hands; before him winged putto (genius of death) holding flame (symbol of soul) and resting on skull.
 1458
 Bronze, 8.5 (3 11/32)
 Kress Collection, A–879.142A

19. **Giovanni Boldù (?)**
 The Emperor Caracalla. Reverse: the same *memento mori* design as on the preceding medal.
 1466
 Bronze, 9.2 (3 5/8)
 Kress Collection, A–880.143A

20. **Giovanni Boldù**
 Nicolaus Schlifer, German musician. Reverse: Apollo with lyre and long scroll.
 1457
 Bronze, 8.1 (3 3/16)
 Kress Collection, A–877.140A

Boldù was also both a painter and a medallist; his strong medallic designs reveal an erudite and rigorous classicism in form and in content, particularly apparent here in his portrayal of himself as an Antique youth, nude and crowned with laurel. The repeated reverse image of the putto with the death's head is found again in Lombard sculpture, including a marble roundel at the Certosa of Pavia.

Bellano and His Contemporaries

1. **Paduan,** second half XV century
 The Holy Family
 Bronze, 8.8 x 7.6 (3 15/32 x 3)
 Kress Collection, A–509.231B

2. **Venetian,** first quarter XVI century
 The Resurrection
 Bronze, 16.7 x 10.6 (6 9/16 x 4 3/16)
 Kress Collection, A–549.271B

3. **Paduan or Venetian,**
 second half XV century
 Saint Jerome
 Bronze, 14.0 x 10.6 (5 $^{1}/_{2}$ x 4 $^{3}/_{16}$)
 Widener Collection, A–1513

4. **Paduan or Venetian,**
 late XV or early XVI century
 Saint Jerome
 Bronze, 8.5 x 12.3 (3 $^{11}/_{32}$ x 4 $^{27}/_{32}$)
 Kress Collection, A–526.248B

5. **Gianfrancesco Enzola,**
 Parmesan, known active 1455-1478
 Saint Jerome
 Bronze, 5.1 x 7.9 (2 x 3 $^{1}/_{8}$)
 Kress Collection, A–335.58B

6. **Gianfrancesco Enzola**
 Martyrdom of Saint Sebastian
 Bronze, 5.1 x 8.6 (2 x 3 $^{3}/_{8}$)
 Kress Collection, A–336.59B

No. 7

7. **Gianfrancesco Enzola (?)**
 Saint George and the Dragon
 Bronze, 4.8 x 5.7 (1 $^{29}/_{32}$ x 2 $^{1}/_{4}$)
 Kress Collection, A–342.65B

8. **Gianfrancesco Enzola**
 Child on a Lion
 Bronze, 7.1 (2 $^{13}/_{16}$)
 Kress Collection, A–341.64B

9. **Gianfrancesco Enzola**
 A Horseman Attacked by Three Lions
 Bronze, 7.0 x 6.9 (2 $^{3}/_{4}$ x 2 $^{23}/_{32}$)
 Kress Collection, A–339.62B

10. **Paduan or Venetian,**
 late XV or early XVI century
 Bowl
 Bronze, 7.5 x 19.6 (2 $^{31}/_{32}$ x 7 $^{23}/_{32}$)
 Kress Collection, A–248.92C

11. **North Italian,** last quarter XV century
 Dead Christ with Four Angels
 Bronze, 9.5 x 11.8 (3 $^{3}/_{4}$ x 4 $^{5}/_{8}$)
 Kress Collection, A–286.9B

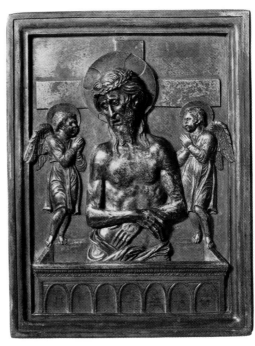

12. **Bartolommeo Bellano,**
Paduan, c. 1434-1496/97
Dead Christ with Two Angels
Gilt bronze, 23.7 x 18.3 (9 $^{11}/_{32}$ x 7 $^{3}/_{16}$)
Kress Collection, A–292.15B

13. **North Italian,** late XV century
Dead Christ
Bronze, 14.4 x 10.0 (5 $^{11}/_{16}$ x 3 $^{15}/_{16}$)
Widener Collection, A–1577

14. **Venetian**
*Dead Christ between the Virgin
and Saint John*
c. 1500
Bronze, 9.0 x 7.3 (3 $^{17}/_{32}$ x 2 $^{7}/_{8}$)
Kress Collection, A–700.422B

The impact of Donatello's high altar in the Santo at Padua and the local interest in bronze casting established during his years there are reflected in the sophistication of the small devotional reliefs produced in the Veneto in the decades following. The influence of Donatello's Paduan pupil Bellano is also felt in the works exhibited here, and Bellano's own oeuvre is represented again by the large gilt *imago pietatis* (no. 12). The images provided with tabernacle frames, which exemplify the contemporary taste in classicizing architectural forms, would originally have been used as paxes. The pax at the far right (no. 14) shows an interesting adaptation of a northern European design. The central image of the Virgin and Saint John taking their last farewell of Christ derives from a German painting of 1457 (Munich) attributed to Hans Multscher.

Riccio and His Generation (GN 7)

The turn of the sixteenth century in northern Italy marked an extraordinary flowering of the art of the small bronze and saw the bronze statuette firmly established as a popular independent genre. Among the many active centers of bronze production, the most prolific was Padua, with its legacy of sculpture in that medium by Donatello and Bellano. Padua's most inventive and influential exponent of the art of bronze casting was its native master Andrea Riccio.

Riccio was trained in his craft by Bellano. Upon the latter's death, Riccio is believed to have completed Bellano's Roccabonella tomb in San Francesco in Padua and, within the next decade, he added two intricate narrative reliefs in bronze to Bellano's series of Old Testament scenes in the choir of the Santo. Riccio's masterpiece, produced between 1507 and 1515, is the Paschal Candlestick, measuring twelve-and-a-half feet high, commissioned by the humanist philosopher, Giambattista de Leone, for the same revered site. The signal monument of Riccio's late style is the bronze tomb from c. 1520 of the Delle Torre, two learned physicians, in San Fermo Maggiore, Verona. (The historiated panels from this work are now in the Louvre.) Comparable in size and scale to the relief sculpture found on Riccio's major ecclesiastical commissions is the large *Entombment* exhibited here on the north wall. One of the most impressive of Riccio's reliefs now outside of Italy, the *Entombment* is signed in cipher on the large urn carried by one of the mourners in the right foreground; the relief may have been intended by the artist to mark his own grave. All of these works attest to Riccio's great genius as synthesizer of antique form and Christian content.

In his sculptural style Riccio merges the local Paduan interests in naturalism and emotionalism, which are evident in Bellano's work and derive largely from Donatello's late sculpture in the Santo, with the technical advancements in bronze casting available in Padua at the time and with a thoroughgoing classicism, based on the study and reshaping of Hellenistic as well as Roman models. That Riccio's classical vocabulary was, moreover, in perfect sympathy with the emphasis on classical learning which dominated the intellectual life of the university city is well illustrated by the innovative imagery of the great Easter Candlestick in the Santo. Here we find the Cardinal Virtues awesomely personified in the garb of Roman matrons, and New Testament figures taking the stately guise of togate senators. There are in addition, incorporated into a program devoted to Christ's sacrifice and redemption of mankind, a scene of animal sacrifice adapted from Roman prototypes and decorative hybrid beasts extracted from ancient art and mythology.

A fascinating document in the history of Renaissance thought, the Paschal Candlestick was crucial to the development of the Paduan sixteenth-century small bronze. There Riccio established the ornamental repertory of satyrs, centaurs, sphinxes, swags, and rams' heads which inspired the imaginative and entirely secular iconography of the bronze statuettes and utensils produced in large number by Riccio

himself, his workshop, and his followers. Undoubtedly the delight of the humanist culture that endorsed the great candlestick, these small-scale evocations of the pagan world were tremendously popular in the early sixteenth century as adornments for the studies of the learned and aristocratic. Like his major commissions, Riccio's small bronzes and plaquettes, which are so richly represented here, are extraordinary for the marvelous vitality of their surfaces achieved through a lively variation of textures and through modeling and chasing of an exquisite sensitivity.

Early Sixteenth-Century Lombardy and the Veneto

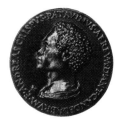 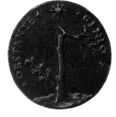

No. 1, obverse *No. 1, reverse*

1. **Follower of Riccio**
 Andrea Briosco, called Riccio, c. 1470-1532, Paduan sculptor. Reverse: a broken laurel tree with withered top falling over to right, and a new leafy branch springing from the trunk lower down; above, a star. 1532(?)
 Bronze, 5.2 (2 $^1/_{16}$)
 Kress Collection, A–1122.385A

A highly appropriate introduction to this gallery is Riccio's honorific medal, probably produced shortly after the great sculptor's death by a close Paduan follower. The medal proclaims Riccio as the author of the Paschal Candlestick in the Santo in its obverse inscription; the likeness, lightly draped *all'antica* at the bust, records the curly hair from which Riccio took his pseudonym. The reverse image appears to allude to the artist's death and his fruitful influence on Paduan sculpture.

2. **Giovanni Maria Pomedelli,**
 Veronese, 1478/79-c. 1537
 Unknown Lady. Reverse: nude bearded man kneeling left, supporting basket of fruit on his head; behind him Cupid with bow and arrows, standing on globe inscribed ASO; on the left, a caduceus; on the right, a vine.
 Bronze, 5.4 (2 $^1/_8$)
 Kress Collection, A–917.180A

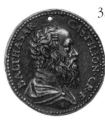

3. **Italian**
 Baldassare Castiglione, 1478-1529, author
 of *The Courtier.* Reverse: Aurora stepping
 from her car; on either side a Psyche re-
 straining a horse; the car rising above the
 edge of the globe, on which part of the
 Mediterranean is shown.
 c. 1518
 Bronze, 3.7 (1 $^{15}/_{32}$)
 Kress Collection, A-1043.305A

This medal dedicated to the great Renaissance
writer is probably the work of a Mantuan or
Roman follower of Cristoforo di Geremia and
may have been based on a design by Raphael.

4. **Mea,** Mantuan, known active c. 1510
 Battista Spagnoli of Mantua, 1448-1516,
 Carmelite poet. Reverse: on three pedes-
 tals, a cherub, a swan, and an eagle.
 c. 1513
 Bronze, 4.9 (1 $^{15}/_{16}$)
 Kress Collection, A-824.87A

5. **Mantuan,** early XVI century
 Corrado Gonzaga, XIV-century noble.
 Without reverse.
 Bronze, 8.1 (3 $^{3}/_{16}$)
 Kress Collection, A-828.91A

6. **Master of the Roman Charity,**
 early XVI century
 Pomona. Uniface plaquette.
 Bronze, 8.1 (3 $^{3}/_{16}$)
 Kress Collection, A-539.261B

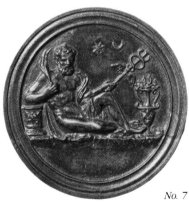

No. 7

7. **Master of the Roman Charity**
 Mercury. Uniface plaquette.
 Bronze, 8.1 (3 $^{3}/_{16}$)
 Kress Collection, A-540.262B

The influence of Riccio is reflected in the style
of this anonymous Paduan or Venetian master.

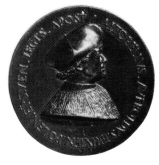

No. 8, obverse No. 8, reverse

8. **Maffeo Olivieri,** Brescian, 1484-1543/44
 Altobello Averoldo of Brescia, Bishop of
 Pola 1497, Apostolic Legate at Venice 1526,
 died 1531. Reverse: nude female figure of
 Truth, unveiled by two nude men.
 1520s
 Bronze, 9.3 (3 $^{21}/_{32}$)
 Kress Collection, A–898.161A

9. **Maffeo Olivieri**
 Vincenzo Malipiero, Venetian patrician,
 brother of Francesco. Reverse: crowned
 eagle on mound amidst waters.
 1523
 Bronze, 6.4 (2 $^{17}/_{32}$)
 Kress Collection, A–896.159A

10. **Maffeo Olivieri**
 Francesco Malipiero, Venetian patrician,
 brother of Vincenzo. Reverse: pelican in
 her piety, standing on tree stump with two
 leafy branches.
 1523
 Bronze, 6.4 (2 $^{17}/_{32}$)
 Kress Collection, A–895.158A

11. **Maffeo Olivieri**
 Sebastiano Montagnacco, died 1540,
 Venetian patrician. Reverse: fortress, with
 tall tree in background.
 1520s
 Bronze, 6.4 (2 $^{17}/_{32}$)
 Kress Collection, A–899.162A

Olivieri's principal extant work is the pair of
figurated candlesticks, made in 1527 for Alto-
bello Averoldo, in Saint Mark's in Venice. A
number of small bronze figures are attributed
to Olivieri; his medals are characterized by a
breadth and spaciousness of design and by the
aristocratic and self-confident air of his sitters.

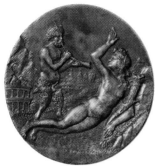
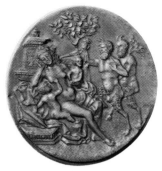

No. 12, obverse No. 12, reverse

12. **Pseudo Fra Antonio da Brescia,**
active early XVI century, possibly at Venice
Abundance and a Satyr. Reverse: allegor-
ical scene.
After 1505/1506
Bronze, 6.0 (2 ³/₈)
Kress Collection, A–395.118B

13. **Pseudo Fra Antonio da Brescia**
Sleeping Cupid. Uniface plaquette.
Bronze, 6.7 (2 ⁵/₈)
Kress Collection, A–394.117B

The oeuvre of this master (which was once
thought to include a medal signed by Fra
Antonio) indicates not only his devout interest
in classical imagery but also a knowledge of
contemporary prints. The figures of Abun-
dance and the Satyr reflect engravings from the
first decade of the sixteenth century by
Raphael's associate, Marcantonio Raimondi,
and by Albrecht Dürer, who had twice traveled
to Venice. The sleeping woman uncovered,
derived from Roman bacchic sarcophagi, and
that of the sleeping Cupid recur frequently
during the period in various genres.

14. **Italian, possibly Venetian**
Giovanni de Nores, 1489-1544, Count of
Tripoli. Without reverse.
c. 1530-1540
Bronze, 9.5 (3 ³/₄)
Kress Collection, A–1233.495bisA

No. 15, obverse

15. **Manner of Antico**
Giulia Astallia. Reverse: phoenix on a
pyre, looking up at the sun.
Bronze, 6.1 (2 ¹³/₃₂)
Kress Collection, A–812.75A

16. **Mantuan,** first quarter XVI century
A Triumph. Uniface plaquette.
Bronze, 4.1 (1 ⁵/₈)
Kress Collection, A–398.121B

17. **Mantuan,** first quarter XVI century
A Triumph, with Hunting Scenes. Uniface
plaquette.
Bronze, 7.7 (3 ¹/₃₂)
Widener Collection, A–1498

The Mantuan bronzes of the period strongly
reflect the style of the gifted and highly
revered Pier Jacopo Alari Bonacolsi (c. 1460-
1528), whose devotion to classicism is evident
in his sculpture as well as in his nickname:
Antico. A native of Mantua, Antico worked
there under the patronage of the Gonzaga,
serving Isabella d'Este as a silversmith and
maker of bronze statuettes and as the restorer
of her collection of ancient art. Antico's bronze
figures are distinctive for their sumptuously
smooth finish and the frequent addition of
details in fire-gilding or silver inlay; many
reproduce ancient statues in Rome or "re-
create" them from fragmented originals. The
female portrait here (no. 15) is of interest in
the below-waist truncation, a convention
found in Pisanello's *Cecilia Gonzaga* medal
and in one of Verrocchio's female portrait
busts. The circular *Triumphs* (nos. 16 and 17)
directly recall Roman coinage in form and
subject.

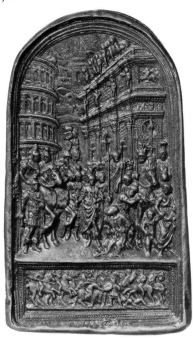

No. 18

18. **Italian, possibly Milanese or Roman,**
early XVI century
Beheading of Saint Paul. Uniface
plaquette.
Bronze, 10.1 x 6.0 (3 ³¹/₃₂ x 2 ³/₈)
Kress Collection, A–612.334B

This superb small relief, with a characteristi-
cally modern attempt to achieve historical

accuracy through costume and a detailed setting, represents the martyrdom of Saint Paul, which occurred outside the walls of Rome during the rule of the Emperor Nero. The structure to the left may represent the Colosseum, that to the right, the Arch of Constantine.

No. 19

19. **North Italian,** first quarter XVI century
 Mars. Uniface plaquette.
 Bronze, 6.7 (2 ⁵/₈)
 Kress Collection, A–685.407B

20. **Paduan,** early XVI century
 Two Bacchantes. Uniface plaquette.
 Bronze, 3.7 x 3.2 (1 ⁷/₁₆ x 1 ¹/₄)
 Kress Collection, A–369.92B

21. **Paduan,** late XV or early XVI century
 Mucius Scaevola. Uniface plaquette.
 Bronze, 3.8 x 3.2 (1 ¹/₂ x 1 ¹/₄)
 Kress Collection, A–370.93B

Francesco da Sant'Agata(?),
Paduan, known active 1491-1528
Hercules and Antaeus
Bronze, 38.0 x 12.0 x 26.5
(15 x 4 ³/₄ x 10 ¹/₂)
Widener Collection, A–113

The superb Widener *Hercules and Antaeus* is one of the great masterpieces of the Renaissance small bronze. It exemplifies a sculptural convention which gained increasingly in prestige among artists and patrons throughout the sixteenth century and was repeatedly employed for over-life-sized monuments and for bronze statuettes alike: the two-figure composition in which conflict between the protagonists is the primary subject. Whether the figures represented are political allegories, personified virtues, or mythological or historical persons, the theme that typically underlies the two-figure group is the eventual triumph of virtue over vice.

The story of Hercules' conquest over Antaeus—whom the hero could overcome only by suspending the evil giant above the earth, which renewed his strength with every contact—was a popular one for Renaissance artists. The motif of the two strongmen locked in a mortal embrace was known in an antique fragment preserved in Rome; Antico produced a small bronze group of the subject, and Antonio Pollaiuolo had earlier treated the theme both in painting and in sculpture.

In his small bronze *Hercules and Antaeus* (Florence), Pollaiuolo brought to bear his

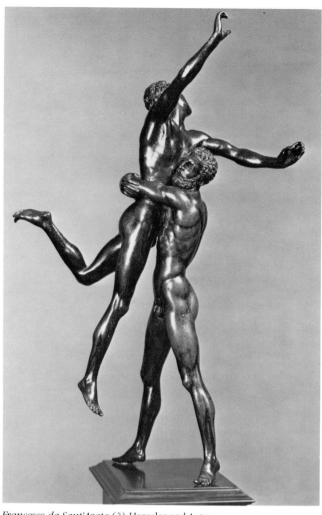

Francesco da Sant'Agata (?), Hercules and Antaeus

pioneering knowledge of human anatomy and movement in a powerful expression of intense muscular and psychological strain. The present work is its direct opposite. Here the muscles of the elongated nudes are articulated but smoothly finished; their movement is not harsh and sudden but dancelike, fluid, and even buoyant. The conflict, which is strangely timeless and evokes no resolution, is conveyed most surely in the grim expressions of the two taut faces. With its skillful penetration of the surrounding space and multiplicity of viewpoints accomplished through the extended limbs, with its beautiful reflection of light from the polished surfaces, the *Hercules and Antaeus* represents a turning away from naturalism toward a mannerist preoccupation with the grace and elegance of the human form.

Francesco da Sant'Agata is known from documents to have worked for many years in Padua as a goldsmith and silversmith. His only remaining signed work is a statuette of Hercules carved in boxwood (London). The

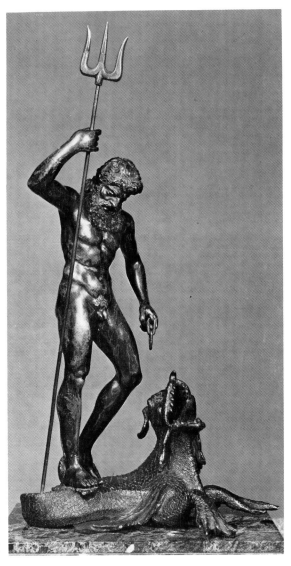

Severo da Ravenna, Neptune on a Sea Monster

Widener bronze, which is generally akin to Riccio's large *Entombment* in the attenuated figural cannon and meticulously defined heads, may be the work of the now-obscure Paduan master.

Severo di Domenico Calzetta, called **da Ravenna,** known active 1496-1525
Neptune on a Sea Monster
Bronze, 45.6 x 26.7 x 20.0
(17 $^7/_8$ x 10 $^1/_2$ x 7 $^7/_8$)
Widener Collection, A–98

The rugged and powerful Neptune standing triumphant over a fantastic marine monster is one of the key works of Severo da Ravenna and one of the most commanding of early sixteenth-century small bronzes. A sculptor in marble as well as bronze, Severo worked in his native city and at Padua. His skill, as was

Riccio's, was extolled by the contemporary commentator on sculpture, Pomponius Gauricus (1504).

A second version of the Neptune, of equally high quality, is preserved in the Frick Collection, New York; lesser examples of the two-figure group are in Florence and Vienna. The association of these bronzes with Severo is assured by the appearance of his signature on a related work, the magnificent bronze *Sea Monster with a Shell* in the Blumka Collection, New York. This highly dynamic and lifelike beast was copied frequently, not only in conjunction with Neptune but also alone in smaller bronze versions, one of which is exhibited in the free-standing case nearby.

The theme of Neptune and the sea monster was a popular one during this period; Isabella d'Este is known to have owned a bronze of the subject. The fantastic anatomy of Severo's sea dragons derives from an influential engraving, *The Battle of the Sea Gods* (c. 1485-1488), by the great Paduan painter and printmaker Andrea Mantegna (1431-1506), who had spent the latter part of his long career at the Gonzaga court in Mantua.

North Italian, first quarter
XVI century
Spinario
Bronze, 14.7 (5 $^3/_4$) h.
Kress Collection, A–167.5C

North Italian, early XVI century
Seated Female Figure
Bronze, 19.0 (7 $^1/_2$) h.
Widener Collection, A–132

The statuette of a naked youth seated on a tree trunk and extracting a thorn from his foot is adapted from an Antique bronze statue in the Capitoline Museum in Rome. Like the *Capitoline She-Wolf,* this work was extremely famous during the Renaissance; the complex pose was copied frequently in painting, and nearly twenty small bronze variations are preserved from the fifteenth and sixteenth centuries. These originate in different north Italian centers, notably Mantua, Padua, and Venice. The Kress *Spinario,* in the delicate treatment of the hair and profile, the arched spine and the upraised foot, is an especially fine example; it may have been produced in Mantua.

The great Mantuan bronze worker Antico is known from documents to have cast a small bronze version of the *Spinario* in 1501 for

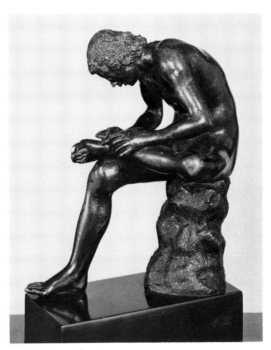

North Italian, Spinario

Isabella d'Este. That figure was placed on the cornice over one of the doors in her rooms at the Castello di San Giorgio in Mantua. Two years later, Isabella requested the artist to provide a companion piece for the seated youth, a statuette to be placed above the other door in the same room. For this task Antico selected as his model a Hellenistic statue of a female figure known to him through one or more Roman copies in marble.

Antico's seminude woman, seated with one leg crossed over the other, achieved great popularity among contemporary artists and collectors. As in the case of the *Spinario,* several versions were produced during the early sixteenth century in various north Italian centers. The Widener bronze exhibited here, in its sensitive expression, modeling, and chasing, is a particularly beautiful descendant of Antico's prototype. The treatment of the base and shell recall motifs found on works attributed to Severo da Ravenna.

Severo da Ravenna(?)
Saint Sebastian
Bronze, 24.6 x 7.7 x 5.8
(9 $^{11}/_{16}$ x 3 $^{1}/_{32}$ x 2 $^{9}/_{32}$)
Kress Collection, A–170.8C

Formerly assigned to Riccio, this statuette shares many characteristics with a small bronze *Saint John the Baptist* in Oxford, attributable to Severo on the basis of his

signed marble statue of that saint in the Santo in Padua. The Kress figure, probably provided originally with a column or tree stump, is a unique cast, although a closely related work exists in the Louvre. The poignantly expressive eyes and mouth are rendered with great care as are the classically arranged locks of hair.

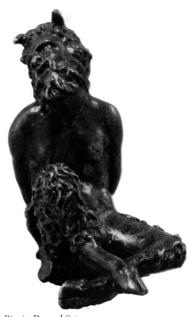

Riccio, Bound Satyr

Andrea Briosco, called **Riccio,**
Paduan, c. 1470-1532
Bound Satyr
Bronze, 7.3 x 4.5 x 7.3
(2 $^7/_8$ x 1 $^{25}/_{32}$ x 2 $^7/_8$)
Kress Collection, A–186.24C

The crouching, fettered satyr, of which this is a particularly fine example, is a motif occurring frequently in Riccio's work and in that of his followers. The horned and goat-legged hybrid creature is derived from ancient representations of Pan, such as those abundantly available to Renaissance artists in reliefs on late Roman bacchic sarcophagi. The decorative use of paired, bound satyrs was also known from the first-century murals in the Golden House of Nero discovered during the late fifteenth century. Surprisingly, the bound pagan creature appears on Riccio's monumental Paschal Candlestick, perhaps symbolizing, in that Christian context, man's subjugation in his nature of that which is base and evil, that which is animal and not divine. Imbuing the figure always with a wistful longing, Riccio employed the bound satyr also in a pagan context, as Pan or Marsyas chastized by Apollo. Taken up by various north Italian sculptors,

the motif was often repeated as ornamentation on utilitarian objects, as on the inkstand exhibited here.

Riccio
Head of a Man (Vulcan)
Bronze, 5.1 x 3.8 x 4.3
(2 $^1/_4$ x 1 $^{13}/_{32}$ x 1 $^{11}/_{16}$)
Kress Collection, A–209.49C

Astounding in the force of emotion achieved on such a small scale, the grimacing head was severed at the neck through breakage or a casting flaw. It recurs on a bronze figure of Vulcan in a private collection. The masterful work is close in style to Riccio's large *Entombment* exhibited at the end of the room.

Workshop of Riccio
Lamp in the Form of a Satyr's Head
Bronze, 7.8 x 5.9 x 10.2
(3 $^1/_{16}$ x 2 $^{11}/_{32}$ x 4 $^1/_{32}$)
Kress Collection, A–211.51C

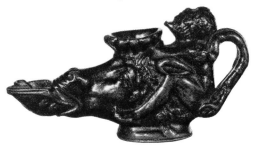

Workshop of Riccio, Lamp in the Form of an Ass' Head

Workshop of Riccio
Lamp in the Form of an Ass' Head
Bronze, 6.9 x 13.7 x 3.6
(2 $^{23}/_{32}$ x 5 $^3/_8$ x 1 $^{13}/_{32}$)
Kress Collection, A–211.62C

These two lamps, based in form and imagery on ancient artifacts, exemplify the taste among learned Renaissance patrons for classicizing desk ornaments in bronze. Often of humorous or even ribald subject matter, such small works were a specialty of Riccio and his workshop.

North Italian, possibly Paduan
*Inkstand with Bound Satyrs
and Three Labors of Hercules*
1530-1540
Bronze, 24.9 (9 $^3/_4$) h.
Widener Collection, A–134

The humanist desk ornament is eloquently represented by the triangular bronze inkwell decorated on the lid and at the corners with close descendants of Riccio's fettered satyr. His influence and probably also that of Severo are evident in this piece, with its skillful adapta-

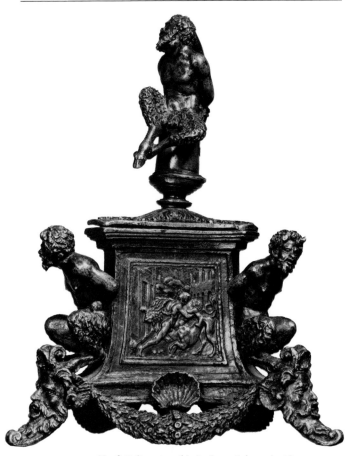

North Italian, possibly Paduan, Inkstand with Bound Satyrs and Three Labors of Hercules

tion and integration of such classical motifs as the acanthus, the shells, the swags, and the carefully modeled horned and bearded masks used to support the base. The artist has also incorporated, as sides of the inkstand, three reliefs by the accomplished plaquette artist Moderno, whose work is displayed in many excellent examples in the adjacent gallery. In its identifiable borrowing and reuse of both ancient and contemporary motifs originating from a variety of sources, the Widener inkstand, several variants of which are still extant, serves well to elucidate for us the creative process of the Renaissance craftsman.

Paduan
Writing Casket
c. 1500
Bronze, 7.8 x 20.3 x 12.0
(3 $^1/_{16}$ x 8 x 4 $^{23}/_{32}$)
Kress Collection, A–214.55C

Paduan
Sandbox
c. 1500
Bronze, 8.0 x 10.6 x 9.4
(3 $^1/_8$ x 4 $^5/_{32}$ x 3 $^{11}/_{16}$)
Kress Collection, A–215.56C

The writing casket, a container for pens, provides another superb example of the prevalent taste for bronze desk ornaments decorated with antique motifs; the imagery and heraldic compositions seen here are inspired by Roman sarcophagi. The popularity of such pieces is attested by the more than twenty versions of this box that survive; the Kress casket has been recognized as the finest.

Closely related to the writing casket in function and design, the triangular sandbox, used to hold sand for drying ink, shares the motifs of swags and winged Gorgon-heads as well as the depressed spherical feet. The pair of objects were most likely produced in the same workshop.

Paduan, Box in the Form of a Crab

Workshop of Severo da Ravenna, Sea Monster

Paduan, late XV or early XVI century
Box in the Form of a Crab
Bronze, 4.8 x 17.1 x 9.3
(1 $^7/_8$ x 6 $^{23}/_{32}$ x 3 $^{21}/_{32}$)
Kress Collection, A–239.80C

Workshop of Severo da Ravenna,
known active 1496-1525
Sea Monster
Bronze, 8.9 x 22.6 x 13.6
(3 $^1/_2$ x 8 $^{29}/_{32}$ x 5 $^3/_8$)
Kress Collection, A–228.69C

A favorite Paduan invention of the period was the box fashioned from a nature cast of a crab-shell. Fiercely "guarding" their contents with spikey claws, such crab boxes wittily demon-

strate the local interest in naturalism and bravura of casting technique. These features are apparent too in the small sea monster, with its carefully worked scales and spines, from Severo's workshop. The hybrid creature shares the pathos of Riccio's half-human satyrs.

Riccio and his Followers

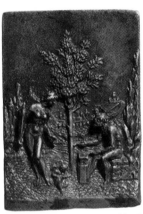

No. 1

No. 5

1. **Andrea Briosco,** called **Riccio,**
 Paduan, c. 1470-1532
 Judith with the Head of Holofernes.
 Reverse: monogram signature, R° I.
 Bronze, 10.7 x 8.4 (4 $^3/_{16}$ x 3 $^5/_{16}$)
 Kress Collection, A–402.125B

2. **Workshop of Riccio**
 Judith with the Head of Holofernes
 Bronze, 6.5 x 2.8 x 1.5
 (2 $^{19}/_{32}$ x 1 $^3/_{32}$ x $^{19}/_{32}$)
 Kress Collection, A–171.9C

The first of a series of splendid plaquettes in high relief, the Judith (no. 1) is a signed work. Its composition is based on an engraving (c. 1500-1505) after Mantegna, who during his later years represented the Old Testament heroine several times. (One may compare the Widener Collection painting exhibited upstairs.) The small statuette of the same subject might have been intended as the handle of a lamp or inkstand.

3. **Riccio**
 Venus, Vulcan and Cupid
 Bronze, 7.7 (3 $^1/_{32}$)
 Kress Collection, A–412.135B

4. **Riccio**
 Fame. Reverse: inverted monogram
 signature
 Bronze, 5.1 x 4.2 (2 $^1/_{32}$ x 1 $^{21}/_{32}$)
 Kress Collection, A–416.139B

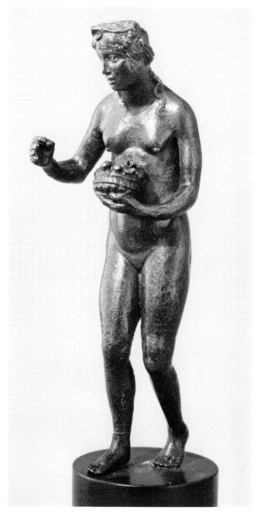

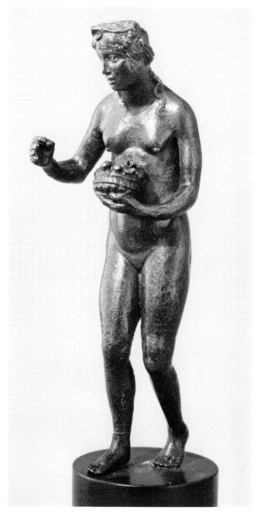

No. 7

5. **Riccio**
 Venus, Vulcan and Cupid
 Bronze, 10.9 x 7.8 (4 $^9/_{32}$ x 3 $^1/_{16}$)
 Kress Collection, A–413.136B

6. **Riccio**
 Venus Chastising Cupid
 Bronze, 10.6 x 8.2 (4 $^3/_{16}$ x 3 $^7/_{32}$)
 Kress Collection, A–410.133B

Riccio's Venus plaquettes recall the paintings of his great Venetian contemporary Giorgione. The allegory of Fame relates to Riccio's reliefs for the Della Torre tomb.

7. **Riccio**
 Pomona
 Bronze, 16.4 x 5.5 x 4.8
 (6 $^7/_{16}$ x 2 $^3/_{16}$ x 1 $^7/_8$)
 Kress Collection, A–173.11C

The beautiful figure of Pomona is an autograph work from Riccio's early career. It may originally have been part of a three-figure narrative group including also a tethered satyr as the chastized Pan.

8. **Riccio**
 Sacrifice of a Swine
 Bronze, 7.8 x 9.4 (3 $^1/_{16}$ x 3 $^{11}/_{16}$)
 Kress Collection, A–418.141B

9. **Riccio**
 Combat at a City Gate. Reverse: mono-
 gram signature, R.
 Bronze, 8.9 x 10.2 (3 $^1/_2$ x 4)
 Widener Collection, A–1589

Inspired in style and subject by classical
reliefs, these plaquettes relate to Riccio's
scenes of sacrifice on the Paschal Candlestick
and the Della Torre tomb.

No. 10

No. 11

10. **Riccio**
 Satyr Uncovering a Nymph
 Bronze, 6.0 x 7.2 (2 $^3/_8$ x 2 $^{13}/_{16}$)
 Kress Collection, A–396.119B

11. **Riccio**
 A Satyr Family
 Bronze, 14.3 x 11.1 (5 $^5/_8$ x 4 $^{11}/_{32}$)
 Kress Collection, A–415.138B

A subject found frequently among Riccio's
statuettes and those of his followers is the
mother satyr tenderly administering to her
satyr child. While the male satyr in Renais-
sance art clearly constitutes a motif borrowed
from ancient sculpture (as in the *Satyr Uncov-
ering a Nymph* above), his representation as
the head of a hybrid family or race is wholly a
fifteenth-century invention and indicates most
probably a merging of antique revivalism with
the medieval lore of the wildman. The satyr or
faun family was a favorite theme of Flemish
and German as well as Italian Renaissance
artists, who often depict a horned and goat-
legged father and an entirely human mother
tending their hybrid infant in a serene sylvan
setting. Rarely are all three creatures shown as
satyrs, as in this relief, which is a unique cast.
Here, too, the mood and content are strikingly
unusual. In this scene, the pastoral tranquility
and gentle rapport between mother and child,

which is characteristic of Riccio's satyress and child-satyr groups, has suddenly been interrupted by the uncontrolled sensuality of the primitive male, who brutally mashes the mother's hand against the rocks, upending her pitcher, and pulls her face away from the child toward himself.

12. **Riccio**
 Saint George and the Dragon
 Bronze, 5.3 x 6.4 (2 $^3/_{32}$ x 2 $^{17}/_{32}$)
 Kress Collection, A–408.131B

13. **Riccio**
 Death of Marcus Curtius
 Bronze, 7.8 x 6.4 (3 $^1/_{16}$ x 2 $^1/_2$)
 Kress Collection, A–409.132B

14. **Riccio**
 Meleager Presenting the Boar's Head to Atalanta
 Bronze, 7.8 x 6.3 (3 $^1/_{16}$ x 2 $^1/_2$)
 Kress Collection, A–414.137B

15. **Riccio(?)**
 Triumph of a Hero
 Bronze, 7.7 x 10.4 (3 $^1/_{32}$ x 4 $^3/_{32}$)
 Kress Collection, A–417.140B

Another example of Riccio's *Saint George* is found on a triangular sandbox, now in London. The *Marcus Curtius,* a rare plaquette, is notable for the unusually high relief. Striking for its beautiful landscape (a subject of increasing importance to the Venetian painters of Riccio's day), the *Meleager* is a unique cast. The Romanizing *Triumph of a Hero* is close in facture and in the treatment of the subject to Riccio's reliefs; it is a fine specimen of a frequently encountered plaquette.

16. **Riccio**
 Three-wick Lamp with Bacchic Scenes
 Bronze, 5.0 x 10.8 x 11.0
 (1 $^{31}/_{32}$ x 4 $^1/_4$ x 4 $^5/_{16}$)
 Kress Collection, A–219.60C

This is an especially beautiful example of Riccio's application of his refined relief style and his vocabulary of themes drawn from bacchic ritual to the decoration of a utilitarian object.

17. **North Italian,** late XV or early
 XVI century
 Descent from the Cross
 Bronze, 6.9 x 5.2 (2 $^3/_4$ x 2 $^1/_{16}$)
 Kress Collection, A–522.244B

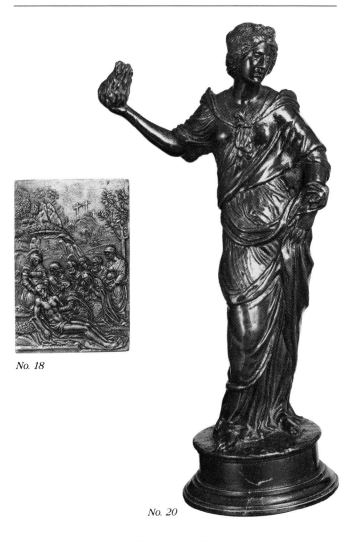

No. 18

No. 20

18. **Emilian,** second quarter XVI century
 The Lamentation
 Gilt bronze, 10.6 x 7.4 (4 $^3/_{16}$ x 2 $^{15}/_{16}$)
 Kress Collection, A–677.399B

19. **Emilian,** early XVI century
 The Entombment
 Bronze, 11.9 x 10.2 (4 $^{11}/_{16}$ x 4)
 Kress Collection, A–584.306B

The plaquettes from the Emilia share with contemporary Paduan bronzes an interest in landscape and dramatic narrative. The *Descent from the Cross,* like a number of the works we have seen, is based on an engraving after Mantegna.

20. **Venetian**
 Charity
 c. 1530
 Bronze, 20.8 (8 $^5/_{32}$) h.
 Kress Collection, A–182.20C

Attired in classical drapery, like Riccio's allegories of virtues on the Easter Candlestick, this personification of the Christian virtue Charity

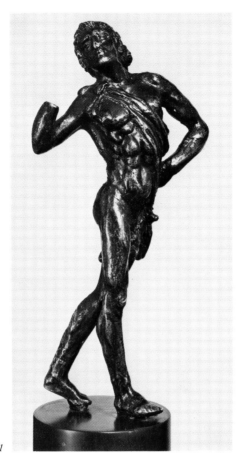

No. 21

(Love) stands in elegant contrapposto, holding a flame in her outstretched right hand. An exquisitely modeled and chased bronze, the figure is the work of a Venetian artist and has been associated with Maffeo Olivieri, whose medallic style is represented in this room.

21. **North Italian(?),** late XV or XVI century
 Dancing Faun
 Bronze, 15.2 x 8.4 (6 x 3 ⁵/₁₆)
 Kress Collection, A–168.6C

This roughly finished, but vigorously muscled male nude stands in sharp contrapposto in an attitude suggestive of dancing or athletic endeavor. Also sometimes associated with Maffeo Olivieri, the figure may have originated in Venice or nearby.

22. **Paduan,** early XVI century
 Toad
 Bronze, 6.1 x 7.9 x 8.0
 (2 ¹³/₃₂ x 3 ¹/₁₆ x 3 ¹/₈)
 Kress Collection, A–243.87C

23. **Paduan,** early XVI century
 Toad with a Tiny Toad on its Back
 Bronze, 6.0 x 13.1 x 8.6
 (2 ¹¹/₃₂ x 5 ¹/₈ x 3 ³/₈)
 Kress Collection, A–241.84C

24. **Workshop of Riccio(?)**
 Inkwell in the Form of a Frog
 beside a Tree Stump
 Bronze, 7.4 x 14.2 x 8.2
 (2 $^7/_8$ x 5 $^9/_{16}$ x 3 $^1/_4$)
 Kress Collection, A–242.86C

Paduan naturalism is exemplified in the bronze toads, cast from real life. Like the crab in the free-standing case, no. 24 has been fashioned into a desk object.

25. **Paduan,** early XVI century
 Lamp
 Bronze, 3.3 x 14.9 x 5.5
 (1 $^9/_{32}$ x 5 $^1/_8$ x 2 $^5/_{32}$)
 Kress Collection, A–222.63C

26. **Paduan**
 Lamp Lid: Sacrifice to Cupid
 c. 1525
 Bronze, 6.0 x 5.2 (2 $^3/_8$ x 2 $^1/_{16}$)
 Kress Collection, A–498.220B

Ornamented with sea monsters and nymphs, the lamp emulates antiquity also in its shape. Its original lid must have been one similar to that shown with it.

27. **Follower of Riccio**
 Sandbox
 c. 1525-1540
 Bronze, 7.4 x 17.0 (2 $^{29}/_{32}$ x 6 $^{11}/_{16}$)
 Kress Collection, A–216.57C

28. **North Italian,** early XVI century
 Five Cupids at Play
 Bronze, 4.4 x 8.0 (1 $^3/_4$ x 3 $^1/_8$)
 Kress Collection, A–289.12B

29. **Italian, possibly Paduan,**
 late XV or early XVI century
 Table Bell
 Bronze, 12.9 x 9.1 (5 $^3/_{32}$ x 3 $^{23}/_{32}$)
 Kress Collection, A–269.113C

The triangular sandbox, like the three-wick lamp (no. 16), is decorated with scenes of bacchanalia. Other casts of the small plaquette, with its classical motif of putti frightening one another with a bearded mask, are found as sides of sandboxes and inkwells. The table bell, too, bears bacchic imagery and includes a favorite theme, the drunken Silenus. The bell is also adorned with its original owner's shield of arms, possibly those of the Calistani family of Verona.

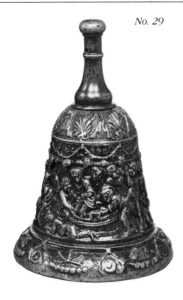

No. 29

No. 32

30. **Riccio**
 Allegorical Scene
 Bronze, 4.9 (1 $^{15}/_{16}$)
 Kress Collection, A–504.226B

31. **Riccio**
 Allegorical Scene. Inscribed,
 in cartouche, ISA.
 Bronze, 5.6 (2 $^{3}/_{16}$)
 Kress Collection, A–503.225B

32. **Riccio**
 Allegorical Scene
 Bronze, 5.6 (2 $^{3}/_{16}$)
 Kress Collection, A–502.224B

33. **Riccio**
 Allegorical Scene
 Bronze, 6.0 (2 $^{11}/_{32}$)
 Kress Collection, A–501.223B

34. **Riccio**
 Allegorical Scene. Inscribed,
 in the exergue, EMNHK O IA.
 Bronze, 6.3 (2 $^{1}/_{2}$)
 Kress Collection, A–499.221B

35. **Workshop of Riccio**
 Allegorical Scene
 Bronze, 6.3 (2 $^{1}/_{2}$)
 Kress Collection, A–500.222B

This series of circular plaquettes in low relief, which illustrate Riccio's repertory of classical motifs with great precision and elegance, all bear enigmatic allegorical meanings. They may have been designed as medallic reverses.

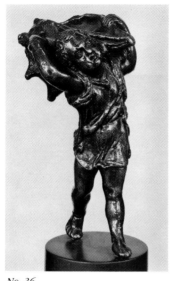

No. 36

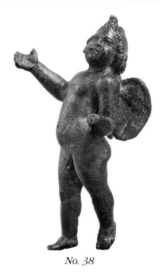

No. 38

36. **Workshop of Riccio**
 Inkwell in the Form of a
 Child Carrying a Shell
 Bronze, 11.6 x 3.7 x 3.9
 (4 ¹⁹/₃₂ x 1 ⁷/₁₆ x 1 ¹⁷/₃₂)
 Kress Collection, A–188.26C

37. **Workshop of Severo da Ravenna(?),**
 known active 1496-1525
 Standing Boy
 Bronze, 9.6 (3 ³/₄) h.
 Kress Collection, A–198.36C

38. **Hellenistic or Roman,**
 2nd century B.C.-1st century A.D.
 Striding Cupid
 Bronze, 7.6 (3) h.
 Kress Collection, A–205.43C

39. **Hellenistic or Roman,**
 2nd century B.C.-1st century A.D.
 Winged Child Carrying a Torch
 Bronze, 10.6 (4 ³/₁₆) h.
 Kress Collection, A–204.42C

40. **Italian,** early XVI century
 Standing Child with Raised Left Arm
 Bronze, 6.2 (2 ⁷/₁₆) h.
 Kress Collection, A–201.39C

41. **Italian,** late XV or early XVI century
 Cupid with Raised Arms
 Bronze, 7.6 (3) h.
 Kress Collection, A–189.27C

42. **Central or North Italian**
 Pacing Female Panther
 c. 1500
 Bronze, 10.0 x 14.2 (3 ¹⁵/₁₆ x 5 ¹⁹/₃₂)
 Kress Collection, A–226.67C

43. **Venetian,** late XV century
 Winged Boy with Hands Raised
 Bronze, 10.5 (4 ¹/₈) h.
 Kress Collection, A–191.29C

44. **Venetian,** late XV century
 Wreathed Boy with Hands Raised
 Bronze, 11.1 (4 ³/₈)
 Kress Collection, A–192.30C

45. **North Italian, possibly Paduan,**
 first half XVI century
 Seated Boy Holding a Jar (an Inkwell?)
 Bronze, 6.3 x 3.7 x 5.5
 (2 ¹/₂ x 1 ¹⁵/₃₂ x 2 ⁵/₃₂)
 Kress Collection, A–187.25C

46. **Severo da Ravenna**
 Arion Seated on a Shell
 Bronze, 8.6 x 5.2 x 4.3
 (3 ⁷/₁₆ x 2 ³/₃₂ x 1 ¹¹/₁₆)
 Kress Collection, A–172.10C

Of paramount importance to this group of figures are nos. 38 and 39. These were collected by Gustave Dreyfus because he and his contemporaries believed them to be Italian Renaissance statuettes. Definitely recognizable today as Antique bronzes, perhaps Hellenistic or perhaps Roman, the two small statuettes are particularly interesting components of the present collection as examples of one kind of ancient bronze available to Renaissance antiquarians. As is evident here, this ancient genre of small-scale, free-standing figures of children inspired a lively tradition of analogous works in and around Padua at the turn of the sixteenth century. In some instances (nos. 36 and 45), these were adapted as desk utensils.

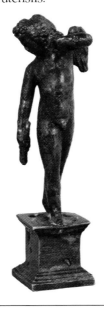

No. 39

Andrea Briosco, called **Riccio,**
Paduan, c. 1470-1532
The Entombment. Inscribed
on urn, AERDNA (retrograde
signature, "Andrea").
Bronze, 50.4 x 75.5 (19 $^7/_8$ x 29 $^3/_4$)
Kress Collection, A–164.1C

The great *Entombment,* already mentioned in
the introduction to this section, is a work of
tremendous importance to the study of the
Renaissance bronze in America and to the
understanding of Riccio's art. The largest of all
his single reliefs, the *Entombment* is a master-
piece of the bronze-casting technique, demon-
strating the Paduan sculptor's virtuosity in the
many-faceted mountainous landscape (with
its partially free-standing trees), in the depth
of the relief, and in the impressive number and
variety of figures it includes.

In one of his most intensely emotive sculp-
tures, Riccio here portrays a cast of thirty-nine
figures, registering in almost as many distinct
physiognomies a range of grief from the most
stoic to the least restrained. At the center of the
composition two bearded, soldierly disciples
labor under the weight of the lifeless, broken

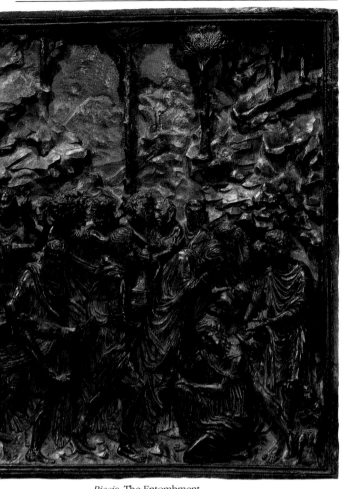

Riccio, The Entombment

body of Christ. Behind them Mary Magdalen shrieks with arms outstretched. Her gesture is repeated in that of the wild-haired woman behind her to the right, in a reverberation of distress that echoes throughout the crowd beyond. The same stance catches our eye again at the left foreground in the female figure who acts as a visual frame to the swaying women attendant upon the ponderous Virgin Mary, whose heavily draped body is powerless to do more than gaze at the face of her Son. Directly above Mary, a woman, portrayed with open mouth and jutting right elbow, grasps her temples in a grief-stricken gesture akin to those of the hunched and completely swathed figure at the mouth of the cave and of the crumpled woman at the lower right, an image which balances the weighty figure of the Virgin on the opposite side. Across the panel, from left to right, toward the rocky tomb, the slow, sad movement of the mourners is brilliantly evoked by the rhythmically repeated curves of bowed heads and stooped shoulders and the repeated angles of bending knees, postures emphasized throughout by the fluent lines of the intricately wrought drapery. In its harnessing of such overtly expressed human

passion to a composition reminiscent of the stately, paced processions to be found on ancient reliefs and one enacted by grand figures dressed in the Antique style, Riccio's *Entombment* reveals an extraordinary profundity of Christian feeling and a remarkable sympathy with the spirit of the classical world

Riccio's *Entombment* Plaquettes

1. **Andrea Briosco,** called **Riccio,**
 Paduan, c. 1470-1532
 The Entombment. Reverse:
 monogram signature, R.
 Bronze, 7.6 x 7.8 (3 x 3 $^1/_{16}$)
 Kress Collection, A–406.129B

2. **Riccio**
 The Entombment
 Bronze, 11.1 x 14.5 (4 $^3/_8$ x 5 $^{11}/_{16}$)
 Widener Collection, A–1590

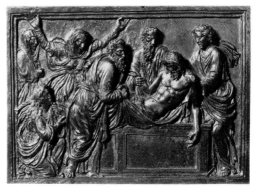

No. 3

3. **Riccio**
 The Entombment
 Bronze, 14.5 x 20.8 (5 $^{11}/_{16}$ x 8 $^3/_{16}$)
 Kress Collection, A–405.128B

4. **Riccio**
 The Entombment
 Bronze, 11.3 x 15.9 (4 $^7/_{16}$ x 6 $^1/_4$)
 Kress Collection, A–404.127B

Riccio depicted the Entombment of Christ several times in small relief. In many ways these compositions share the vocabulary of the large relief, as can be observed in the excellent casts included here.

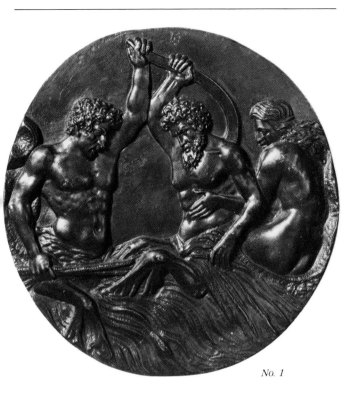

Leopardi and His Influence

1. **Workshop of Alessandro Leopardi(?),**
 Venetian, known active 1482-1522/23
 Combat of Ichthyocentaurs
 Bronze, 18.1 (7 1/8)
 Kress Collection, A–538.260B

2. **Venetian**
 Allegory of Music
 c. 1500
 Bronze, 11.5 x 7.1 (4 1/2 x 2 25/32)
 Kress Collection, A–593.315B

3. **Venetian,** first half XVI century
 Triumph of Neptune
 Bronze, 21.5 (8 15/32)
 Kress Collection, A–583.305B

4. **Venetian,** late XV or early XVI century
 An Assembly of Gods
 Bronze, 6.5 x 15.0 (2 9/16 x 5 29/32)
 Kress Collection, A–528.250B

These secular works are examples of Venetian relief sculpture, and they look forward to the flourishing of bronze production in Venice during the later sixteenth century. The bold composition of warring sea creatures is, like Severo's dragons, inspired by Mantegna's much admired *Battle of the Sea Gods* engraving. The imagery is closely related to that dec-

orating the three great flagstaffs which stand before the Basilica in the Piazza San Marco in Venice. These were the work of the bronze master Leopardi, who was also responsible for casting Verrocchio's equestrian monument in Venice. Nos. 3 and 4, too, are reminiscent of Leopardi's work, while the *Music* recalls the figural style of the Venetian sculptor Tullio Lombardo (c. 1455-1532).

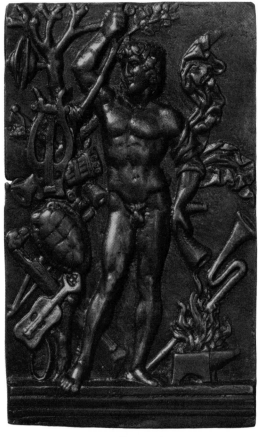

Venetian, Allegory of Music

The Narrative Manner in Sixteenth-Century Italy (GN 8)

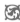

The sculpture displayed in this section represents primarily the work of sixteenth-century artists who specialized in the creation of narrative plaquettes. This genre, in which a sculptor could display great finesse in modeling and skill in composing on a small scale, was a particularly popular one during the period; as the favorite interest of Gustave Dreyfus, it is exceptionally well represented here. Frequently the legend of one hero will be found depicted in a series of scenes, each on a separate plaquette. In his many years of careful purchasing and trading of plaquettes, the discriminating French collector was often able to complete such a narrative series and, moreover, to obtain the finest existing cast of a given work.

Small narrative plaquettes were produced during the later quattrocento and the cinquecento by artists who were active in various Italian centers. Whether treating ancient subject matter or biblical scenes, they often adopted a classicizing style, which is at times directly comparable to the self-conscious mannerist and *maniera* currents in central Italian and Emilian painting.

Also exhibited here is the Widener collection of Italian maiolica. Another art form which attained its peak during the sixteenth century, ceramic tableware painted and glazed in rich colors is represented in many notable examples from the foremost centers of its production. Again often mannerist in style, the historiated maiolica plates share with the plaquettes in the depiction of mythological characters and events. Displayed nearby are bronze table accessories from the period: mortars and bells from the Kress Collection.

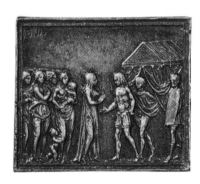

No. 1

No. 4

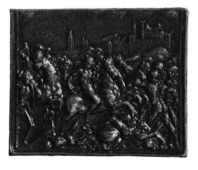

The Master of Coriolanus and Contemporary Classicists

1. **Master of Coriolanus,** North Italian, active c. 1500
 Coriolanus and the Women of Rome
 Bronze, 4.2 x 5.0 (1 $^{21}/_{32}$ x 1 $^{31}/_{32}$)
 Kress Collection, A–420.143B

2. **Master of Coriolanus**
 Coriolanus Leaving Rome
 Bronze, 6.3 (2 $^1/_2$)
 Kress Collection, A–421.144B

3. **Master of Coriolanus**
 The Banishment of Coriolanus
 Bronze, 4.3 x 5.1 (1 $^{11}/_{16}$ x 2)
 Kress Collection, A–424.147B

4. **Master of Coriolanus**
 Coriolanus in Battle before Rome
 Bronze, 4.0 x 5.0 (1 $^9/_{16}$ x 1 $^{31}/_{32}$)
 Kress Collection, A–425.148B

5. **Master of Coriolanus**
 Allegory of Victory
 Bronze, 4.2 x 5.4 (1 $^{21}/_{32}$ x 2 $^1/_8$)
 Kress Collection, A–423.146B

6. **Master of Coriolanus**
 A Roman Triumph
 Bronze, 4.2 x 4.8 (1 $^{21}/_{32}$ x 1 $^{29}/_{32}$)
 Kress Collection, A–422.145B

7. **Master of Coriolanus**
 Naval Scene
 Bronze, 6.3 (2 $^1/_2$)
 Kress Collection, A–427.150B

8. **Master of Coriolanus**
 Soldiers Attacking a Gate
 Bronze, 6.3 (2 $^1/_2$)
 Kress Collection, A–428.151B

Conventionally identified by the subject of his seried depiction of episodes from the life of the Roman hero Coriolanus, this plaquette artist worked in the classicizing mode characteristic of northern Italy at the turn of the century. Four of the Coriolanus plaquettes are shown here.

9. **Italian,** XVI century
 Hercules
 Bronze, 11.0 x 5.9 (4 $^5/_{16}$ x 2 $^{11}/_{32}$)
 Kress Collection, A–671.393B

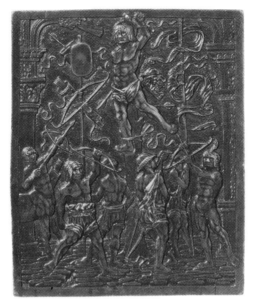

10. **Italian, possibly Bolognese,**
 late XV or early XVI century
 Martyrdom of Saint Sebastian
 Bronze, 7.6 x 6.5 (3 x 2 $^{17}/_{32}$)
 Kress Collection, A–368.91B

 A work of exceptionally high quality, this
 delicately delineated and rare relief
 occurs also in a silver version mounted as
 a pax, preserved in San Petronio, Bologna.
 It shares an interest in classical architec-
 ture with the following devotional pla-
 quette.

11. **Milanese,** late XV or early XVI century
 The Flagellation
 Bronze, 7.1 x 5.3 (2 $^{13}/_{16}$ x 2 $^{3}/_{32}$)
 Kress Collection, A–521.243B

12. **Paduan,** late XV or early XVI century
 Vulcan Forging the Arrows of Cupid
 Bronze, 5.5 (2 $^{5}/_{32}$)
 Kress Collection, A–570.292B

13. **Italian,** second quarter XVI century
 Venus in Armor
 Bronze, 6.3 (2 $^{15}/_{32}$)
 Kress Collection, A–689.411B

14. **Italian,** after the Antique,
 early XVI century
 Scipio Africanus
 Bronze, 7.5 x 5.9 (2 $^{15}/_{16}$ x 2 $^{5}/_{16}$)
 Kress Collection, A–319.42B

15. **Italian,** late XV or early XVI century
 Bull-baiting
 Bronze, 1.9 x 2.3 ($^{3}/_{4}$ x $^{7}/_{8}$)
 Kress Collection, A–366.89B

No. 15

16. **Italian,** mid-XVI century
The Triumph of Flora
Bronze, 2.6 x 7.6 (1 $^1/_{32}$ x 3)
Widener Collection, A–1555

17. **Italian (?),** XVI century
The Rape of Lucretia (?)
Bronze, 3.7 x 2.9 (1 $^{15}/_{32}$ x 1 $^1/_8$)
Kress Collection, A–588.310B

18. **North Italian,** late XV or early XVI century
The Three Sons with their Father's Corpse
Bronze, 3.7 x 8.2 (1 $^7/_{16}$ x 3 $^1/_4$)
Kress Collection, A–567.289B

No. 19

19. **Italian,** early XVI century
The Death of Laocoön
After 1506
Bronze, 4.6 (1 $^{13}/_{16}$)
Kress Collection, A–604.326B

One of a group of small plaquettes closely related to Antique objects, the Laocoön is of special interest in its representation of a celebrated ancient sculpture which was unearthed in 1506. Already known to the Renaissance from a description by Pliny, the rediscovered Hellenistic figural group, with its dramatic diagonal lines and its contorted figures used expressively to portray the death of the Trojan priest, had a considerable impact on subsequent painting and sculpture.

20. **North Italian,** late XV or early XVI century
A Triumph
Bronze, 4.7 x 6.3 (1 $^7/_8$ x 2 $^{15}/_{32}$)
Kress Collection, A–568.290B

21. **Mantuan,** early XVI century
A Triumph
Bronze, 4.9 x 7.4 (1 $^{15}/_{16}$ x 2 $^{29}/_{32}$)
Kress Collection, A–576.298B

22. **Italian,** after the Antique, XV century
A Youth
Bronze, 4.0 (1 $^{19}/_{32}$)
Kress Collection, A–323.46B

23. **Italian,** first half XVI century
A Woman
Bronze, 4.6 (1 $^{13}/_{16}$)
Kress Collection, A–581.303B

Ulocrino, the Pseudo-Melioli, and the Master IO.F.F.

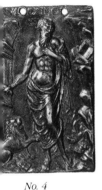

No. 4

1. **Ulocrino,** Paduan or Venetian, active early XVI century
 Hercules and Antaeus
 Bronze, 7.0 x 5.2 (2 ³/₄ x 2 ¹/₃₂)
 Kress Collection, A–435.158B

2. **Ulocrino**
 Apollo and Marsyas
 Bronze, 7.1 x 5.3 (2 ¹³/₁₆ x 2 ³/₃₂)
 Kress Collection, A–434.157B

3. **Ulocrino**
 Saint Cecilia
 Bronze, 7.1 x 5.3 (2 ¹³/₁₆ x 2 ³/₃₂)
 Kress Collection, A–438.161B

4. **Ulocrino**
 Saint Jerome
 Bronze, 7.8 x 5.0 (3 ¹/₁₆ x 1 ³¹/₃₂)
 Kress Collection, A–430.153B

5. **Ulocrino**
 The Death of Meleager
 Bronze, 7.2 x 5.3 (2 ²⁷/₃₂ x 2 ³/₃₂)
 Kress Collection, A–436.159B

6. **Ulocrino**
 Allegorical Scene
 Bronze, 6.6 x 4.7 (2 ⁹/₁₆ x 1 ²⁷/₃₂)
 Kress Collection, A–429.152B

This artist is known only by the signature that occurs on several of his many plaquettes. They appear to have been produced at Padua or Venice and, like many of the works exhibited in this case, relate closely to the objects in the previous room.

7. **Pseudo-Melioli (?),** North Italian, active late XV century–early XVI century
 Vulcan Forging the Arrows of Cupid
 Gilt bronze, 6.0 (2 ³/₈)
 Kress Collection, A–349.72B

8. **Pseudo-Melioli**
 Mucius Scaevola
 Bronze, 6.9 (2 ²³/₃₂)
 Kress Collection, A–352.75B

9. **Pseudo-Melioli**
 Romans Passing Under the Yoke
 Bronze, 4.4 (1 ³/₄)
 Kress Collection, A–354.77B

No. 9

10. **Pseudo-Melioli**
 Mars and Venus
 Lead, 5.0 (2)
 Kress Collection, A–347.70B

A master of Roman themes whose works are relatively rare, this anonymous plaquette artist was formerly thought to be identical with the Mantuan medallist, Melioli, whose work we encountered earlier.

11. **Mantuan,** last quarter XV century
 A Satyr
 Bronze, 10.7 x 8.1 (4 $^3/_{16}$ x 3 $^3/_{16}$)
 Kress Collection, A–281.4B

12. **Mantuan,** last quarter XV century
 A Bacchante
 Bronze, 11.0 x 8.5 (4 $^5/_{16}$ x 3 $^3/_8$)
 Kress Collection, A–282.5B

The two oval reliefs, the first of which is a notably superior cast, are known in other examples and are based on the decorated reverse of a mirror now in London. The figures derive from ancient gems and compose an allegory of reproduction.

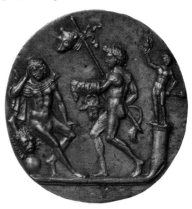

No. 13

13. **Master IO.F.F.,** possibly Giovanni di Fondulino Fonduli da Crema, known active 1468 and 1484 in Padua
 Allegorical Scene with Hercules (?) and a Bacchant
 Bronze, 7.0 (2 $^3/_4$)
 Kress Collection, A–618.340B

14. **Master IO.F.F. (?)**
 Circular Frieze of Centaurs and Tritons
 Bronze, 6.6 (2 $^5/_8$)
 Kress Collection, A–592.314B

15. **Master IO.F.F.**
 Phaedra and Hippolytus
 Bronze, 6.4 (2 $^{17}/_{32}$)
 Kress Collection, A–615.337B

16. **Master IO.F.F.**
 Ariadne on Naxos
 Bronze, 5.7 (2 ¼)
 Kress Collection, A–616.338B

17. **Master IO.F.F.**
 The Judgment of Paris
 Bronze, 5.6 (2 ³/₁₆)
 Kress Collection, A–619.341B

18. **Master IO.F.F.**
 An Assembly of Gods
 Bronze, 4.2 x 3.4 (1 ²¹/₃₂ x 1 ¹¹/₃₂)
 Widener Collection, A–1532

19. **Master IO.F.F.**
 Allegory of Union (?)
 Bronze, 6.3 x 6.0 (2 ¹⁵/₃₂ x 2 ³/₈)
 Kress Collection, A–626.348B

20. **Master IO.F.F.**
 Death of Marcus Curtius
 Bronze, 6.2 x 6.0 (2 ⁷/₁₆ x 2³/₈)
 Kress Collection, A–625.347B

No. 20

21. **Master IO.F.F.**
 Horatius Cocles Defending the Bridge
 Bronze, 6.1 x 6.0 (2 ¹³/₃₂ x 2 ³/₈)
 Kress Collection, A–623.345B

22. **Master IO.F.F.**
 Mucius Scaevola
 Bronze, 6.1 x 5.9 (2 ¹³/₃₂ x 2 ⁵/₁₆)
 Kress Collection, A–624.346B

The master who signed his plaquettes IO.F.F. has been identified, tentatively, with one Giovanni di Fondulino Fonduli, who is known from documents to have worked in bronze at Padua during the second half of the fifteenth century. The artist's many-figured scenes from Greek mythology and Roman history often take the shape of a shield and would have been intended to adorn sword hilts. A two-sided *Allegory of Faith* attributed to this master is exhibited in the transparent case next to this one.

Medals in the Classical Style

1. **Master IO.F.F. (?),** possibly Giovanni di Fondulino Fonduli da Crema, known active 1468 and 1484 in Padua
 Allegory of Faith. Obverse: nude youth devoured by three lions. Reverse: circular frieze of Tritons and Nereids.
 Bronze, 6.0 (2 ³/₈)
 Kress Collection, A–590.312B

No. 2

2. **Cristoforo Foppa,** called **Caradosso,**
 c. 1452-1526/27, active in Milan, Mantua,
 and Rome
 A Triumph
 Bronze, 5.4 x 3.0 (2 $\frac{1}{8}$ x 1 $\frac{3}{16}$)
 Kress Collection, A–379.102B

3. **Caradosso**
 Hercules and Cacus
 Bronze, 6.1 x 3.7 (2 $\frac{13}{32}$ x 1 $\frac{15}{32}$)
 Kress Collection, A–381.104B

4. **Caradosso**
 Silenus Attacked by Bacchantes
 Bronze, 5.0 x 4.9 (1 $\frac{31}{32}$ x 1 $\frac{15}{16}$)
 Kress Collection, A–374.97B

5. **Caradosso**
 Marine Scene
 Bronze, 5 x 4.9 (1 $\frac{31}{32}$ x 1 $\frac{15}{16}$)
 Kress Collection, A–376.99B

6. **Caradosso**
 Battle of Centaurs and Lapiths
 Bronze, 5.1 x 5.0 (2 x 1 $\frac{31}{32}$)
 Kress Collection, A–373.96B

7. **Caradosso**
 Niccolò Orsini, 1442-1510, Count of Pitigli-
 ano and Nola, Captain of the Army of the
 Roman Church and of the Florentine
 Republic. Reverse: Orsini in armor, riding
 to right accompanied by two halberdiers.
 1485-1495
 Bronze, 4.1 (1 $\frac{19}{32}$)
 Kress Collection, A–933.196A

8. **Caradosso**
 Donato Bramante, c. 1444-1514, architect.
 Reverse: figure of Architecture seated,
 holding compasses and square, her right
 foot on a weight; in background, a view
 of Saint Peter's according to Bramante's
 design.
 Bronze, 4.3 (1 $\frac{11}{16}$)
 Kress Collection, A–930.193A

No. 8, obverse

9. **Caradosso**
 Julius II (Giuliano della Rovere,
 1443-1513), Pope 1503. Reverse: view of
 Saint Peter's according to Bramante's
 design.
 1506 (Foundation medal)
 Bronze, 5.6 (2 $\frac{7}{32}$)
 Kress Collection, A–931.194A

Caradosso worked for many years as a gold-
smith and medallist in Milan, serving the

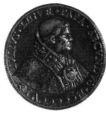

No. 9, obverse *No. 9, reverse*

Sforza court. He went in 1505 to Mantua and then to Rome. In 1509 he founded the guild of Roman goldsmiths. The artist is mentioned in sixteenth-century written accounts as the author of a silver inkstand. A project which is said to have taken him twenty-six years to complete, the work was ornamented with plaquettes, including a version of the *Centaurs and Lapiths* shown here (no. 6).

Caradosso's move to Rome coincided precisely with the establishment of the papal city as the undisputed center of High Renaissance art under Julius II's patronage of Michelangelo, Raphael, and Bramante. An exceptionally powerful figure in his militant church reforms, political strengthening of the Papal States, and determination to rebuild medieval Rome and restore it to imperial grandeur, Julius II is portrayed in one of Caradosso's medals (no. 9). The work is of great historical significance in that it commemorates the pope's astonishing decision to tear down the eleven-hundred-year-old Basilica of Saint Peter's and his commission of Bramante in 1506 to replace the seat of Western Christianity with a grandiose structure in the modern idiom. The medallic reverse preserves Bramante's magnificent design, which was subsequently carried out only in part. The great High Renaissance architect is himself honored in one of Caradosso's medals (no. 8).

10. **Roman**
 Julius II (Giuliano della Rovere, 1443-1513), Pope 1503. Reverse: shield of the Rovere ensigned with crossed keys and tiara.
 1507
 Struck bronze, 3.1 (1 $^7/_{32}$)
 Kress Collection, A–976.238A

11. **Roman**
 Leo X (Giovanni de'Medici, 1475-1521), Pope 1513. Reverse: shield of Medici arms ensigned with crossed keys and tiara.
 Bronze, 7.8 (3 $^1/_{16}$)
 c. 1513-1515
 Widener Collection, A–1493

The medals represent Julius and his luxury-minded Medici successor Leo X, who continued the former's patronage in the Vatican of Raphael, providing the painter with numerous major commissions and appointing him Superintendent of Antiquities.

No. 12

12. **Giovanni Bernardi,** Bolognese, 1496-1553
 The Adoration of the Magi
 Blue glass, 9.8 x 7.2 (3 $^7/_8$ x 2 $^{27}/_{32}$)
 Kress Collection, A–656.378B

This highly unusual work in blue glass appears to be an impression taken from a mold similar to those Bernardi used for casting bronze plaquettes. The artist's oeuvre is further represented in the wall case directly beyond.

13. **Roman**
 Jesus Christ. Reverse: inscription (John xi:27) within wreath.
 c. 1500
 Bronze, 9.0 (3 $^{17}/_{32}$)
 Kress Collection, A–981.243A

14. **Valerio Belli,** Vicentine c. 1468-1546
 Pietro Bembo, 1470-1547, Cardinal 1538.
 Reverse: Bembo partially draped, reclining under trees beside a stream, holding a branch.
 Struck bronze, 3.4 (1 $^{11}/_{32}$)
 Kress Collection, A–1123.386A

Belli, whose work is also represented in a case on the south wall, here portrays the prolific sixteenth-century Neoplatonist scholar, who through his editions of Dante and Petrarch, became the great arbiter of Italian letters.

Bembo was a favorite of Leo X and was made a Cardinal by Paul III.

15. **Italian**

Paul III (Alessandro Farnese, 1468-1549), Pope 1534. Reverse: fight between a griffin and a serpent; all in wreath.
c. 1540
Bronze, 6.2 (2 $^{7}/_{16}$)
Kress Collection, A–1118.381A

No. 16

16. **Guglielmo della Porta,**
Lombard-Roman, c. 1515?-1577
Paul III (Alessandro Farnese, 1468-1549), Pope 1534.
c. 1545
Bronze, 29.9 x 21.0 x 15.7
(11 $^{3}/_{4}$ x 8 $^{1}/_{4}$ x 6 $^{1}/_{8}$)
Gift of Asbjorn R. Lunde, A–1765

Here represented is the Farnese Pope Paul III, a patron of both Titian and Michelangelo. The portrait bust illustrates on a small scale the sculptural style of Guglielmo della Porta, whose full-scale portraits are distinguished by a lively character interpretation and a grandiose extension of the bust. One bronze bust of Paul III by Guglielmo is recorded in 1547, and three marble busts are known; Guglielmo worked also on a seated image intended for the pope's tomb. A sculptor of major importance whose birthdate is unknown, Guglielmo della Porta probably originated in Lombardy. He was active in Genoa during the early 1530s and came to Rome toward the end of that

decade. In 1547 he was made *Bollatore Aposto-lico,* the prestigious office in charge of making lead seals for papal bulls, a position he won in competition with Benvenuto Cellini.

17. **Alessandro Cesati,** called **Il Grechetto,** known active in Rome 1538-1561
Paul III (Alessandro Farnese, 1468-1549), Pope 1534. Reverse: Ganymede watering the Farnese lilies, resting his left hand on the shoulder of an eagle.
1545
Struck bronze, 4.0 (1 $^9/_{16}$)
Kress Collection, A–1103.366A

Paul III is again portrayed (no. 17) by a medal-list whose nickname suggests his interest in ancient subjects (nos. 18 and 19) and his unusually close adherence in style to ancient coins.

18. **Il Grechetto**
Priam, King of Troy. Reverse: view of Troy, with galleys in harbor before it.
Bronze, 3.9 (1 $^{17}/_{32}$)
Kress Collection, A–1106.369A

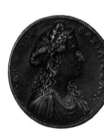

No. 19

19. **Il Grechetto**
Dido, Queen of Carthage. Reverse: view of Carthage, with galleys in harbor before it.
Bronze, 4.5 (1 $^{25}/_{32}$)
Kress Collection, A–1105.368A

20. **Monogrammist HB,** active c. 1525-1550, possibly in Padua
Hercules. Reverse: Hercules in cuirass, lion-skin over arm, standing to left leaning on spear; a messenger brings him the shirt of Nessus.
Bronze, 4.0 (1 $^9/_{16}$)
Kress Collection, A–1148.411A

21. **Italian,** XVI century (?)
Antinous, favorite of the Emperor Hadrian, died A.D. 130. Reverse: male figure reclin-ing on back of griffin.
Bronze, 4.2 (1 $^{21}/_{32}$)
Kress Collection, A–1255.516A

22. **Italian,** late XV or early XVI century
Meleager, nude, pursuing the Calydonian Boar. Reverse: Meleager on horseback, in armor.
Bronze, 9.1 (3 $^9/_{16}$)
Kress Collection, A–353.76B

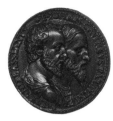
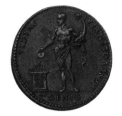

No. 23, obverse No. 23, reverse

23. **Giovanni dal Cavino,** Paduan, 1500-1570
 Alessandro Bassiano, Paduan scholar, and
 Giovanni dal Cavino, the medallist. Re-
 verse: partially draped male figure of
 Genius, standing, holding dolphin in left
 hand, sacrificing with patera in right over
 flaming altar.
 Struck bronze, 3.6 (1 $^{13}/_{32}$)
 Kress Collection, A-1126.389A

24. **Giovanni dal Cavino**
 Giovanni Mels, jurist, born at Udine, died
 1559. Reverse: Mels as Genius sacrificing
 with patera on flaming altar; holds cornu-
 copia in left hand.
 Struck bronze, 3.8 (1 $^{1}/_{2}$)
 Kress Collection, A-1130.393A

25. **Giovanni dal Cavino**
 Alfonso II d'Avalos, 1502-1546, Marquess
 of Vasto. Reverse: palm tree; on left, man
 in cloak with hands behind his back, and a
 pile of arms; on right, a woman (Africa)
 seated on cuirass, mourning, beside a
 ship's prow.
 Bronze, 3.7 (1 $^{15}/_{32}$)
 Kress Collection, A-1125.388A

26. **Giovanni dal Cavino**
 Giampietro Mantova Benavides, Paduan
 physician, died 1520. Reverse: façade of
 temple; within, statue of goddess holding
 cornucopia.
 Struck bronze, 3.6 (1 $^{13}/_{32}$)
 Kress Collection, A-1127.390A

27. **Giovanni dal Cavino**
 Balduino del Monte, brother of Julius III,
 Count of Montesansavino 1550, died 1556.
 Reverse: combat between two horsemen;
 temple in background.
 Struck bronze, 4.2 (1 $^{21}/_{32}$)
 Kress Collection, A-1131.394A

28. **Giovanni dal Cavino**
 Cosimo Scapti. Reverse: female figure of
 Health seated to left, before statuette of
 Bacchus placed on a column under a vine;
 she gives drink from a patera to a serpent

which rears itself from the ground over a branch of the vine.
Struck bronze, 3.8 (1 $^1/_2$)
Kress Collection, A–1135.398A

29. **Giovanni dal Cavino**
Girolamo Cornaro, 1485-1551, Venetian patrician, Capitano di Padova 1539-1540. Reverse: Cornaro seated on platform, distributing alms.
Struck bronze, 3.7 (1 $^{15}/_{32}$)
Kress Collection, A–1128.391A

30. **Giovanni dal Cavino**
Francesco Querini, Venetian patrician, poet and soldier, active 1544. Reverse: She-wolf suckling Romulus and Remus.
Struck bronze, 3.7 (1 $^{15}/_{32}$)
Kress Collection, A–1133.396A

31. **Giovanni dal Cavino**
Homer. Reverse: armed male figure standing holding spear, eagle at his feet; on left, seated woman with cornucopia; on right, seated man with spear, approached by Victory; below, two reclining river deities, one with a dragon, the other with another monster.
Struck bronze, 3.5 (1 $^3/_8$)
Kress Collection, A–1136.399A

32. **Giovanni dal Cavino**
Head of Arethusa to left, surrounded by dolphins (imitation of a Syracusan coin). Reverse: a triumph.
Struck bronze, 3.8 (1 $^1/_2$)
Kress Collection, A–1137.400A

33. **Giovanni dal Cavino**
Sabina, wife of the Emperor Hadrian, died A.D. 136. Reverse: Ceres seated to left on modius, holding three ears of corn and a lighted torch (imitation of a Roman sestertius).
Struck bronze, 3.4 (1 $^{11}/_{32}$)
Kress Collection, A–1141.404A

34. **Giovanni dal Cavino**
Antinous, favorite of the Emperor Hadrian, died A.D. 130. Reverse: Mercury taming Pegasus.
Struck bronze and copper, 3.8 (1 $^1/_2$)
Kress Collection, A–1466.726A

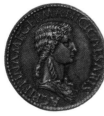 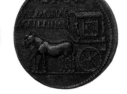

No. 35, obverse No. 35, reverse

35. **Giovanni dal Cavino**
Agrippina Senior, daughter of Agrippa,
wife of Germanicus, died A.D. 33. Reverse:
funeral car drawn by two mules (imitation
of a Roman sestertius).
Struck bronze, 3.5 (1 ³/₈)
Kress Collection, A–1138.401A

36. **Giovanni dal Cavino**
Lucius Verus, Roman Emperor A.D. 161-
169. Reverse: Roma seated to left on a
cuirass, her right foot on a helmet; the
emperor approaches holding a sceptre in
his left hand, and offering her with his
right a fleur-de-lis; behind, a Victory
approaches to crown her, carrying a palm
branch (imitation of a Roman medallion).
Struck bronze and copper, 3.8 (1 ¹/₂)
Kress Collection, A–1145.408A

37. **Giovanni dal Cavino**
Faustina Junior, wife of Marcus Aurelius,
died A.D. 176. Reverse: the empress and
five other women and a child sacrificing
before a circular temple containing a
statue of Mars(?) (imitation of a Roman
sestertius).
Struck bronze, 3.5 (1 ³/₈)
Kress Collection, A–1144.407A

Like the medals of his Roman counterpart Il
Grecchetto, those of Cavino are directly in-
spired by examples of classical coinage. Cav-
ino's oeuvre similarly includes medals com-
memorating ancient as well as contemporary
personages. The examples shown here are
struck rather than cast.

Moderno

The most prolific plaquette artist of Renaissance Italy,
Moderno is also among the most accomplished masters to
work in this genre. Under the apt pseudonym with which he
signed many of his plaquettes, Moderno is known to have
worked as a goldsmith and seal maker in Rome during the
early sixteenth century, along with Caradosso, Cellini, and
Valerio Belli. Various attempts have been made to discover
Moderno's real name; the most plausible suggestion identi-
fies him with one Galeazzo Mondella, a Veronese gem cutter,

active c. 1500. The Kress holdings of Moderno plaquettes constitute by far the greatest collection of his work.

Moderno's plaquettes, which include Christian and classical subjects alike, are distinguished for their astonishing technical intricacy and ability to reflect a flickering, nervous light, which enhances their dramatic content. The highly refined figures, generally nude or lightly draped in the classical style, represent an enormous range of anatomical postures and are skillfully grouped, often in large numbers, in an endless variety of complex compositions. In several of Moderno's religious plaquettes and in the series of Orpheus roundels ascribed to him, an acute sensitivity to nature is revealed as well.

1. **Style of Moderno,** North Italian, active late XV and early XVI centuries
 Saint Sebastian
 Bronze, 13.1 x 9.1 (5 $^5/_{32}$ x 3 $^{19}/_{32}$)
 Kress Collection, A–453.176B

2. **Moderno**
 Saint Sebastian
 Bronze, 7.7 x 5.7 (3 $^1/_{32}$ x 2 $^1/_4$)
 Kress Collection, A–454.177B

3. **Moderno**

 Saint Jerome
 Bronze, 7.8 x 6.0 (3 $^1/_{16}$ x 2 $^{11}/_{32}$)
 Kress Collection, A–455.178B

4. **Style of Moderno**
 Saint Jerome
 Bronze, 5.8 x 4.4 (2 $^9/_{32}$ x 1 $^{23}/_{32}$)
 Kress Collection, A–456.179B

5. **Moderno**
 Madonna and Child Enthroned with Two Angels; incised inscription.
 Gilt bronze, 6.4 x 5.3 (2 $^1/_2$ x 2 $^3/_{32}$)
 Kress Collection, A–442.165B

6. **Moderno**
 Madonna and Child Enthroned with Saints
 Bronze, 6.9 x 5.4 (2 $^{23}/_{32}$ x 2 $^1/_8$)
 Kress Collection, A–441.164B

7. **Moderno**
 Madonna and Child Enthroned with Saint Anthony Abbot and Saint Jerome
 1490
 Bronze, 11.1 x 6.6 (4 $^3/_8$ x 2 $^{19}/_{32}$)
 Kress Collection, A–440.163B

No. 9 *No. 11*

8. **Moderno**
 The Flagellation
 Bronze, 14.1 x 10.5 (5 $^9/_{16}$ x 4 $^1/_8$)
 Widener Collection, A–1564

9. **Moderno**
 The Crucifixion
 Bronze, 11.5 x 7.8 (4 $^{17}/_{32}$ x 3 $^1/_{16}$)
 Kress Collection, A–447.170B

10. **Moderno**
 The Entombment
 Bronze, 3.7 x 2.8 (1 $^7/_{16}$ x 1 $^1/_8$)
 Kress Collection, A–519.241B

11. **Moderno**
 The Entombment
 Bronze, 10.6 x 6.9 (4 $^3/_{16}$ x 2 $^{23}/_{32}$)
 Kress Collection, A–449.172B

12. **Moderno**
 The Entombment
 Bronze, 7.0 x 7.2 (2 $^3/_4$ x 2 $^{27}/_{32}$)
 Kress Collection, A–450.173B

13. **Moderno**
 *The Dead Christ Supported by the Virgin
 and Saint John*
 Bronze, 8.3 x 6.6 (3 $^9/_{32}$ x 2 $^{19}/_{32}$)
 Kress Collection, A–451.174B

14. **Moderno**
 The Resurrection
 Bronze, 10.0 x 6.5 (3 $^{15}/_{16}$ x 2 $^9/_{16}$)
 Kress Collection, A–452.175B

15. **Style of Moderno**
 *The Dead Christ Supported by the Virgin
 and Saint John*
 Bronze, 8.1 x 5.8 (3 $^3/_{16}$ x 2 $^1/_4$)
 Kress Collection, A–523.245B

16. **Moderno**
 The Continence of Scipio
 Bronze, 5.8 x 7.5 (2 ¼ x 2 ¹⁵/₁₆)
 Kress Collection, A–579.301B

17. **Style of Moderno**
 Battle Scene
 Bronze, 5.3 (2 ³/₃₂)
 Kress Collection, A–494.216B

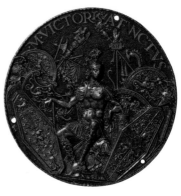

No. 18

18. **Moderno**
 Mars Surrounded by Trophies
 Gilt bronze, 7.0 (2 ³/₄)
 Kress Collection, A–462.185B

19. **Moderno**
 Augustus and the Sibyl
 Bronze, 5.7 (2 ¼)
 Kress Collection, A–458.181B

20. **Moderno**
 David Triumphant over Goliath
 Before 1507
 Bronze, 7.1 x 5.6 (2 ¹³/₁₆ x 2 ³/₁₆)
 Widener Collection, A–1562

21. **Moderno**
 David Triumphant over Goliath
 Before 1507
 Bronze, 10.6 (4 ⁵/₃₂)
 Kress Collection, A–439.162B

22. **Moderno**
 Hercules and the Cattle of Geryon
 Bronze, 7.1 x 5.4 (2 ²⁵/₃₂ x 2 ⅛)
 Kress Collection, A–479.202B

23. **Moderno**
 Hercules and a Centaur
 Before 1507
 Bronze, 6.9 x 5.5 (2 ²³/₃₂ x 2 ⁵/₃₂)
 Kress Collection, A–469.192B

24. **Moderno**
 Cacus Stealing the Cattle of Geryon from Hercules

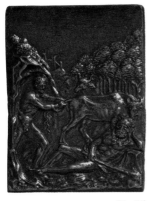

No. 24

No. 25

Bronze, 7.0 x 5.4 (2 ³/₄ x 2 ¹/₈)
Kress Collection, A–468.191B

25. **Moderno**
Hercules and Antaeus
Bronze, 7.5 x 5.9 (2 ¹⁵/₁₆ x 2 ⁵/₁₆)
Kress Collection, A–477.200B

26. **Moderno**
Hercules Triumphant over Antaeus
Bronze, 6.9 x 5.5 (2 ²³/₃₂ x 2 ⁵/₃₂)
Kress Collection, A–480.203B

27. **Moderno**
Hercules and the Nemean Lion
Bronze, 10.5 (4 ³/₁₆)
Kress Collection, A–472.195B

28. **Moderno (?)**
Hercules and the Nemean Lion
Bronze, 7.8 x 6.6 (3 ¹/₁₆ x 2 ¹⁹/₃₂)
Kress Collection, A–471.194B

29. **Moderno**
Hercules and the Lernean Hydra
Bronze, 9.7 x 7.8 (3 ¹³/₁₆ x 3 ¹/₁₆)
Widener Collection, A–1565

30. **Moderno (?)**
Hercules and Antaeus
Bronze, 9.7 x 7.7 (3 ¹³/₁₆ x 3 ¹/₃₂)
Kress Collection, A–478.201B

31. **Moderno**
Hercules and the Nemean Lion
Bronze, 9.2 x 4.2 (3 ⁵/₈ x 1 ²¹/₃₂)
Kress Collection, A–474.197B

32. **Style of Moderno**
Hercules and the Nemean Lion
Bronze, 5.7 x 6.4 (2 ¹/₄ x 2 ¹/₂)
Kress Collection, A–473.196B

No. 34

33. **Moderno**
 Nessus and Dejanira
 Bronze, 9.4 x 4.3 (3 $^{23}/_{32}$ x 1 $^{11}/_{16}$)
 Kress Collection, A–475.198B

34. **Moderno (?)**
 Orpheus Playing to the Animals
 Bronze, 10.6 (4 $^{3}/_{16}$)
 Widener Collection, A–1570

35. **Moderno (?)**
 Orpheus Descending into Hades
 Bronze, 10.7 (4 $^{7}/_{32}$)
 Kress Collection, A–484.206B

36. **Moderno (?)**
 Orpheus Losing Eurydice
 Bronze, 10.5 (4 $^{1}/_{8}$)
 Kress Collection, A–486.208B

37. **Moderno (?)**
 The Death of Orpheus
 Bronze, 6.1 (2 $^{13}/_{32}$)
 Kress Collection, A–488.210B

38. **Moderno (?)**
 Arion Rescued by the Dolphin
 Bronze, 10.5 (4 $^{1}/_{8}$)
 Kress Collection, A–482.205B

39. **Moderno**
 Mars and Victory
 Before 1507
 Bronze, 10.5 (4 $^{1}/_{8}$)
 Kress Collection, A–459.182B

40. **Moderno**
 The Death of Hippolytus (or *The Fall of Phaeton*)
 Bronze, 10.5 (4 $^{1}/_{8}$)
 Widener Collection, A–1563

Giovanni Bernardi

Another skillful composer of elegant nudes in elaborate scenes, the Bolognese artist Bernardi traveled to Rome, where during the 1530s and 1540s he served the papal mint. He is best known as a proficient practitioner of a newly developing and much sought after art, that of engraving with designs the treasured rock crystals found in nature and fashioned into decorative reliefs or vessels and liturgical objects, such as those displayed here in the small gallery beyond the next. As a crystal engraver, Bernardi worked for Cardinal Ippolito de' Medici and for Cardinal Alessandro Farnese (later Pope Paul III).

Many of the compositions which occur on sixteenth-century rock crystals are found also on plaquettes, and the easily portable small bronze reliefs may even have served as a means of transmitting designs from one crystal engraver to another. Bernardi's *Adoration of the Magi* (no. 1) is almost identical in composition with his blue glass relief, seen in the transparent case at the center of the room. That work may actually have been made as an inexpensive imitation of rock crystal.

1. **Giovanni Bernardi,** Bolognese, 1496-1553
 The Adoration of the Magi
 Bronze, 7.8 x 7.1 (3 $^1/_{16}$ x 2 $^{25}/_{32}$)
 Kress Collection, A–655.377B

2. **Giovanni Bernardi**
 Meleager Slaying the Calydonian Boar
 c. 1544
 Bronze, 9.6 x 11.4 (3 $^{25}/_{32}$ x 4 $^{15}/_{32}$)
 Kress Collection, A–669.391B

 This work is cast from one of the rock-crystal reliefs in the Cassetta Farnese (Naples), Bernardi's masterpiece.

3. **Giovanni Bernardi**
 A Panther Hunt
 Lead, 6.6 x 8.4 (2 $^{19}/_{32}$ x 3 $^5/_{16}$)
 Kress Collection, A–665.387B

4. **Giovanni Bernardi**
 Neptune
 Bronze, 8.0 x 6.6 (3 $^1/_8$ x 2 $^{19}/_{32}$)
 Kress Collection, A–668.390B

No. 4

5. **Italian,** late XVI century
 Cupid on a Flying Swan
 Bronze, 7.5 x 6.6 (2 $^{15}/_{16}$ x 2 $^{19}/_{32}$)
 Kress Collection, A–661.383B

6. **Giovanni Bernardi**
 The Rape of Ganymede
 After 1532
 Bronze, 6.8 x 9.1 (2 $^{11}/_{16}$ x 3 $^9/_{16}$)
 Kress Collection, A–660.382B

As is no. 8 below, this composition is based on a design by Michelangelo.

7. **Giovanni Bernardi**
 Prometheus
 Bronze, 7.0 x 9.2 (2 $^3/_4$ x 3 $^5/_8$)
 Widener Collection, A–1504

8. **Giovanni Bernardi**
 The Fall of Phaeton
 After 1533
 Bronze, 9.0 x 6.8 (3 $^9/_{16}$ x 2 $^{11}/_{16}$)
 Kress Collection, A–659.381B

9. **Giovanni Bernardi**
 The Rape of the Sabines
 Before 1535
 Bronze, 6.6 x 7.5 (2 $^{19}/_{32}$ x 2 $^{15}/_{16}$)
 Kress Collection, A–663.385B

10. **Giovanni Bernardi**
 The Justice of Brutus
 Lead, 5.0 x 6.8 (2 x 2 $^{11}/_{16}$)
 Kress Collection, A–657.379B

11. **Giovanni Bernardi**
 The Continence of Scipio
 Bronze, 3.2 x 4.0 (1 $^1/_4$ x 1 $^{23}/_{32}$)
 Widener Collection, A–1503

12. **Studio of Giovanni Bernardi**
 A Youth
 Bronze, 3.4 x 2.7 (1 $^3/_8$ x 1 $^1/_{16}$)
 Kress Collection, A–324.47B

No. 8

13. **Giovanni Bernardi**
 Venus and Cupid with other Gods
 Lead, 3.8 x 4.6 (1 $^1/_2$ x 1 $^{13}/_{16}$)
 Kress Collection, A–658.380B

14. **Giovanni Bernardi**
 Allegorical Male Figure
 Bronze, 4.6 x 3.9 (1 $^{13}/_{16}$ x 1 $^{17}/_{32}$)
 Kress Collection, A–667.389B

15. **Italian,** XVI century
 Hercules and Antaeus
 Bronze, 4.8 x 3.7 (1 $^7/_8$ x 1 $^{15}/_{32}$)
 Widener Collection, A–1544

16. **Florentine,** mid-XVI century
 Apollo and Marsyas
 Bronze, 5.0 x 4.1 (2 x 1 $^{19}/_{32}$)
 Kress Collection, A–666.388B

17. **After Giovanni Bernardi**
 Bull-baiting
 Bronze, 6.4 x 9.4 (2 $^{17}/_{32}$ x 3 $^{11}/_{16}$)
 Kress Collection, A–693.415B

18. **Italian,** third quarter XVI century
 Victory between Fame and Peace
 Bronze, 6.3 x 7.9 (2 $^{15}/_{32}$ x 3 $^3/_{32}$)
 Kress Collection, A–610.332B

19. **Italian,** late XVI century
 Minerva and Vulcan
 Bronze, 6.4 (2 $^1/_2$)
 Kress Collection, A–609.331B

20. **Moderno (?)**
 The Death of Lucretia
 Bronze, 9.4 x 7.8 (3 $^{11}/_{16}$ x 3 $^1/_{16}$)
 Kress Collection, A–492.214B

Valerio Belli

Like Bernardi, Belli was tremendously celebrated as a crystal and gem engraver. He worked in Rome and Venice before returning to his native Vicenza. His smoothly and eloquently orchestrated figural compositions are extremely beautiful, and the examples displayed here are among the finest preserved. Of particular interest are nos. 5, 8, and 9, which are casts of Belli's rock-crystal reliefs, now in the Vatican, which originally adorned the base of a rock-crystal Crucifix. The *Jesus Among the Doctors* (no. 4) relates analogously to a rock-crystal relief on Belli's masterpiece, the Casket of Pope Clement VII (now in Florence). An incuse, no. 7, may have been used as a mold for producing lead or plaster casts.

1. **Italian,** mid-XVI century
 Saint Matthew
 Bronze, 3.8 (1 ½)
 Kress Collection, A–679.401B

No. 2

2. **Valerio Belli,** Vicentine, c. 1468-1546
 The Adoration of the Shepherds
 Bronze, 8.0 x 6.9 (3 $^{17}/_{32}$ x 2 $^{23}/_{32}$)
 Kress Collection, A–627.249B

3. **Valerio Belli (?)**
 The Adoration of the Magi
 Lead, 6.6 x 5.6 (2 $^{19}/_{32}$ x 2 $^{3}/_{16}$)
 Kress Collection, A–630.352B

4. **Valerio Belli**
 Jesus Among the Doctors
 Bronze, 6.1 x 9.9 (2 $^{13}/_{32}$ x 3 $^{29}/_{32}$)
 Kress Collection, A–631.353B

5. **Valerio Belli**
 The Betrayal of Christ
 Bronze, 8.8 x 9.7 (3 $^{15}/_{32}$ x 3 $^{27}/_{32}$)
 Kress Collection, A–632.354B

6. **Valerio Belli**
 Christ before Pilate
 Bronze, 6.0 x 9.9 (2 $^{3}/_{8}$ x 3 $^{29}/_{32}$)
 Kress Collection, A–633.355B

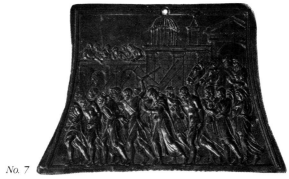

No. 7

7. **Valerio Belli**
 Christ Carrying the Cross
 Bronze, 7.7 x 11.8 (3 $^1/_{32}$ x 4 $^{21}/_{32}$)
 Kress Collection, A–634.356B

8. **Valerio Belli**
 Christ Carrying the Cross
 Bronze, 8.7 x 9.6 (3 $^7/_{16}$ x 3 $^{25}/_{32}$)
 Kress Collection, A–635.357B

9. **Valerio Belli**
 The Entombment
 Bronze, 8.9 x 9.8 (3 $^1/_2$ x 3 $^7/_8$)
 Kress Collection, A–637.359B

10. **Valerio Belli**
 The Entombment
 Bronze, 6.1 x 9.9 (2 $^{13}/_{32}$ x 3 $^7/_8$)
 Kress Collection, A–636.358B

11. **Italian,** late XV or early XVI century
 The Three Sons with their Father's Corpse
 Bronze, 2.3 x 2.8 ($^7/_8$ x 1 $^1/_8$)
 Kress Collection, A–367.90B

12. **Valerio Belli (?)**
 Venus (?)
 Lead, 5.1 x 4.2 (2 x 1 $^{21}/_{32}$)
 Kress Collection, A–644.366B

13. **Florentine,** mid-XVI century
 Perseus Mounted on Pegasus
 Bronze, 3.4 x 2.7 (1 $^{11}/_{32}$ x 1 $^1/_{16}$)
 Kress Collection, A–648.370B

No. 13

14. **Valerio Belli**
 Peace and Prosperity
 Lead, 4.3 (1 $^{11}/_{16}$)
 Kress Collection, A–650.372B

15. **Valerio Belli**
 The Triumph of Silenus
 Bronze, 2.5 x 3.2 (1 x 1 $^1/_4$)
 Kress Collection, A–312.35B

16. **Valerio Belli**
 Peace
 Bronze, 4.4 x 3.3 (1 $^{23}/_{32}$ x 1 $^{5}/_{16}$)
 Kress Collection, A–651.373B

17. **Florentine(?),** mid-XVI century
 Hercules and Antaeus
 Bronze, 4.4 x 3.4 (1 $^{23}/_{32}$ x 1 $^{11}/_{32}$)
 Kress Collection, A–649.371B

18. **Valerio Belli**
 A Lion Hunt
 Bronze, 6.9 x 8.0 (2 $^{23}/_{32}$ x 3 $^{5}/_{32}$)
 Kress Collection, A–653.375B

19. **North Italian,** early XVI century
 Head of Medusa
 Bronze, 4.5 (1 $^{3}/_{4}$)
 Kress Collection, A–490.212B

Early Maiolica

The art of ornamented tin-glazed earthenware, known as maiolica, took root in Italy toward the end of the fifteenth century. Used for tableware, pharmaceutical jars, and decorative elements applied to architecture, maiolica was produced from refined clay, generally shaped on the wheel or pressed from molds, and fired. The pieces were then covered with an opaque white ground of tin glaze and painted with colored glazes before a second firing. Maiolica tableware was made for both functional and ceremonial purposes. Many of the dishes that have come down to us are emblazoned with the original owner's heraldic device, many are inscribed with dates, and several pieces are signed on the back by the author, enabling us to identify the work of specific craftsmen.

Here represented are some of the earliest centers in which the art of maiolica flourished: the Tuscan cities of Caffagiolo and Siena (nos. 1 and 2) and the city of Faenza (which gave its name to the French equivalent of maiolica, *faïence*) in the Emilia Romagna (nos. 3 and 7). Especially beautiful is the Sienese plate (no. 2) representing Narcissus gazing on his reflection in a fountain. Typical of Sienese maiolica are the soft colors and delicate delineation. The intricate ornamental border of classicizing grotesquerie finds parallels among the other examples. Also represented is the Duchy of Urbino which during the 1520s attained preeminence in the field of maiolica production. Like no. 4, nos. 5 and 6 may be works from the active pottery at Castel Durante or they may have been made at Urbino or Pesaro.

1. **Caffagiolo**
 Bowl with floral border; in center, laureate bust of a youth, to left.
 c. 1500
 Maiolica, 15.2 (6)
 Widener Collection, C–41

No. 2 No. 3

2. **Siena**
 Plate with border of grotesques; in center,
 Narcissus admiring his reflection in a
 fountain, with a landscape beyond.
 c. 1510
 Maiolica, 25.7 (10 1/8)
 Widener Collection, C–40

3. **Faenza**
 Plate with border of grotesques and
 shields of arms; in center, putti holding
 another shield with arms of the Gritti of
 Venice.
 c. 1520
 Maiolica, 24.8 (9 3/4)
 Widener Collection, C–39

4. **Castel Durante**
 Plate with border of putti and trophies
 amid grotesques; in center, Cupid stand-
 ing, armed, in a landscape.
 c. 1520
 Maiolica, 22.9 (9)
 Widener Collection, C–38

5. **Duchy of Urbino**
 Dish with border of urns and cherubs'
 heads; in center, armorial device of bird
 on bale; inscribed VINCENZO AMA-DIO
 1529–SPQR.
 1529
 Maiolica, 24.1 (9 1/2)
 Widener Collection, C–69

6. **Duchy of Urbino**
 Dish with border of dolphins and delphi-
 griffs; in center, bust of a youth, to left.
 c. 1535
 Maiolica, 24.8 (9 3/4)
 Widener Collection, C–68

No. 6

7. **Faenza**
 Plaque with fruited wreath enclosing a shield of arms; inscribed *15/32*.
 1532
 Maiolica, 30.5 (12)
 Widener Collection, C–67

Maestro Giorgio of Gubbio

The Widener collection of maiolica is noteworthy for its inclusion of the several plates exhibited here which are dated to the 1520s and bear the signature of Giorgio Andreoli. Active for many years in Gubbio, Master Giorgio generally added a metallic lustre to his works. These include maiolica decorated with shields of arms and ornamented borders and also examples of *istoriata* ware, that is, plates entirely given over to the representation of a narrative scene. As is characteristic of historiated maiolica, such scenes often derive from contemporary prints, which in turn are sometimes based on major paintings. The plates showing Minerva with Cupid (no. 2) and the battle scene (no. 4) are based on engravings by Raphael's adherent, Marcantonio Raimondi. The Hercules and Antaeus (no. 1) is close in design to a print by that master, and the representation of the Muse of History, Clio (no. 3) is copied from a set of Ferrarese *tarocchi* (tarot engravings). The large ceremonial plates (nos. 5 and 6) belonged to a table service, other extant pieces of which are signed.

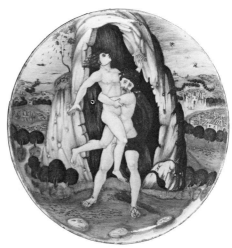

No. 1

1. **Giorgio Andreoli,** c. 1465/70-1553, known active at Gubbio from 1485
 Dish with scene of Hercules overcoming Antaeus before the mouth of a cave, with an extensive landscape beyond. Reverse: inscribed in lustre MAS° GIORGIO DA UGUBIO *1520*
 1520
 Maiolica, 24.8 (9 ¾)
 Widener Collection, C–55

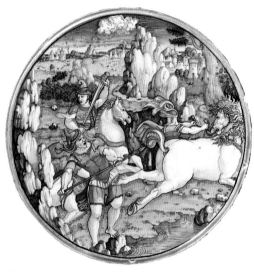

No. 4

2. **Giorgio Andreoli**
 Plate with landscape scene of the recon-
 ciliation of Minerva and Cupid. Reverse:
 inscribed in lustre *1525* M° G°.
 1525
 Maiolica, 26.0 (10 ¼)
 Widener Collection, C–58

3. **Gubbio**
 Dish with marine scene of Clio carried
 on the back of a swan; inscribed CLIO.
 c. 1525-1535
 Maiolica, 25.7 (10 ⅛)
 Widener Collection, C–65

4. **Giorgio Andreoli**
 Flat Plate with landscape scene of a battle
 between Romans and Carthaginians. Re-
 verse: inscribed in lustre *1525* M° G°.
 1525
 Maiolica, 30.3 (11 ⅞)
 Widener Collection, C–59

5. **Giorgio Andreoli**
 Large Plate with floral border; in center,
 shield of arms of the Vigeri of Savona.
 Reverse: inscribed in lustre *1524* M° G °.
 1524
 Maiolica, 36.2 (14 ¼)
 Widener Collection, C–56

6. **Giorgio Andreoli**
 Large Plate with border of floral gro-
 tesques; in center, shield of arms of the
 Vigeri of Savona. Reverse: inscribed in lus-
 tre *1524* M° G°.
 1524
 Maiolica, 36.8 (14 ½)
 Widener Collection, C–57

7. **Giorgio Andreoli**
 Plate with floral border; in center, shield impaling arms of Burgundy with those of Fregoso of Genoa; inscribed ·A·/·F·. Reverse: inscribed in lustre *1526* M G.
 1526
 Maiolica, 30.5 (12)
 Widener Collection, C–60

8. **Salimbene Andreoli,** brother of Giorgio Andreoli, known active 1485 at Gubbio, died 1523
 c. 1520-1523
 Dish with floral border; in center, shield of arms of the Saracinelli of Orvieto.
 Maiolica, 23.5 (9 ¹/₄)
 Widener Collection, C–54

Maiolica Painted in Urbino

The city of Urbino was especially celebrated as a center of maiolica production for its *istoriata* ware. The pictorial plates made in Urbino during the period 1520-1540 are distinguished for their elaborate narrative compositions and their brilliant and skillfully applied colors.

Among the greatest practitioners of the art was Nicolò da Urbino, the author of an impressive historiated service bearing Este-Gonzaga arms. Nicolò's elegant and masterful draftsmanship, his incredibly rich range of glowing colors, and his subtle, atmospheric treatment of the landscape are evident in the *Adoration* plaque. The Venus and Cupid scene, which shares these characteristics, is either by him or by a close follower.

1. **Nicolò da Urbino,** Durantine, known active c. 1520-c. 1540 in Urbino
 Plaque with scene of the Adoration of the Magi, in an extensive landscape.
 c. 1525
 Maiolica, 22.2 x 16.5 (8 ³/₄ x 6 ¹/₂)
 Widener Collection, C–66

2. **Nicolò da Urbino or a Follower**
 Plate with the Triumph of Venus and Cupid, in a radiant cloudscape.
 c. 1535; lustred at Gubbio
 Maiolica, 25.4 (10)
 Widener Collection, C–61

Another notable maiolica master, Avelli relied generally on prints by Marcantonio Raimondi for the figural types which occur in his mythological depictions. This holds true for the Ovidian scene represented on the dish with arms of the Pucci family and of the Hero and Leander plate exhibited in the adjacent case. The image of Laocoön and his sons is probably based on a print illustrating the famous ancient statue.

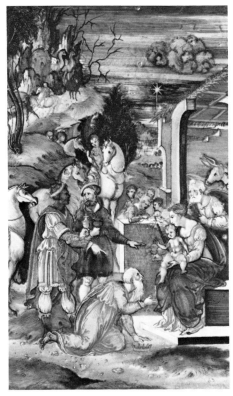

No. 1

3. **Francesco Xanto Avelli da Rovigo,**
 known active at Urbino 1530-1542
 Dish with landscape scene of Neptune
 ravishing Theophane in the presence of
 Cupid, a shepherd, and sheep; in center,
 shield of arms of Piero-Maria Pucci of
 Florence. Reverse: inscriptions giving
 date, iconography, and signature, FRA:
 XANTO A. DA ROVIGO.
 1532
 Maiolica, 25.8 (10 ¹/₈)
 Widener Collection, C–70

4. **Francesco Xanto Avelli or a Follower**
 Dish with landscape scene of the death
 of Laocoön and his sons. Reverse: inscrip-
 tion giving date and iconography.
 1539; lustred at Gubbio
 Maiolica, 26.4 (10 ³/₈)
 Widener Collection, C–63

The remaining examples of Urbino *istoriata* ware include
pieces associated with the Durantino potters. The atelier of
Maestro Guido Durantino (who had moved to Urbino from
Castel Durante) is represented by no. 5—with its impres-
sively spacious landscape—which is part of a large service
executed for Anne de Montmorency, the indefatigable sold-
ier and diplomat who served Francis I, Henry II, and Cathe-
rine de' Médicis. Nos. 6, 7, and 9 illustrate Ovidian stories,
including the rarely depicted scene of Erigone courted by
Bacchus transformed into a cluster of grapes.

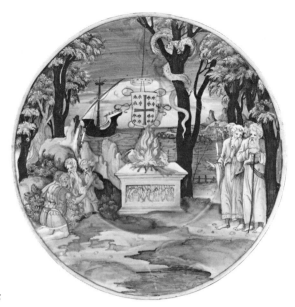

No. 5

5. **Workshop of Guido Durantino,**
 active from c. 1520 in Urbino
 Plate with landscape and marine scene of
 the Sacrifice of the Greeks and the Augury
 of Calchas; in upper center, shield of arms
 of Anne de Montmorency, later Constable
 of France. Reverse: inscription giving icon-
 ography and attribution, IN BOTEGA D Mº
 GUIDO DURANTINO IN URBINO.
 c. 1535
 Maiolica, 29.8 (11 ³/₄)
 Widener Collection, C–71

6. **Francesco Durantino (?),** active from
 c. 1540 in Urbino
 Small Dish with Leda and the Swan in a
 wooded landscape; Jupiter repeated
 above; at left, Eros and Anteros(?). Re-
 verse: inscription giving iconography.
 c. 1540
 Maiolica, 20.3 (8)
 Widener Collection, C–72

7. **Francesco Durantino (?)**
 Plate with landscape and marine scene
 of Bacchus enthroned with Erigone, sur-
 rounded by Cupid and nymphs; on top
 rim, a shield of arms. Reverse: inscription
 giving iconography.
 c. 1540
 Maiolica, 26.7 (10 ¹/₂)
 Widener Collection, C–73

8. **Urbino**
 Plate with scene of Hercules, Omphale,
 and Cupid in an extensive landscape.
 c. 1540
 Maiolica, 25.4 (10)
 Widener Collection, C–75

9. **Urbino**
Plate with landscape scene of Jupiter, Juno and Io transformed into a cow. Reverse: monogram inscription, M (or w?).
c. 1535-1540; lustred at Gubbio
Maiolica, 28.5 (11 ¼)
Widener Collection, C–64

Table Bells

The sixteenth-century taste for ornamented bronze utensils included table bells. Extant examples are often decorated with a vocabulary of classical designs similar to that used for the desk ornaments encountered in the previous room and also with heraldic identification of the owner. No. 2 is of special interest as a signed piece. It bears a medal-like portrait of Lodovico Sforza and may have been commissioned by the Duke of Milan from the artist, probably during the last decade of the fifteenth century. Small bells such as these were objects of daily use, to summon servants or call meetings to order. Hand bells were also employed in conducting the Mass. The bronze alloy used for bells often had a higher than usual proportion of tin to copper in order to produce a clearer ring.

1. **Francesco Xanto Avelli**
Plate with scene of Hero leaping from her tower to join the drowned Leander; in center, a shield of arms. Reverse: inscriptions giving date and iconography.
1538; lustred at Gubbio
Maiolica, 26.7 (10 ½)
Widener Collection, C–62

No. 2

2. **Giovanni I Alberghetti,** Ferrarese-Venetian, known active 1505-1515
Table Bell with Portrait of Lodovico Maria Sforza, 1451-1508, called Il Moro, 7th Duke of Milan 1494-1508.
c. 1494-1499 (?)
Bronze, 15.2 x 9.9 (6 x 3 ²⁹/₃₂)
Kress Collection, A–263.107C

3. **Italian,** first half XVI century
Table Bell
Bronze, 14.9 x 10.5 (5 ⁷/₈ x 4 ¹/₈)
Kress Collection, A–264.108C

4. **Italian, probably Venetian,**
XVI century
Table Bell with Shields of Moro Arms
Bronze, 13.3 x 11.0 (5 ¼ x 4 ⁵/₁₆)
Kress Collection, A–268.112C

5. **Italian, possibly Venetian,**
XVI century
Table Bell
Bronze, 13.1 x 10.2 (5 $^5/_{32}$ x 4)
Kress Collection, A–265.109C

6. **Italian,** XVI century
Table Bell with Shield of Grimaldi Arms
Bronze, 12.8 x 10.5 (5 $^1/_{32}$ x 4 $^5/_{32}$)
Kress Collection, A–266.110C

Ceremonial Dishes from Deruta

This group of large plates bearing decorative borders and bold central images is characteristic of the lustred maiolica produced in Deruta during the first third of the sixteenth century. The dish bearing an inscribed image of Faustina (no. 2) is a particularly beautiful example of the blue glaze and gold lustre technique. An additional piece is displayed with the mortars, in the adjacent vitrine. No. 3 bears Medici arms combined with the papal insignia and must therefore have been commissioned by Leo X (1513-1521) or, as is more likely, by Clement VII (1523-1534).

1. **Deruta**
Large Dish with floral border; in center, scene of horsemen fighting.
first third XVI century
Maiolica, 40.6 (16)
Widener Collection, C–43

2. **Deruta**
Large Dish with a border of floral motifs and cornucopiae; in center, bust of a woman, to left: F/AUSTI/NA PULIT/A E B/ELLA.
first third XVI century
Maiolica, 40.6 (16)
Widener Collection, C–47

3. **Deruta**
Large Dish with floral border; in center, Papal shield of Medici arms.
1513-1534
Maiolica, 40.6 (16)
Widener Collection, C–44

4. **Deruta**
Large Dish with scale border; in center, crowned monogram and bust of Nero, to left.
first third XVI century
Maiolica, 42.5 (16 $^3/_4$)
Widener Collection, C–45

No. 4, below

Bronze Mortars

During the Renaissance, the bronze mortar was a household object of fundamental use. Along with bells and cannons, mortars constituted the staple production of the bronze foundries, and they were generally sandcast. Superior examples such as these were often embellished with classical motifs and inscribed or emblazoned with the owner's arms. Separate molds for such additional elements appear to have been applied to a mold standard for the object's shape, and together the joined molds were used to produce a negative impression in the sand.

1. **Deruta**
 Large Dish with scale border; in center, Madonna and Child; inscribed AVE / SANTI/SSIMA M/ARIA MATE/R DEI REG/INA CELI.
 first third XVI century
 Maiolica, 45.1 (17 ¾)
 Widener Collection, C–50

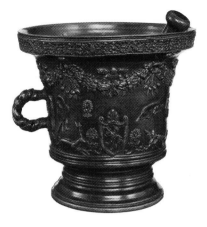

No. 3

2. **Italian,** early XVI century
 *Mortar Ornamented with Putti
 and Griffins*
 Bronze, 13.3 x 17.7 (5 ¹/₄ x 6 ³¹/₃₂)
 Kress Collection, A–252.96C

3. **Italian,** early XVI century
 Mortar with Rope-shaped Handle; Pestle
 Bronze, 15.3 x 17.0 (6 x 6 ¹¹/₁₆)
 Kress Collection, A–253.97C

4. **Italian, probably Venetian,**
 XVI century
 Mortar with Two Dolphin-shaped Handle.
 Bronze, 15.0 x 18.6 (5 ⁷/₈ x 7 ⁹/₃₂)
 Kress Collection, A–250.94C

5. **Italian, probably Venetian,**
 XVI century
 Mortar with Shields of Badoer Arms
 Bronze, 13.4 x 16.8 (5 ⁹/₃₂ x 6 ⁵/₈)
 Kress Collection, A–256.100C

6. **Italian,** mid-XVI century
 *Mortar Ornamented with Tritons and
 Goats' Heads*
 Bronze, 8.1 x 11.6 (3 ³/₁₆ x 4 ⁹/₁₆)
 Kress Collection, A–250.94C

The High Renaissance in Milan and Venice (GN 9)

The splendid era of Venetian High Renaissance painting, dominated by Titian, Tintoretto, and Veronese, was also a remarkably creative period of sculptural activity in the Most Serene Republic. An extraordinary number of major pictorial, sculptural, and architectural projects were initiated during the sixteenth century in Venice, and these in large part determine the face of the radiant city as it is today.

With its strong local tradition of bronze casting, Venice produced in this period monumental statues and reliefs in bronze, beautifully fashioned and many-figured bronze church furnishings, and statuettes, plaquettes, and medals of the highest quality. In addition, Venetian sculptors developed a genre of grandly scaled household objects in bronze—such as andirons, candlesticks, and doorknockers—appropriate for the adornment of the spacious palaces and villas designed by Palladio and his contemporaries.

The primary artistic force in Venetian sixteenth-century sculpture was the Florentine Jacopo Sansovino (1486-1570). Trained by Andrea Sansovino (c. 1467-1529), the compatriot sculptor from whom he took his name, Jacopo worked during the first quarter of the century in Florence and Rome, drawing the notice of Michelangelo and Raphael and obtaining significant commissions. In 1527, the year of the disastrous Sack of Rome by the troops of the Emperor Charles V, Jacopo departed for Venice, where by 1529 he was appointed chief of the building projects of Saint Mark's and where he spent the rest of his long and active career. As an architect, Sansovino introduced to Venice the grandiose, classically inspired building style of High Renaissance Rome in such signal structures as the Mint and the Library importantly situated along the Piazza San Marco at the mouth of the Grand Canal.

Sansovino's sculpture was also destined for civic sites of the greatest prominence. His powerfully muscled, colossal statues of Mars and Neptune stand at the staircase leading to the Doge's Palace. Four exquisite bronze figures of Athena, Apollo, Mercury, and Peace embellish the *loggetta* at the base of the bell tower facing the Palace in the Piazza San Marco, and the Basilica itself boasts dramatic narrative reliefs in bronze, which decorate the choir tribune and the sacristy door, as well as four seated bronze figures of the Evangelists which ornament the balustrade of the high altar.

Not only was Sansovino immensely productive as a sculptor in Venice, but in addition he had several exceptionally gifted followers. These include Danese Cattaneo, who was also a poet, and the prolific masters Alessandro Vittoria, Girolamo Campagna, and Tiziano Aspetti. All of these great artists combined their production of monumental sculpture in bronze or marble with activity in the genre of the small bronze.

Among the post-Michelangelo generation of sculptors in Italy, two of the most outstanding exponents active in Milan

were Leone Leoni and Annibale Fontana. Of Tuscan origins, Leoni was established as a medallist in Padua in 1537 and shortly thereafter worked in Rome for the papal mint. From 1542 to 1545 and from 1550 to 1589 he served as master of the imperial mint in Milan. In the service of Charles V, he traveled to Augsburg and Brussels, and for him and his son, Philip II of Spain, Leoni produced an impressive number of full-figure and bust-length portraits of the emperor and other members of the Hapsburg family. (One of Leoni's portrait busts of Charles V in armor is on view in the West Sculpture Hall upstairs.) Leoni's work for the court of Spain includes an outstanding group (1582) of twenty-seven bronze statues executed by him and his son Pompeo for the high altar of the Escorial. Leoni also executed several monumental commemorative figures for churches in Milan. The church of Santa Maria presso San Celso in Milan was the major focus of Fontana's sculptural activity; both its façade and interior are embellished with the master's reliefs and figures carved in marble, which look forward to the baroque style. Also celebrated as a bronze caster, Fontana made four large candlesticks for the Certosa of Pavia.

Leoni, Fontana, and the Venetians Cattaneo and Vittoria are here represented by medallic works. These masters, and many of the other medallists whose pieces are exhibited (in the transparent case toward the south center of the room), are exceptional for their time in continuing to cast medals from wax models rather than adopting the less sensitive technique of striking medals from dies.

Medals from the Veneto and Lombardy

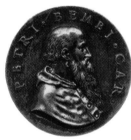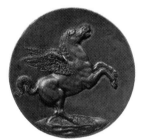

No. 1, obverse No. 1, reverse

1. **Italian**
 Pietro Bembo, 1470-1547, Cardinal 1538, Venetian philogist, poet, and belletrist. Reverse: the spring of Hippocrene starting from Mount Helicon under the hoofs of Pegasus.
 1537-1547
 Bronze, 5.5 (2 $^5/_{32}$)
 Kress Collection, A–1159.422A

 Another distinguished medal of Bembo, whom we saw portrayed in the previous gallery, this piece has at times been associated with Cellini, who is known to have prepared a medal of the sitter. Either a north Italian or a central Italian origin is possible for the work.

2. **Giovanni Maria Mosca,** Paduan,
c. 1495?-1574
Sigismund Augustus, 1520-1572, Grand
Duke of Lithuania 1544, King of Poland
1548. Reverse: lion walking to left.
1532
Bronze, 6.6 (2 $^{19}/_{32}$)
Kress Collection, A–1149.412A

Active from 1515 as a portrait sculptor and
medallist in Padua and Venice, Mosca moved
in 1530 to Poland.

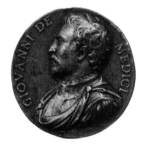

No. 3, obverse *No. 3, reverse*

3. **After Danese Cattaneo,**
Carrarese-Venetian, c. 1509-1573
Giovanni de' Medici delle Bande Nere,
1498-1526. Reverse: thunderbolt issuing
from a cloud.
Bronze, 5.7 (2 $^{1}/_{4}$)
Kress Collection, A–1155.418A

4. **Danese Cattaneo**
Elisabetta Querini, daughter of Francesco
Querini of Venice, wife of Lorenzo Mas-
solo, widowed 1556. Reverse: the Three
Graces.
Bronze, 4.1 (1 $^{19}/_{32}$)
Kress Collection, A–1156.419A

Cattaneo is known to have made a medal of
Giovanni delle Bande Nere immediately after
the Medici leader's death. Replicas were made
in 1546; in the same year, Pietro Aretino men-
tioned the medal in a letter to Giovanni's son
Cosimo I, who later became the first Grand
Duke of Tuscany.

5. **Alessandro Vittoria,** Venetian,
1525-1608
Tommaso Rangone, 1493-1577, physician
of Ravenna. Reverse: female figure at left
placing a wreath on the horns of an ox;
above, God the Father in the clouds.
1558(?)
Bronze, 5.4 (2 $^{1}/_{8}$)

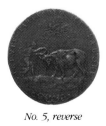

No. 5, reverse Kress Collection, A–1238.500A

6. **Matteo Pagano,** called **della Fede,**
Venetian, known active 1543-1562
Tommaso Rangone, 1493-1577, physician
of Ravenna. Reverse: Juno, nude, recum-
bent within the Milky Way; eagle brings
infant Hercules to her; below, lilies grow-
ing and three birds.
Bronze, 3.9 (1 $^{17}/_{32}$)
Kress Collection, A-1240.502A

7. **Alessandro Vittoria**
Caterina Sandella of Venice, wife 1548
of Pietro Aretino (see no. 19). Without
reverse.
Bronze, 5.6 (2 $^{7}/_{32}$)
Kress Collection, A-1158.421A

8. **Alessandro Vittoria(?)**
Don Nicola Vicentino, c. 1511-1572, priest
and musicologist. Reverse: organ and
cymbalum.
1555(?)
Bronze, 5.0 (1 $^{31}/_{32}$)
Kress Collection, A-1247.508A

9. **Alessandro Vittoria**
Gaspare Borgia, Bishop of Segorbe 1530,
died 1556. Without reverse.
1551-1552(?)
Bronze, 5.2 (2 $^{1}/_{16}$)
Kress Collection, A-1157.420A

Portrait sculpture in Venice during the second
half of the century was dominated by the mag-
nificently imposing and yet immediate and
lifelike busts created by this dynamic master.
Vittoria's busts share with his medals an acute
observation of character and attention to
subtle surface modeling. The two portraits of
Rangone (nos. 5 and 6), a famous patron of
Tintoretto and Sansovino, are of special note,
as is Vittoria's representation of Pietro Areti-
no's wife (no. 7). While Vittoria's sitters are
usually shown in contemporary dress, Cater-
ina Sandella is distinguished by wearing
Antique garb. The sitter is further removed
from the everyday world through Vittoria's
introduction of a socle at the termination of
the bust. These features suggest that the medal
commemorates Caterina's death.

10. **Andrea Spinelli,** Parmesan-Venetian,
1508-1572(?)
Eternity and Fame. Obverse: veiled figure
of Eternity standing to front, holding a
globe from which rises the Phoenix on its

pyre. Reverse: winged figure of Fame seated on a celestial globe, blowing two trumpets.
1541
Struck bronze, 3.6 (1 $^{13}/_{32}$)
Kress Collection, A–1256.517A

11. **Andrea Spinelli**
Andrea Gritti, 1455-1538, Doge of Venice 1523. Reverse: representation of Sansovino's first model for the church of San Francesco della Vigna in Venice.
1534 (Foundation medal)
Bronze, 3.6 (1 $^{13}/_{32}$)
Kress Collection, A–1150.413A

12. **Andrea Spinelli**
Antonio Mula, Venetian patrician, Duke of Candia 1536, member of the Council of Ten 1538. Reverse: Mula and another man in robes, joining hands.
1538
Struck bronze, 3.9 (1 $^{9}/_{16}$)
Widener Collection, A–1495

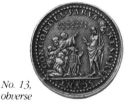 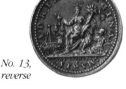

No. 13, obverse *No. 13, reverse*

13. **Andrea Spinelli**
Pietro Lando, c. 1462-1545, Doge of Venice 1539, with Venetian Senators, kneeling before Christ. Reverse: Venice, crowned, seated on lion, holding cornucopia and scales; on left, galley at sea; on right, arms.
1539
Struck bronze, 4.0 (1 $^{9}/_{16}$)
Kress Collection, A–1153.416A

14. **Andrea Spinelli**
Girolamo Zane, Venetian Senator. Reverse: the penitent Saint Jerome, in a landscape.
1540
Gilt struck bronze, 4.0 (1 $^{9}/_{16}$)
Kress Collection, A–1152.415A

Born in Parma, Spinelli worked mainly in Venice, serving the Venetian mint as engraver from 1535 until 1572. Struck from engraved dies, Spinelli's medals well illustrate the extent of graphic detail to be achieved through this process. Although on a minute scale, they beautifully exemplify the pomp and pageantry of sixteenth-century Venice.

15. **Italian,** XVI century
Marcantonio Trevisan, c. 1475-1554, Doge of Venice 1553. Reverse: in wreath, inscription recording death of the Doge in 1554.
Bronze, 6.3 (2 $^{15}/_{32}$)
Kress Collection, A–1242.504A

16. **Italian**
Girolamo Priuli, c. 1486-1567, Doge of Venice 1559. Reverse: Alvise Diedo, scholar and poet, Primicerius of Saint Mark's 1563.
1566
Bronze, 9.6 (3 $^{25}/_{32}$)
Kress Collection, A–1236.498A

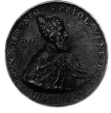

No. 16, obverse

17. **Leone Leoni,** Milanese, 1509-1590
Andrea Doria, 1468-1560, Genoese admiral. Reverse: view of a galley at sea; standard with double-headed eagle on poop; small boat with two oarsmen coming away; fisherman angling from rock in the foreground.
1541
Bronze, 4.2 (1 $^{21}/_{32}$)
Kress Collection, A–1168.431A

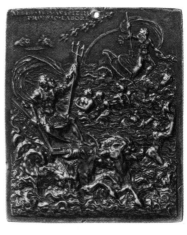

No. 18

18. **Leone Leoni**
Andrea Doria Guided by Neptune. Uniface plaquette.
c. 1541
Bronze, 8.7 x 7.5 (3 $^{7}/_{16}$ x 2 $^{15}/_{16}$)
Kress Collection, A–670.392B

Leoni's triumphant commemoration of the great Genoese admiral, both in the medal and in the small relief seen here, originated from a singularly dramatic occasion. In 1540, during his early employ at the papal mint, Leoni had been condemned to the galleys for conspiring against the papal jeweler. Doria obtained the artist's release in 1541, and Leoni continued his career, as already noted, in Milan.

19. **Leone Leoni(?)**
 Pietro Aretino, 1492-1557, satirist. Reverse:
 nude female figure of Truth, seated,
 crowned by Victory; her right foot rests on
 a crouching satyr before her; she points to
 him and looks up at Jupiter(?) in the
 clouds at left.
 Bronze, 6.0 (2 3/$_8$)
 Kress Collection, A–1164.427A

Leoni is known in 1537, also early in his career,
to have prepared medals of Bembo, Aretino,
and Titian. It has been thought by some that
this medal of the famous satirist is Leoni's
work. The obverse recalls Titian's great portrait
of the sitter now in the Frick Collection; the
reverse is inscribed with the recusant Aretino's
opinion that Truth engenders Hate.

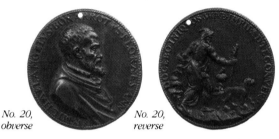

No. 20, No. 20,
obverse reverse

20. **Leone Leoni**
 Michelangelo Buonarroti, 1475-1564. Flor-
 entine artist. Reverse: blind man with a
 staff and a water flask, led by a dog.
 c. 1561
 Bronze, 5.9 (2 5/$_{16}$)
 Kress Collection, A–1166.429A

Among Leoni's most beautiful medals is that
honoring Michelangelo. This work reveals
great mastery in the modeling of the aged
master's features and in the handling of the
atmospheric landscape of the reverse, with its
poignant image of the blind wanderer led by a
dog.

21. **Leone Leoni(?)**
 Girolamo Cardano, 1501-1576, physician
 and philosopher of Pavia. Reverse: vision
 of several people advancing toward a
 vine; below, the word ONEIPON (dream).
 1550
 Bronze, 5.0 (1 31/$_{32}$)
 Kress Collection, A–1227.489A

22. **Leone Leoni**
 Maarten de Hane, 1475-1556, Flemish
 merchant active in Venice. Reverse: Hope,
 with hands raised in prayer, looking to
 heaven.
 Bronze, 6.9 (2 25/$_{32}$)
 Widener Collection, A–1481

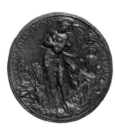

23. **Pompeo Leoni,** Milanese, c. 1533-1608
Ercole II d'Este, 1508-1559, 4th Duke of
Ferrara 1534. Reverse: Patience standing,
hands crossed on breast, chained by left
foot to a rock on which is a vase
surmounted by a celestial globe; liquid
flows from spout of vase; landscape back-
ground.
Lead, 6.9 (2 $^{23}/_{32}$)
Kress Collection, A-1183.446A

Leone Leoni's son Pompeo was also a sculptor
of note and, traveling to Spain, continued his
father's affiliation with the Spanish monarchy.
The intricate allegory of Patience on the
reverse of Pompeo's medal of Ercole II d'Este
is based on an elaborate conceit originally
devised by Giorgio Vasari in response to a
request to Michelangelo for such an image by
Benedetto Varchi, the poet and historian.

24. **North Italian,** XVI century
Rearing Horse
Bronze, 20.2 x 23.0 (7 $^{29}/_{32}$ x 9 $^{1}/_{32}$)
Widener Collection, A–116

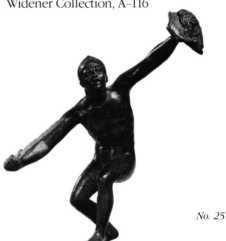

No. 25

25. **North Italian, possibly Leone Leoni**
A Warrior
Bronze, 17.3 (6 $^{13}/_{16}$) h.
Widener Collection, A–131

This intensely commanding figure of a nude
warrior poised to spring into combat is known
in various casts. The lively statuette is similar
to the small figures of warriors which decorate
one of Leoni's bronze busts of Charles V
(Vienna).

26. **Milanese,** mid-XVI century
Gianfrancesco Martinioni, Milanese phy-
sician. Reverse: bust of Hippocrates(?) to
left, with long beard, wearing tall round
hat with Greek inscription on the band.
Bronze, 4.8 (1 $^{7}/_{8}$)
Kress Collection, A-1162.425A

27. **Italian,** XVI century
Calidonia Visconti, wife of Lucio Cav-
anago. Reverse: eagle standing on arms,
looking up at sun above clouds.
Bronze, 4.1 (1 $^{19}/_{32}$)
Kress Collection, A–1248.509A

28. **Italian,** XVI century
Carlo Visconti, 1523-1565, Cardinal 1565.
Reverse: stalk of branching coral.
Bronze, 6.9 (2 $^{23}/_{32}$)
Kress Collection, A–1249.510A

29. **Milanese,** mid-XVI century
Pietro Piantanida of Milan. Reverse:
Faith, holding chalice in left hand, point-
ing with right to heaven.
Bronze, 5.0 (1 $^{31}/_{32}$)
Kress Collection, A–1160.423A

30. **Milanese,** mid-XVI century
Jean de Lorraine, 1498-1550, Cardinal
1518. Reverse: Prudence, holding mirror
in left hand, compasses in right, advanc-
ing to right, a dragon at her feet.
Bronze, 5.1 (2)
Kress Collection, A–1161.424A

No. 31, reverse

31. **Annibale Fontana,** Milanese, 1540-1587
Fernando Francesco II d'Avalos, 1530-
1571, Marquess of Pescara. Reverse: Fer-
nando, nude, as Hercules, his foot on the
dragon, plucking the Apples of the Hesper-
ides; landscape and cities in background.
Bronze, 7.2 (2 $^{27}/_{32}$)
Kress Collection, A–1179.442A

32. **Annibale Fontana**
Giovanni Paolo Lomazzo, 1538-1600,
Milanese painter and writer on art. Re-
verse: Lomazzo presented by Mercury to
Fortune.
c. 1560
Bronze, 5.0 (1 $^{31}/_{32}$)
Kress Collection, A–1180.443A

33. **Annibale Fontana(?)**

Giambattista Castaldi, Count of Piadena, General of Charles V, died 1562. Reverse: Castaldi in armor, receiving sceptre from a woman, behind whom is a Turk; a bearded man approaches on the right.
Bronze, 4.6 (1 $^{13}/_{16}$)
Kress Collection, A–1181.444A

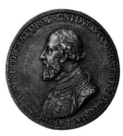

No. 34, obverse *No. 34, reverse*

34. **Annibale Fontana(?)**

Gonsalvo de Córdoba, 1443-1515, called the Great Captain. Reverse: battle under the walls of a city; one horseman carries Gonsalvo's banner; flag of France flying from the keep.
Bronze, 5.8 (2 $^9/_{32}$)
Kress Collection, A–1182.445A

The medals of Fernando Francesco II d'Avalos and Giovanni Paolo Lomazzo (nos. 31 and 32) are distinguished for the elegance of their execution and for their allegorical content. They are mentioned as works by Fontana in the writings of Lomazzo, who was one of the most significant art theorists of the later sixteenth century. Nos. 33 and 34 are the work of an artist signing his medals ANNIB or ANNIBAL; he may be identical with Fontana. That of Gonsalvo (no. 34) honors a historic personage in whom interest was revived with the publication of a biography in 1550 by Paolo Giovio.

35. **Italian,** first half XVI century

Allegorical Plaquette. Obverse: grotesque monster. Reverse: standing Janus holding key and sceptre, surrounded by celestial bodies, a globe, and a burning sphere.
Bronze, 8.5 x 5.8 (3 $^{11}/_{32}$ x 2 $^9/_{32}$)
Kress Collection, A–613.335B

36. **Italian**

Piero Valeriano Bolzanio, 1475-1558, scholar of Belluno. Reverse: Mercury (Hermes), holding caduceus and resting left hand on broken obelisk inscribed with hieroglyphs.
c. 1545-1550
Bronze, 6.1 (2 $^{13}/_{32}$)
Kress Collection, A–1246.507bisA

No. 36, reverse

The reverse, showing Mercury interpreting hieroglyphs from a broken obelisk, alludes to the sitter's major opus *Hieroglyphica,* published in 1556 in Basel. The sixteenth-century taste for arcane imagery is evident as well in the curious double-faced plaquette (no. 35).

37. **Italian**
 Laura Gonzaga Trivulzio, born 1525/ 1530. Reverse: river god Mincio reclining to left, with hand on urn from which water flows; on left, a tree; in background, town on hill.
 c. 1550
 Bronze, 4.7 (1 $^{27}/_{32}$)
 Kress Collection, A–1244.506A

38. **Italian,** third quarter XVI century
 Unknown Lady. Without reverse.
 Bronze, 6.2 (2 $^{7}/_{16}$)
 Kress Collection, A–1253.514A

39. **Johann Jakob Kornmann,** called **Cormano,** Augsburger, died 1649
 Francesco Morosini, 1618-1694, Venetian admiral, Doge of Venice 1688. Without reverse.
 1640s
 Bronze, 5.2 (2 $^{1}/_{16}$)
 Kress Collection, A–1219.481A

40. **Cormano**
 Francesco Maria Brancacci, Cardinal 1634, died 1675. Without reverse.
 1636
 Bronze, 8.3 (3 $^{1}/_{4}$)
 Kress Collection, A–1220.482A

The seventeenth century is here represented in two medals by a German artist who worked during the 1630s and 1640s in Venice and Rome. As do those of the Leoni and several of the artists encountered in the next rooms Cormano's career illustrates the increasing cross-migration of artists between European artistic centers during the sixteenth and seventeenth centuries.

Venetian, XVII century
Andiron with Figure of Jupiter
Bronze, 79.2 x 37.6 (31 $^{1}/_{8}$ x 14 $^{3}/_{4}$)
Widener Collection, A–137A

Venetian, XVII century
Andiron with Figure of Juno
Bronze, 79.6 x 37.6 (31 $^{1}/_{4}$ x 14 $^{3}/_{4}$)
Widener Collection, A–137B

The andirons terminating in graceful figures of Jupiter and Juno are known in several versions and are representative examples of the type produced in Venice for private palaces during the later sixteenth and early seventeenth centuries. The decorative garlands are similar to those found on the doorknocker at the center of the south wall.

Venetian, third quarter XVI century
Altar Candlestick with Shield of Arms of the Garzoni of Venice
Bronze, 57.2 x 24.1 x 20.5
(22 ¹/₂ x 9 ¹/₂ x 8)
Kress Collection, A–223.64C

Venetian, third quarter XVI century
Altar Candlestick with Shield of Arms of the Garzoni of Venice
Bronze, 57.2 x 24.1 x 20.5
(22 ¹/₂ x 9 ¹/₂ x 8)
Kress Collection, A–224.65C

The pair of candlesticks richly exemplifies the current decorative vocabulary of putti, scrolls, masks, and hybrid beasts.

Jacopo Sansovino,
Florentine-Venetian, 1486-1570
Doorknocker with Nereid, Triton, and Putti
c. 1550
Bronze, 35.6 x 28.8 x 8.5
(14 x 11 ³/₈ x 3 ³/₈)
Pepita Milmore Fund, A–1820
Illustration, p. 231

The splendid doorknocker is an unusually large example of the genre, and the characteristic outline is here brilliantly defined by an imaginative and rhythmic interlacing of powerfully conceived figures. The swags and putti recall the sculptural frieze on Sansovino's Library in Venice, and the postures of the putti, with sharply bent heads and legs astraddle, are particularly close to those seen in the putti frieze on Sansovino's bronze door in San Marco. An early drawing of our doorknocker illustrates the now lost hinge, shaped like a grotesque mask, from which it would have been suspended. The object's actual use as a doorknocker is attested by the dulled patina of the up-curving acanthus at the base.

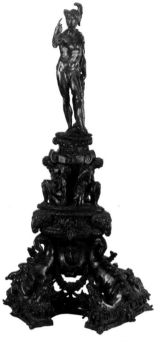

Circle of Girolamo Campagna,
with Figure of Venus

Circle of Tiziano Aspetti, Andiron
with Figure of Mars

Circle of Tiziano Aspetti,
Paduan-Venetian, 1565-1607
Andiron with Figure of Mars
Bronze, 107.6 x 55.8 x 41.2
(42 ³/₈ x 22 x 16 ¹/₄)
Kress Collection, A–1645A

Circle of Girolamo Campagna,
Veronese-Venetian, 1549/50-1625?
Andiron with Figure of Venus
Bronze, 103.4 x 56.3 x 40.2
(40 ³/₄ x 22 ¹/₈ x 15 ⁷/₈)
Kress Collection, A–1645B

Undoubtedly created by one master as a pair, these magnificent andirons are again larger than usual examples of their type (measuring well over a yard), and they are superb examples of the technique of casting and finishing bronze. Their authorship is as yet unclear. They were formerly attributed to Jacopo Sansovino on the basis of analogies between the smoothly defined figures and his *loggetta* statues. However, the figure of Mars strongly recalls specific works by Aspetti, while the Venus and the exquisitely finished triads of atalantids below have been associated with Campagna. The doubly horse-headed, fire-breathing, polymastic monsters at the bases, versions of which are found in bronze decorative pieces by the Venetan sculptors Segala, Roccatagliata, and de Levis, are inventions of extraordinary originality.

The taste established in Padua at the turn of the sixteenth century for small bronze figures of classical subjects continued in the Veneto, as we see from the works displayed in the small, free-standing case. Such statuettes of gods and goddesses, children, and cupids are comparable in style to those found on elaborate bronze furnishings, such as the door-knocker, candlesticks, and andirons nearby.

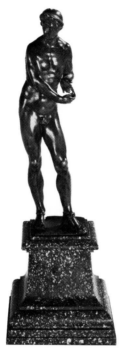

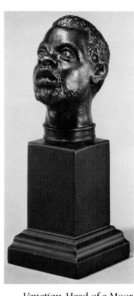

Venetian, Head of a Moor

Venetian, Mercury

Venetian, second half XVI century
Mercury
Bronze, 20.4 x 29.4 (8 ¹/₃₂ x 11 ¹/₂)
Widener Collection, A–111

This small bronze, which probably represents Mercury as the god of elocution, captures the figural style of the monumental nudes produced during the period to enhance the urban fabric of Venice. While the anatomical proportions recall Sansovino's figures, the torsion of the pose suggests Aspetti's influence.

North Italian, first half XVI century
Bust of a Man
Bronze, 20.2 (7 ¹⁵/₁₆) h.
Widener Collection, A–130

The bust is closely based on Roman Republican portraits and may have been made in Mantua.

Venetian, second half XVI century
Head of a Moor
Cast iron, 5.7 x 3.7 x 4.6
(2 ¹/₄ x 1 ⁷/₁₆ x 1 ¹³/₁₆)
Kress Collection, A–207.46C

North Italian, late XVI
or early XVII century
Child Clasping a Bird
Bronze, 7.6 (3) h.
Kress Collection, A–202.40C

The expressive and carefully detailed head is finished with a collar and may have served as the handle to a walking stick or other implement. The child may similarly have been designed as a handle or finial.

Venetian, late XVI or early XVII century
Cupid on a Dolphin
Gilt bronze, 13.3 x 14.2 x 13.3
(5 ¼ x 5 ⅝ x 5 ¼)
Lent by the Musée du Louvre, OA–9569

The complex poses of this playful group anticipate the baroque and rococo styles.

Venetian, second half XVI century
Cupid on a Dolphin
Bronze, 8.1 (3 ³/₁₆) h.
Kress Collection, A–203.41C

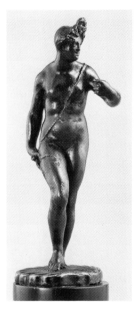

Venetian, Fortuna

Venetian, second half XVI century
Fortuna
Bronze, 13.4 (5 ¼)
Kress Collection, A–176.14C

Mounted on a shell of modern manufacture, the delicately poised wind-borne nude represents not Venus but Fortune (or Occasion). The figure may have been intended to decorate an inkstand.

Plaquettes relating to Jacopo Sansovino and His Contemporaries

1. **Style of Andrea Sansovino,**
 Tuscan, c. 1467-1529
 Madonna and Child with Saints
 Bronze, 11.9 x 7.8 (4 $^{19}/_{32}$ x 3 $^{1}/_{32}$)
 Widener Collection, A–1558

2. **Central or North Italian,** XVI century
 Madonna and Child with Saint John
 Bronze, 13.8 x 10.3 (5 $^{7}/_{16}$ x 4 $^{1}/_{16}$)
 Formerly Molthein Collection, 68
 (Anonymous Loan)

3. **Italian,** XVI century
 Hercules
 Bronze, 4.0 (1 $^{9}/_{16}$)
 Formerly Molthein Collection, 112
 (Anonymous Loan)

4. **Central Italian,** mid-XVI century
 Apollo and Marsyas
 Bronze, 13.8 x 13.7 (5 $^{7}/_{16}$ x 5 $^{7}/_{16}$)
 Formerly Molthein Collection, 102
 (Anonymous Loan)

5. **Central or North Italian,** mid-XVI
 century
 Feast of the Olympian Gods
 Bronze, 13.2 x 23.8 (5 $^{1}/_{4}$ x 9 $^{3}/_{8}$)
 Formerly Molthein Collection, 97
 (Anonymous Loan)

6. **Italian,** mid-XVI century
 Descent from the Cross
 Bronze, 12.8 x 7.7 (5 $^{1}/_{32}$ x 3 $^{1}/_{32}$)
 Widener Collection, A–1580

No. 7

7. **Style of Jacopo Sansovino,** 1486-1570
 The Madonna of the Rosary
 mid-XVI century
 Bronze, 14.8 x 9.9 (5 $^{13}/_{16}$ x 3 $^{29}/_{32}$)
 Widener Collection, A–1549

8. **Style of Jacopo Sansovino**
The Madonna of the Rosary
mid-XVI century
Bronze, 19.3 x 14.7 (7 $^{19}/_{32}$ x 5 $^{25}/_{32}$)
Widener Collection, A–1550

9. **Venetian,** mid-XVI century
Madonna and Child with Saint John
Bronze, 17.2 x 12.2 (6 $^{25}/_{32}$ x 4 $^{13}/_{16}$)
Widener Collection, A–1546

10. **Emilian**
The Adoration of the Shepherds
1561
Bronze, 19.5 x 14.6 (7 $^{11}/_{16}$ x 5 $^{3}/_{4}$)
Widener Collection, A–1542

11. **Lombard,** mid-XVI century
The Entombment
Bronze, 4.3 x 3.9 (1 $^{11}/_{16}$ x 1 $^{17}/_{32}$)
Kress Collection, A–520.242B

12. **Emilian,** mid-XVI century
The Lamentation
Bronze, 4.1 x 3.4 (1 $^{5}/_{8}$ x 1 $^{11}/_{32}$)
Kress Collection, A–690.412B

13. **Emilian**
The Lamentation
c. 1560
Bronze, 19.7 x 14.9 (7 $^{3}/_{4}$ x 5 $^{7}/_{8}$)
Widener Collection, A–1543

No. 12

The many large plaquettes displayed here reflect the relief style of major masters of the time. The graceful and elaborately draped female figural types of Sansovino are clearly echoed in nos. 7 and 8. The small *Entombment* (no. 11) derives from a painting of the same subject by the Lombard painter Gaudenzio Ferrari, and the principal figures in the oval *Lamentation* (no. 12) record a lost composition by the great Emilian early-sixteenth-century painter Correggio.

14. **Italian,** XVI century
A Turk
Bronze, 9.3 (3 $^{21}/_{32}$) h.
Kress Collection, A–1254.515A

15. **Veneto-Islamic,** mid-XVI century
Bowl
Bronze, 5.2 x 14.2 (2 $^{1}/_{16}$ x 5 $^{19}/_{32}$)
Kress Collection, A–249.93C

No. 14

The bronze bowl decorated with Islamic arabesques and inscribed with the name Hatim generally recalls the inlaid metalwork

made by Moslem craftsmen who settled in Venice during the sixteenth century. The bowl and the silhouetted portrait of a Turk, possibly a sultan or sultan's envoy, serve to remind us of the geographic position of Venice and her commercial supremacy as gateway to the east, a role which diminished steadily throughout the period of her most splendid artistic achievement.

Negroli, Helmet in the Form of a Grotesque Mask

Gian Paolo di Negroli,
Milanese, active mid-XVI century
Helmet in the Form of a Grotesque Mask
c. 1540
Iron, 33.0 x 35.6 (13 x 14)
Widener Collection, C–80

North Italian, second half XVI century
"The Morosini Helmet"
Iron, 27.9 x 35.6 (11 x 14)
Widener Collection, C–81

The art of the Renaissance armorer is represented in these two elaborate helmets from the Widener Collection. The first is the work of one of the leading sixteenth-century armorers in Milan, the long-established center of armor production in Italy. A stylistically similar breastplate signed by Negroli is preserved in the Metropolitan Museum in New York, and a cuirass at the Louvre is thought to have been part of the same suit of armor as the piece exhibited here. Made of iron, the Negroli helmet is decorated with floral and animal designs akin to the ornamental vocabulary of classicizing objects in bronze. The helmet embossed with raised gilt and silvered arabesques and ornamented with gold pseudo-damascening is both striking and unusual.

The Renaissance in Germany and The Netherlands (GN 9)

In Italy, as we have seen, the evolution of small bronze sculpture was closely allied with the development of monumental sculpture and was a genre employed by many of the most eminent sculptors of the period. The art of the Renaissance small bronze in the Germanic lands and in the low countries grew, rather, out of native medieval traditions for the production in brass or bronze of figures and objects for ecclesiastic use. Large-scale sculpture continued generally to be carved from stone or wood and to be produced by artists distinct from those who worked in bronze and other metals.

The influence of the Italian classicizing aesthetic began to be reflected in German bronzes, as well as in northern European painting, toward the turn of the sixteenth century. Important centers for the production of bronzes in the new style were the significantly situated south German trade cities of Augsburg and Nuremberg. Among the most prominent Renaissance bronze casters were members of the Vischer family of Nuremberg, headed by Peter Vischer the Elder, who in 1488 began work on a figurated architectural canopy in bronze, commissioned to cover the reliquary of Saint Sebald; the impressive complex was completed by the Vischer sons in 1519. The most talented of these was Peter the Younger, who appears to have traveled shortly after 1512 to Padua or to one of the other major bronze-working centers in northern Italy. His skillful treatment of classical subjects in the Italian style (here represented in the case on the north wall) constitutes a noteworthy contribution to the development of small bronze sculpture beyond the Alps. So, too, does the international taste of the imperial Hapsburg family, exemplified by the Emperor Maximilian I's establishment around 1514 of a local foundry to cast the elaborate, many-figured bronze decoration for his tomb chapel in Innsbruck.

Representative examples of German figural bronzes are displayed in the free-standing case near the entrance to this room. The genre of the independent bronze statuette did not, however, achieve in the north the popularity it enjoyed in Renaissance Italy. Antique prototypes were, of course, less available to artists and patrons, and the characteristic tenor of humanist studies was a more strictly literary one. On the other hand, a taste for elegantly worked plaquettes depicting classical themes prevailed in Germany and The Netherlands during the period (here represented by plaquettes in the wall cases), and these are often closely related in figural style and composition to contemporary mannerist painting in the north.

The commemorative medal was extremely popular in the Germanic countries, and the Kress examples illustrate well the distinctive aspect of the genre in its adaptation there. Noteworthy characteristics include the intricacy of workmanship, a meticulous attention to details of dress, a high proportion of silver and lead pieces, the repeated use of heraldic imagery for reverse designs, and the frequent varying of the profile convention with three-quarter or full-face portraits.

German and Flemish Medals

1. **Hans Schwarz,** born Augsburg 1492;
 known active 1515-1532
 Kunz von der Rosen, confidential coun-
 cilor of Maximilian I, died 1519. Without
 reverse.
 Bronze, 6.4 (2 $^{17}/_{32}$)
 Kress Collection, A–1323.584A

An influential medallist, Schwarz worked in
his native Augsburg and in a number of other
regions, including Nuremberg, the Palatinate,
Poland, Denmark, Paris, and the Netherlands.
His medals are cast from wooden models, a
practice sometimes also used in Germany for
bronze figures in the round.

2. **German or Austrian,** XVI century
 Maximilian I, 1459-1519, Emperor 1493,
 shown as Archduke of Austria. Reverse:
 Mary of Burgundy, his wife 1477, died
 1482.
 After 1500, though dated 1479
 Struck silver, 4.2 (1 $^{21}/_{32}$)
 Kress Collection, A–1356.616A

The first of the Hapsburg medals represented
here, that of Maximilian I and Mary of Bur-
gundy (both important patrons of the arts), is
based on a medal by Candida, whose oeuvre is
represented with the French Renaissance
sculpture in the third gallery beyond.

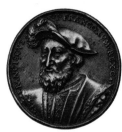 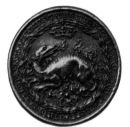

No. 3, obverse *No. 3, reverse*

3. **Ludwig Neufahrer,** active c. 1530-1562
 at Nuremberg, Vienna, and Prague,
 died 1563
 Francis I, 1494-1547, King of France 1515.
 Reverse: in a wreath, salamander in
 flames; below it, L N; above, crown.
 Silver, 4.3 (1 $^{11}/_{16}$)
 Kress Collection, A–1275.536A

4. **German or Austrian**
 Ferdinand I, 1503-1564, Archduke of Aus-
 tria 1519, Emperor 1556. Reverse: Anna of
 Hungary, his wife 1521.
 1524
 Bronze, 6.0 (2 $^{3}/_{8}$)
 Kress Collection, A–1359.619A

5. **German or Austrian**
 Ferdinand I, 1503-1564, Archduke of Austria 1519, Emperor 1556. Reverse: eagle displayed, charged with shield of arms.
 1541
 Silver, 5.3 (2 $^3/_{32}$)
 Kress Collection, A–1361.621A

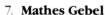

6. **Mathes Gebel,** Nuremberger,
 c. 1500-1574
 Charles V, 1500-1558, King of Spain 1516, Emperor 1519-1556. Reverse: in wreath, FVNDATORI QUIETIS MDXXX.
 1530
 Base silver, 3.7 (1 $^{15}/_{32}$)
 Kress Collection, A–1339.599A

No. 6, obverse

7. **Mathes Gebel**
 Christoph Kress von Kressenstein. Reverse: blazon of arms.
 1526
 Lead, 3.9 (1 $^{17}/_{32}$)
 Kress Collection, A–1447.707A

8. **Mathes Gebel**
 Johann Friedrich, 1503-1554, Elector of Saxony 1532. Reverse: inscription and blazon of arms.
 c. 1532
 Base silver, 4.6 (1 $^{13}/_{16}$)
 Kress Collection, A–1435.695A

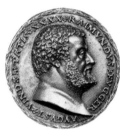 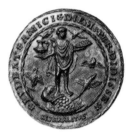

No. 9, obverse *No. 9, reverse*

9. **Mathes Gebel**
 Raimond Fugger, 1489-1535, German scholar and patron of the arts. Reverse: allegory of Liberality.
 Base silver, 4.2 (1 $^{21}/_{32}$)
 Kress Collection, A–1437.697A

10. **Mathes Gebel**
 Lorenz Truchses von Pommersfelden, 1473-1543. Reverse: inscription and tablet.
 Lead, 4.1 (1 $^{19}/_{32}$)
 Kress Collection, A–1438.698A

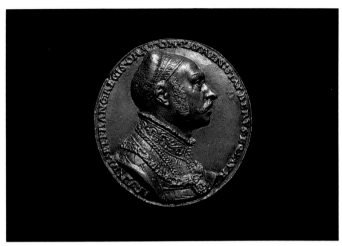

11. **Mathes Gebel**
 Lorenz Staiber, 1485/86-1539, German
 writer and orator. Reverse: Frau Staiber.
 1535
 Lead, 3.8 (1 ½)
 Kress Collection, A–1439.699A

12. **Mathes Gebel**
 Philipp, Count Palatine, 1503-1548. Re-
 verse: shield with two casques and crests.
 1528
 Bronze, 4.2 (1 ²¹/₃₂)
 Kress Collection, A–1337.597A

13. **Mathes Gebel**
 Frederick, 1460-1532, Archduke of Bran-
 denburg-Ansbach 1528. Reverse: inscrip-
 tion and blazon of arms.
 1528
 Lead, 3.8 (1 ½)
 Kress Collection, A–1455.715A

Gebel, who became a citizen of Nuremberg in
1523, is the finest exponent of Nuremberg
medallic art. His precise and refined style is
related to the strong local tradition of gold-
smith work.

14. **Hans Reinhart the Elder,** Saxon,
 known active 1535-1574, died 1581
 The Fall of Man. Reverse: the Crucifixion.
 Gilt bronze, 6.6 (2 ¹⁹/₃₂)
 Kress Collection, A–722.444B

15. **Hans Reinhart**
 Johann Friedrich, 1503-1554, Elector of
 Saxony 1532. Reverse: shield with three
 helms and crests.
 1535
 Silver, 6.5 (2 ⁹/₁₆)
 Kress Collection, A–1345.605A

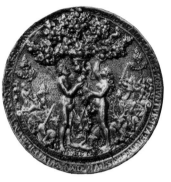
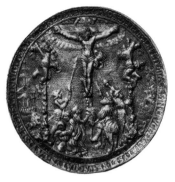

No. 14, obverse *No. 14, reverse*

16. **Hans Reinhart**

Charles V, 1500-1558, King of Spain 1516, Emperor 1519-1556. Reverse: double-headed eagle, crowned, charged with shield and collar of the Fleece; at sides, two pillars of Hercules and PLVS OVLTRE.
1537
Silver, 6.4 (2 $^{17}/_{32}$)
Kress Collection, A–1346.606A

Reinhart was the leading Saxon medallist of the middle of the sixteenth century. His distinguished patrons included Cardinal Albrecht of Brandenburg and the Elector Johann Friedrich of Saxony (no. 15). The circular gilt plaquette (no. 14) illustrates Reinhart's detailed workmanship; with the Temptation are represented scenes of the creation of Eve and the expulsion from Eden. The inscription tells us that the double-sided plaquette was made for Johann Friedrich. Reinhart's medallic portraits of the elector and of the Emperor Charles V (no. 16) are unusually forceful in the strongly defined heads, below-waist truncations, and inclusion of hands holding attributes of power.

17. **Friedrich Hagenauer,** Strasbourger, known active 1525-c. 1543

Philipp Melancthon, 1497-1560, reformer. Reverse: inscription from Psalm xxxvi.
1543
Bronze, 4.7 (1 $^{27}/_{32}$)
Kress Collection, A–1334.594A

18. **Friedrich Hagenauer**

Giovanni Alessandro Balbiani of Chiavenna, Captain in the army of Georg van Frundsberg 1529. Without reverse.
1529
Bronze, 5.8 (2 $^{9}/_{32}$)
Kress Collection, A–1330.590A

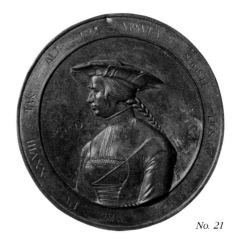

No. 21

19. **Friedrich Hagenauer**
 Margaret von Firmian, 1509-1536, wife of
 Caspar von Frundsberg (1500-1536). With-
 out reverse.
 1529
 Lead, 6.1 (2 $^{13}/_{32}$)
 Kress Collection, A–1445.705A

20. **Friedrich Hagenauer**
 Sebastian Liegsalz of Munich.
 Without reverse.
 1527
 Lead, 12.6 (4 $^{31}/_{32}$)
 Kress Collection, A–1328.589A

21. **Friedrich Hagenauer**
 Ursula Liegsalz of Munich.
 Without reverse.
 1527
 Lead, 12.6 (4 $^{31}/_{32}$)
 Kress Collection, A–1329.589A

22. **Friedrich Hagenauer**
 Caspar Winntzrer, 1475 (or 1465)-1542.
 Reverse: inscription.
 1526
 Lead, 6.8 (2 $^{11}/_{16}$)
 Kress Collection, A–1450.710A

23. **Friedrich Hagenauer**
 Augustin Lösch, 1471-1535, Chancellor of
 the Duchy of Bavaria. Without reverse.
 1526
 Lead, 6.7 (2 $^{5}/_{8}$)
 Kress Collection, A–1457.717A

24. **Friedrich Hagenauer**
 Unknown man. Without reverse.
 Bronze, 5.2 (2 $^{1}/_{16}$)
 Kress Collection, A–1331.591A

25. **Friedrich Hagenauer**
 Johannes Mulicum, Infirmater in the Cistercian monastery of Kamp near Neuss.
 Reverse: inscription.
 Bronze, 4.7 (1 $^{27}/_{32}$)
 Kress Collection, A–1332.592A

An outstanding medallic portraitist, Hagenauer worked in Munich, Augsburg, Strasbourg, Baden, Cologne, and the Netherlands. The large portraits of Sebastian and Ursula Liegsalz (nos. 20 and 21) are separate castings in lead taken from wooden models still preserved in Munich. The two reliefs were originally intended for the obverse and reverse of a single medal.

26. **Bernardo Rantvic,** Flemish,
 active in Italy, died c. 1596
 Sir Richard Shelley, c. 1513-c. 1589, Prior of the English Nation of the Knights of Malta. Reverse: griffin, ducally gorged, in a landscape.
 Bronze, 7.0 (2 $^3/_4$)
 Kress Collection, A–1380.640A

A Flemish painter, goldsmith, and medallist, Rantvic is known to have worked as a painter in Siena. The present medal is based on another made probably in Venice in 1577 of the same sitter.

27. **Concz Welcz,** Bohemian,
 known active 1532-1551
 Luna. Reverse: Diana to right, holding horn and staff; across field, c w.
 Struck silver, 1.9 ($^3/_4$)
 Kress Collection, A–1362.622A

Welcz was a medallist and goldsmith at Joachimstal in Bohemia.

28. **German or Austrian**
 John Huss Centenary. Reverse: Huss at the stake; across field, CONDEMNATUR.
 1515
 Struck silver, 4.3 (1 $^{11}/_{16}$)
 Kress Collection, A–1357.617A

29. **Georg Holdermann,** Nuremberger,
 1585-1629
 Willibald Pirckheimer and Albrecht Dürer, the latter at an easel drawing the former. Without reverse.
 Silver, 4.4 x 5.3 (1 $^3/_4$ x 2 $^3/_{32}$)
 Kress Collection, A–1363.623A

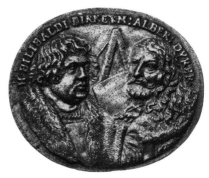

No. 29

This oval, uniface medal is of special interest as a double portrait representing Nuremberg's greatest artist, Dürer (1471-1528), sketching his patron and lifelong best friend, the humanist scholar and Nuremberg patrician Willibald Pirckheimer (1470-1530).

30. **Flemish**
 Hadrian VI (Adrian Dedal, 1459-1523), Pope 1522. Without reverse.
 1522/23
 Bronze, 8.6 (3 ³/₈)
 Kress Collection, A–1369.629A

Possibly the work of a seal engraver, this large and boldly modeled medal is Flemish and portrays the last non-Italian pope before our time.

31. **Jacob Zagar,** Flemish, known active
 1554-1584
 Frédéric Perrenot, Sieur de Champagney, Governor of Antwerp 1571. Reverse: stern view of a ship sailing through a strait between high rocks; over it, a putto hovers, bearing scales; above, device of Perrenot, NI CA NI LA.
 1574
 Bronze, 6.2 (2 ⁷/₁₆)
 Kress Collection, A–1370.630A

Zagar was an amateur medallist; a lawyer by profession, he held high office in Middelburg. His subject, Perrenot, was instrumental in the defense of Antwerp against the Spanish.

32. **Christoph Weiditz,** German,
 known active 1523-1536
 Ambrosius Jung, 1471-1548, city-physician of Augsburg. Reverse: shield of arms.
 1528
 Bronze, 7.0 (2 ³/₄)
 Kress Collection, A–1326.587A

33. **Christoph Weiditz**
 Francisco Covo (Deloscopos), Chancellor of Charles V in Spain, in Augsburg 1530, in

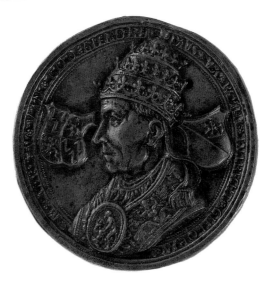

No. 30

Brussels 1531. Reverse: man riding toward a cliff, carrying scroll inscribed FATA VIAM INVENIENT.
1531
Lead, 6.0 (2 ³⁄₈)
Kress Collection, A–1327.588A

Weiditz worked in Strasbourg, Ulm, Augsburg, Spain, and the Netherlands as a medallist, wood carver, and gold- and silversmith.

34. **Hans Bolsterer,** Nuremberger,
 known active 1540-1567
 Johann Fichard, 1512-1581, Syndic of Frankfurt am Main. Reverse: Elizabeth, his wife.
 1547
 Bronze, 4.7 (1 ²⁷⁄₃₂)
 Kress Collection, A–1347.607A

35. **Hans Kels the Younger,** Augsburger,
 c. 1510-c. 1565
 Barbara Reihingin, wife of Georg Hermann. Reverse: shield of arms.
 1538
 Lead, 5.2 (2 ¹⁄₁₆)
 Kress Collection, A–1461.721A

36. **Valentin Maler,** Nuremberger,
 known active 1563-1593
 Jakob Muffel, 1509-1569, of Nuremberg. Without reverse.
 1569
 Lead, 5.5 (2 ⁵⁄₃₂)
 Kress Collection, A–1351.611A

37. **Valentin Maler**

Jakob Fugger the Elder, 1459-1523. Without reverse.
Lead, 4.7 x 4.2 (1 $^{27}/_{32}$ x 1 $^{21}/_{32}$)
Kress Collection, A–1353.613A

Active in Nuremberg for three decades, Maler was an extremely popular medallist.

38. **Joachim Deschler,**

Nuremberger, c. 1500-1571/72
Hieronymus Paumgartner, 1497-1565, of Nuremberg. Reverse: shield of Paumgartner arms.
1553
Bronze, 6.5 (2 $^9/_{16}$)
Kress Collection, A–1348.608A

Made a citizen of Nuremberg in 1537, Deschler served the courts of Austria, Saxony, and the Palatinate.

39. **Johann Philipp von der Pütt,**

Nuremberger, known active
from 1586, died 1619
Julius Geuder, 1531-1594, of Nuremberg. Without reverse.
Silver, 4.4 (1 $^3/_4$)
Kress Collection, A–1355.615A

Von der Pütt came from Dordrecht to Nuremberg in 1586 and worked there as a goldsmith, wax modeler, and medallist.

South German, first half XVI century
Female Nude (Lucretia?)
Bronze, 23.0 x 11.3 x 10.2
(9 $^1/_{32}$ x 4 $^7/_{16}$ x 4)
Kress Collection, A–184.22C

The lovely female nude, whose extraordinary hair-dressing bears traces of gilding, most likely represents either Venus or, if the handle she grasps in her right hand was intended for a dagger, the Roman heroine Lucretia. This finely finished bronze is probably the work of an Augsburg or Nuremberg master. Along with the other pieces in the same case, it illustrates the northern adaptation—partly through the influence of Peter Vischer the Younger—of the Paduan sixteenth-century conventions for statuettes and decorative objects representing children, animals, and characters from ancient literature.

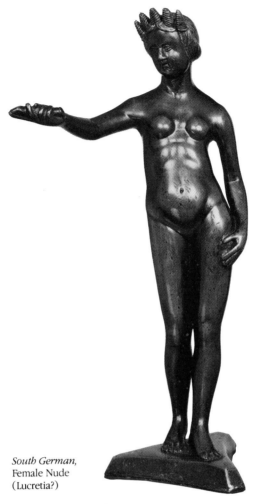

South German,
Female Nude
(Lucretia?)

German, c. 1600
Dancing Faun
Bronze, 23.1 x 25.2 (9 $^1/_{16}$ x 9 $^7/_8$)
Widener Collection, A-114

The beautiful *Dancing Faun* is distinguished for the skillful execution of its lively pose and its high degree of finish.

The Master of the Apollo Fountain(?)
known active 1532 in Nuremberg
Child on a Dolphin
Bronze, 14.5 x 9 x 9.5
(5 $^3/_4$ x 3 $^1/_2$ x 3 $^3/_4$)
Kress Collection, A-195.33C

The figure relates narrowly to the bronze fountain dated 1532 for the Rathaushof in Nuremberg. The authorship of the fountain is obscure.

Flemish, XVI century
Handle in the Form of
Three Winged Children
Bronze, 6.4 (2 $^1/_2$) h.
Kress Collection, A-194.32C

This figural group was probably designed as a bell or dagger handle.

German, probably Nuremberg,
first half XVI century
Seated Boy Holding a Bird
Bronze, 6.4 (2 $^{17}/_{32}$) h.
Kress Collection, A–193.31C

Although the theme was a popular one in Germany, the present bronze is a unique cast. Based in part on a celebrated *Boy Holding a Dog* from the Vischer workshop, this piece was probably made in Nuremberg.

South German, first half XVI century
Child with a Puppy
Bronze, 10.8 (4 $^{1}/_{4}$) h.
Kress Collection, A–196.34C

Also a unique composition, the statuette is based on a classical motif of a boy stealing a puppy from its mother; the figure of a bitch may once have accompanied it. The base is not original to the work.

Caspar Gras, Crow

German, late XVI century
Bear
Bronze, 6.6 x 2.4 x 2.6 (2 $^{9}/_{16}$ x $^{15}/_{16}$ x 1)
Kress Collection, A–234.75C

This engaging beast is terminated with a circular molding at the base and probably served as a bell or seal handle.

German, possibly Nuremberg,
second quarter XVI century
Hound Scratching its Left Ear
Bronze, 5.9 x 9.2 x 8.7
(2 $^{9}/_{32}$ x 3 $^{5}/_{8}$ x 3 $^{7}/_{16}$)
Kress Collection, A–231.72C

This is an exceptionally fine cast of a theme known in several German bronzes.

Caspar Gras, Württemberger, 1590-1674
Crow
Bronze, 11.2 x 4.7 x 7.6
(4 $^{11}/_{32}$ x 1 $^{25}/_{32}$ x 2 $^{31}/_{32}$)
Kress Collection, A–238.79C

The *Crow* is a masterpiece of the late-sixteenth- and seventeenth-century taste for naturalistic small bronzes inspired by the great Flemish-Italian master Giambologna. It is remarkable for its extreme delicacy and sensitivity to realistic detail. Gras worked as a sculptor in bronze for the Archdukes Maximilian III, Leopold V, and Ferdinand Karl of the Tyrol. For the latter, Gras is known to have cast a series of similar bronze birds.

Plaquettes by Vischer and Flötner

1. **Peter Vischer the Younger,**
 Nuremberger, 1487-1528
 Orpheus and Eurydice
 c. 1515
 Bronze, 19.5 x 15.0 (8 x 5 $^{21}/_{32}$)
 Kress Collection, A–709.431B

The most beautiful example in this section of the depiction of an Antique theme, and indeed one of the most superb reliefs in the collection, is Peter Vischer the Younger's *Orpheus and Eurydice*. Identified as the work of this master by his mark (two fish on an arrow) at the upper right, the relief reveals the influence of drawings by Dürer of Adam and Eve and shows also the influence of Vischer's first-

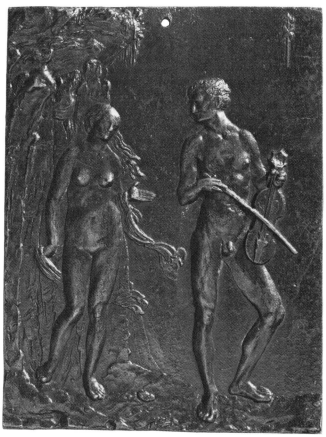

No. 1

hand knowledge of north Italian bronzes. The subtly modeled and carefully posed nudes, their tender expressions, and the shadowy and barren landscape of Hades are marvelously evocative of the tragic nature of Orpheus' backward glance, which determined that his beloved Eurydice would remain forever in Hades. The work is a unique cast; there exists a smaller version in bronze (known in three casts) and two drawings of the subject by Vischer.

2. **Peter Flötner,**
 Nuremberger, c. 1485-1546
 Thalia
 Bronze, 7.4 x 5.0 (2 $^{29}/_{32}$ x 2)
 Kress Collection, A–711.433B

3. **Peter Flötner**
 Fortitude
 Bronze, 7.8 x 5.5 (3 $^1/_{16}$ x 2 $^5/_{32}$)
 Kress Collection, A–710.432B

A goldsmith and wood carver as well, Flötner was the most prolific and influential plaquette artist of Nuremberg. The *Thalia* is one of a series of nine plaquettes representing the Muses; the *Fortitude,* one of a series of the seven Virtues.

4. **Style of Peter Flötner**
 Minerva
 Bronze, 4.6 x 2.9 (1 $^{13}/_{16}$ x 1 $^1/_8$)
 Kress Collection, A–727.449B

5. **Style of Peter Flötner**
 Mars
 Bronze, 4.6 x 2.9 (1 $^{13}/_{16}$ x 1 $^1/_8$)
 Kress Collection, A–726.448B

Other examples of this pair of plaquettes were used to decorate the doors of a small cabinet (formerly in Berlin).

6. **German,** mid-XVI century
 Fortuna
 Gilt bronze, 9.9 x 5.6 (3 $^{29}/_{32}$ x 2 $^3/_{16}$)
 Kress Collection, A–729.451B

7. **German,** mid-XVI century
 Venus and Cupid
 Bronze, 12.8 x 6.9 (5 $^1/_{32}$ x 2 $^{23}/_{32}$)
 Kress Collection, A–718.440B

The figure of Venus is generally reminiscent in type of the nude female statuette on an inkwell (Berlin) made in 1547 by Georg Vischer of Nuremberg.

Franco-Flemish, c. 1430
Pietà
Marble, 29.9 x 36.2 (11 ³/₄ x 14 ¹/₄)
Gift of Mrs. Ralph Harman Booth 1942

German and Netherlandish Plaquettes

1. **German,** second half XV century
 Madonna and Child
 Gilt bronze, 8.5 x 7.6 (3 ⁵/₁₆ x 3)
 Kress Collection, A–723.445B

2. **Flemish,** c. 1500
 Saint Matthew
 Bronze, 5.8 (2 ⁹/₃₂)
 Kress Collection, A–701.423B

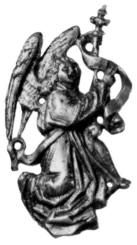

No. 3

3. **Flemish,** late XV or early XVI century
 The Angel Gabriel
 Gilt bronze, 6.0 x 3.6 (2 ¹¹/₃₂ x 1 ¹³/₃₂)
 Kress Collection, A–704.426B

These devotional objects are stylistically related to fifteenth-century northern European painting. The subject of no. 2 suggests that it was one of a series of four evangelists and may have been intended to adorn the base of a cross. The delicately beautiful Gabriel would have accompanied an image of the Annunciate Virgin, possibly decorating a tabernacle or other liturgical object.

4. **Master of the Judgment of Solomon(?),** South Netherlandish, active c. 1580
 Allegory of Charity
 Bronze, 9.0 x 6.2 (3 ¹/₂ x 2 ³/₈)
 Pepita Milmore Fund, A–1841

This plaquette, along with various others in the case, is an excellent example of the plaquettes produced in the low countries

during the late sixteenth century. Their complex compositions, elegantly proportioned figures, and agitated drapery recall Flemish mannerist painting.

5. **German,** last quarter XVI century
Christ Crowned with Thorns
Gilt bronze, 14.3 x 10.3 (5 $^5/_8$ x 4 $^1/_{16}$)
Kress Collection, A–724.446B

6. **German, possibly Augsburg,**
early XVI century
Madonna and Child with Four Angels
Bronze, 13.7 x 10.3 (5 $^7/_{16}$ x 4 $^1/_{32}$)
Kress Collection, A–721.443B

7. **German, possibly Nuremberg,**
second quarter XVI century
Cupid Playing on a Lute
Gilt bronze, 5.4 (2 $^1/_8$)
Kress Collection, A–692.414B

8. **Master P.G.,** active c. 1550,
probably at Nuremberg
Christ and Nicodemus
Bronze, 5.3 (2 $^3/_{32}$)
Kress Collection, A–715.437B

9. **German,** late XVI century
Hagar and the Angel
Bronze, 5.1 (2)
Kress Collection, A–587.309B

10. **German Follower of
Antonio Abondio,** c. 1600
Dead Christ with Two Angels
Bronze, 6.1 x 5.9 (2 $^{13}/_{32}$ x 2 $^{11}/_{32}$)
Widener Collection, A–1526

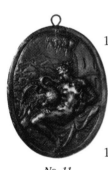

11. **Paul Hübner,** Augsburger,
known active 1582-1614
Leda and the Swan
early XVII century
Bronze, 6.2 x 4.8 (2 $^7/_{16}$ x 1 $^{29}/_{32}$)
Kress Collection, A–730.452B

No. 11

12. **Paul Hübner**
Venus and Cupid
early XVII century
Bronze, 10.3 x 7.7 (4 $^1/_{16}$ x 3 $^1/_{32}$)
Kress Collection, A–731.453B

A member of a celebrated Augsburg family of gold- and silversmiths, Hübner worked in the classicizing style typical of the turn of the seventeenth century.

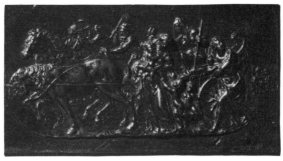

No. 15

13. **German,** c. 1600
 The Burial of Sarah
 Bronze, 7.3 x 8.6 (2 $^7/_8$ x 3 $^3/_8$)
 Widener Collection, A–1527

14. **German or Netherlandish,** c. 1600
 Lot and His Daughters
 Bronze, 4.2 x 5.3 (1 $^{21}/_{32}$ x 2 $^3/_{32}$)
 Kress Collection, A–681.403B

15. **German or South Netherlandish,** c. 1600
 Triumph of Humility
 Bronze, 6.6 x 12.6 (2 $^5/_8$ x 4 $^{31}/_{32}$)
 Widener Collection, A–1522

This work is one of a series of finely executed and carefully conceived representations of allegorical triumphs, subjects derived ultimately from Petrarch's *Trionfi.* The series includes six plaquettes; five of them are exhibited here (nos. 15-19). The *Triumph of Humility* is based on an engraving, by the Flemish artist Hieronymous Cock (c. 1510-1570), based in turn on designs by the Dutch artist Martin van Heemskerk (1498-1575).

16. **German or South Netherlandish,** c. 1600
 Triumph of the Church
 Bronze, 6.9 x 12.3 (2 $^{23}/_{32}$ x 4 $^{27}/_{32}$)
 Kress Collection, A–706.428B

17. **German or South Netherlandish,** c. 1600
 Triumph of Poverty
 Bronze, 6.6 x 12.6 (2 $^{19}/_{32}$ x 4 $^{31}/_{32}$)
 Widener Collection, A–1521

18. **German or South Netherlandish,** c. 1600
 Triumph of Wealth
 Bronze, 6.8 x 12.6 (2 $^{11}/_{16}$ x 4 $^{31}/_{32}$)
 Formerly Molthein Collection, 535
 (Anonymous Loan)

No. 21

No. 23

19. **German or South Netherlandish,** c. 1600
Triumph of Justice
Bronze, 6.5 x 12.3 (2 $^9/_{16}$ x 4 $^{27}/_{32}$)
Kress Collection, A–708.430B

20. **South German,** c. 1600
Open-work Appliqué
Bronze, 11.1 x 5.7 (4 $^3/_8$ x 2 $^1/_4$)
Widener Collection, A–1594

21. **German,** early XVII century
Spring and Summer
Bronze, 9.6 x 8.2 (3 $^{25}/_{32}$ x 3 $^7/_{32}$)
Kress Collection, A–686.408B

22. **German,** early XVII century
Autumn and Winter
Bronze, 9.6 x 8.6 (3 $^{25}/_{32}$ x 3 $^3/_8$)
Kress Collection, A–687.409B

23. **After François Duquesnoy,**
Franco-Flemish, 1594-1643
Infant Bacchanalians
Bronze, 10.1 x 6.3 (3 $^{31}/_{32}$ x 6 $^{13}/_{32}$)
Widener Collection, A–1518

This plaquette closely echoes the style of the great baroque sculptor Duquesnoy, who was

born in Brussels and worked in Italy, chiefly in Rome. In addition to his monumental contributions, Duquesnoy evolved a sculptural convention for lusciously well-padded babies which became enormously popular in the decorative arts.

24. **Franco-Flemish,** XVI century
 The Judgment of Paris
 Bronze, 5.4 (2 $^1/_8$)
 Widener Collection, A–1520

25. **Flemish,** second half XVI century
 Cincinnatus at the Plow
 Bronze, 3.3 x 6.3 (1 $^9/_{32}$ x 2 $^{15}/_{32}$)
 Kress Collection, A–589.311B

26. **South German,** second half XVI century
 Ecce Homo
 Gilt copper, 6.0 x 8.4 (2 $^3/_8$ x 3 $^5/_{16}$)
 Widener Collection, A–1516

27. **Netherlandish,** second half XVI century
 Amorous Couple
 Bronze, 7.7 x 5.5 (3 $^1/_{32}$ x 2 $^5/_{32}$)
 Formerly Molthein Collection, 526
 (Anonymous Loan)

28. **Flemish(?),** mid-XVII century
 The Judgment of Paris
 Bronze, 6.4 x 6.3 (2 $^{17}/_{32}$ x 2 $^{15}/_{32}$)
 Kress Collection, A–733.455B

29. **After Peter van Vianen,**
 Flemish, 1570-1628
 The Entombment
 Bronze, 17.0 x 14.5 (6 $^{11}/_{16}$ x 5 $^{23}/_{32}$)
 Widener Collection, A–1596

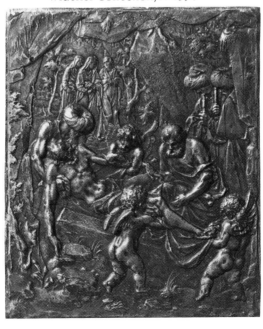

No. 29

No. 20, Friedrich Hagenauer, Sebastian Liegsalz *of Munich (see p. 150)*

Masterworks for Late Renaissance Courts (GN 10)

This small room is devoted chiefly to Widener Collection decorative arts dating from the second half of the sixteenth century. The period, which followed the astonishing political consolidation of far-flung regions of Europe under the Emperors Maximilian I and Charles V, is characterized by a remarkable internationality of decorative style. Beautifully wrought objects of like aspect were produced in various artistic centers in the lowlands, the Germanic countries, Italy, and Spain. Frequently master craftsmen, as we have already seen in the previous gallery, traveled from one grand court to another throughout Europe or received commissions through correspondence from patrons far away. Designs were transmitted through sketches, prints, and plaquettes, and costly gifts were exchanged among princes.

North Italian, probably Milanese
Pendant with the Head of Medusa
c. 1570
Chalcedony, enameled gold, gems, and
pearl, 11.3 x 6.6 (4 $^7/_{16}$ x 2 $^3/_8$)
Widener Collection, C–31

Netherlandish, last quarter XVI century
Pendant with a Sphinx
Enameled gold, gems, and pearls,
11.1 x 5.2 x 1.5 (4 $^3/_8$ x 2 $^1/_{32}$ x $^9/_{16}$)
Widener Collection, C–32

Netherlandish, probably Antwerp
Pendant with Europa and the Bull
c. 1580-1590
Baroque pearl, enameled gold,
gems, and smaller pearls,
13.6 x 6.8 x 2.7 (5 $^{11}/_{32}$ x 2 $^{11}/_{16}$ x 1 $^1/_{16}$)
Widener Collection, C–29

Italian or Spanish(?)
Pendant with a Centaur
c. 1571 (?)
Baroque pearl, enameled gold,
gems, and smaller pearls,
13.1 x 5.5 x 2.1 (5 $^5/_{32}$ x 2 $^5/_{32}$ x $^{13}/_{16}$)
Widener Collection, C–35

South German
Pendant with a Mermaid
c. 1580-1590
Baroque pearl, enameled gold,
gems, and smaller pearls,
13.2 x 7.6 x 1.1 (5 $^3/_{16}$ x 3 x $^7/_{16}$)
Widener Collection, C–33

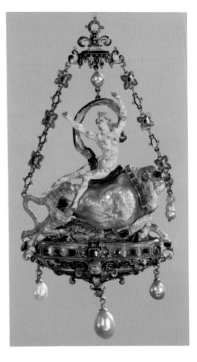

South German, Pendant with a Mermaid

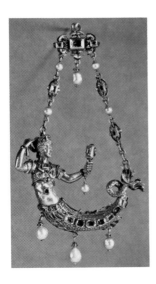

The international taste for large and elaborate jewels ornamented with mythological figures and encrusted with precious gems is demonstrated by the five examples displayed in the first case to the right. With the Europa, Centaur, and Mermaid pendants, we can observe that the goldsmith's starting point for his creation was often one of the curious and highly prized "baroque" pearls found in nature. The large and dramatically irregular pearl was then fashioned into a fanciful figure with the skillful addition of elements in enameled gold, and the composition completed with gold filigree, smaller pearls, and gems.

The most outstanding of these jewels is the pendant representing Europa and the Bull. The elegantly attenuated figure of the lively sea-bound Europa, turned sharply at the waist and reaching up and out, is executed with great bravura; the base on which the bull is mounted is hinged to serve as a box. The work is closely analogous to printed designs for jewels by the Antwerp masters Assuerus van Londerseel and Hans Collaert the Elder.

The beautifully engraved chalcedony Medusa is based on antique gems decorated with the often encountered motif of the Gorgon's head. It illustrates the current taste for such re-creations of Antiquity. The presence of vertical and horizontal drill holes through the stone suggests that the piece was originally mounted in a different manner.

Milanese, Vessel

Milanese, third quarter XVI century
Vessel engraved with hunting scenes.
Rock crystal and enameled gold,
15.1 x 12.7 x 8.0 (5 $^{15}/_{16}$ x 5 x 3 $^{1}/_{8}$)
Widener Collection, C–24

Milanese, third quarter XVI century
Cylindrical Vessel engraved with
floral ornaments and urns.
Rock crystal and enameled gold,
25.6 x 9.7 x 9.7 (10 $^{1}/_{16}$ x 3 $^{25}/_{32}$ x 3 $^{25}/_{32}$)
Widener Collection, C–25

Much admired in the late-sixteenth-century courts was the art of shaping natural rock crystals into ceremonial vessels and liturgical objects and embellishing these with goldwork, gems, and engraved decoration. The taste for such marvelous objects has been mentioned above in regard to the two great early exponents of crystal engraving active in Rome, Giovanni Bernardi and Valerio Belli.

The vessels displayed here exemplify the crystal engraver's craft in both ornamental and narrative designs. The unusually shaped vessel with hunting scenes may have been intended as a lamp. Both pieces relate closely to the work of Gasparo Miseroni, who was active in Milan c. 1550 to c. 1570 and belonged to the first generation of a famous Milanese family of crystal workers who later moved their workshop to Bohemia. Gasparo's patrons included Cosimo I de' Medici and the Emperor Maximilian II.

The Saracchi Workshop(?),
Altar Cross

The Saracchi Workshop(?), Milan
Altar Cross, the base engraved with
scene of Christ Carrying the Cross.
c. 1580-1590
Rock crystal, enameled gold and
gems, 44.9 x 15.2 (17 $^{11}/_{16}$ x 6)
Widener Collection, C–19

This elegant piece, once said to have belonged
to Pope Paul V Borghese, bears stylistic affini-
ties with works produced by the Saracchi fam-
ily of crystal engravers also active in Milan. The
scene at the foot of the cross is based on
Valerio Belli's relief of the same subject (an
example is exhibited earlier with Belli's
plaquettes), which could have been known in
Milan through bronze, lead, or plaster casts. Of
special interest are the sloping trees added to
Belli's composition by the Milanese artisan;
these, we find, mask fractures originally pres-
ent in the crystal. Also noteworthy are the
gem-encrusted gold mounts. While some are
modern replacements, notably the three
square mounts on the cross that mask the
holes from which a *corpus* would originally
have been supported, the mounting at the
lower end of the cross itself is an exceptionally
refined example of the goldsmith's art.

Milanese, XVI century
Vessel in the Form of a Dragon
Rock crystal, enameled gold,
and gems, 23.1 x 17.4 x 14.9
(9 $^3/_{32}$ x 6 $^{27}/_{32}$ x 5 $^{27}/_{32}$)
Widener Collection, C–23

Ferdinand Eusebio Miseroni,
Bohemian, known active 1661-1684
Covered Cup
1661-1684
Rock crystal, enameled gold,
and gems, 19.3 x 7.9 x 7.9
(7 $^{19}/_{32}$ x 3 $^1/_8$ x 3 $^1/_8$)
Widener Collection, C–27

The crystal vessel shaped like a winged dragon
represents a type found in several sixteenth-
century crystals. It illustrates the concurrent
courtly appetite for the bizarre and exotic. The
covered cup decorated with diamonds and a
ruby is by a seventeenth-century Miseroni
descendant, who worked at the court of
Prague.

**South German, probably Freiburg-
im-Breisgau,** second half XVI century
Covered Cup with serpent handle.
Rock crystal, with later enameled gold
mountings, 23.2 x 10.3 x 10.3
(9 $^1/_8$ x 4 $^1/_{16}$ x 4 $^1/_{16}$)
Widener Collection, C–22

South German, early XVII century
Reliquary Cross
Rock crystal, enameled gold, gems,
and pearls, 27.0 x 13.4 x 10.7
(10 $^5/_8$ x 5 $^9/_{32}$ x 4 $^7/_{32}$)
Widener Collection, C–20

Freiburg-im-Breisgau and Augsburg
Covered Cup with shield of arms
of Schönburg-Waldenburg.
1566
Rock crystal and enameled gold,
23.8 x 7.7 x 7.7 (9 $^3/_8$ x 3 x 3)
Widener Collection, C–21

The art of the rock crystal in Germany is
represented by these three pieces. The small
slender covered cup, which bears a lengthy
inscription dating the piece to 1566 and iden-
tifying it as belonging to the Schönburg-
Waldenburg family, is an exquisite and surpris-
ingly early example of the fluted crystals cut in
Freiburg during the later sixteenth and early

Freiburg - im - Breisgau and Augsburg, Covered Cup

seventeenth centuries. As in this work, Freiburg crystals were often furnished in Augsburg with their gold, enameled mounts. The enamel work, which includes a shield of arms on the inside of the lid, is remarkable for its delicacy and translucence. The larger cup shown here is also typical of Freiburg crystals in the faceted cut of the bowl and lid. The crudely executed enameled gold mountings may be modern restorations.

The reliquary cross appears to be a composite of south German elements of diverse origin. The enameled gold *répoussé* base, ornamented with an idyllic landscape including animals, plants, and a fountain, is very beautifully worked, yet its oval shape does not conform to the round base of the carved crystal cross; the present base may be a substitution for another support.

1. **Alfonso Ruspagiari,** Reggian, 1521-1576
 Camilla Ruggieri
 Bronze, 6.9 (2 ²³/₃₂)
 Kress Collection, A–1185.447bisA

2. **Alfonso Ruspagiari**
 Unknown Lady, observed from the right by a man.
 Lead, 6.9 (2 ²³/₃₂)
 Kress Collection, A–1188.450A

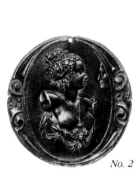

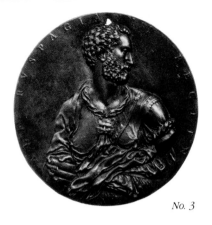

No. 2 No. 3

3. **Alfonso Ruspagiari**
 Self-Portrait
 Lead, 7.9 (3 ¹/₈)
 Kress Collection, A-1186.448A

4. **Emilian,** second half XVI century
 Unknown Lady
 Lead, 6.5 (2 ⁹/₁₆)
 Kress Collection, A-1199.461A

5. **Emilian,** second half XVI century
 Unknown Lady
 Lead, 5.5 (2 ⁵/₃₂)
 Kress Collection, A-1200.462A

6. **Andrea II Cambi,** called **Bombarda,**
 Cremonese, known active c. 1560-1575
 at Reggio Emilia
 Anna Maurella Oldofredi d'Iseo
 Lead, 6.0 (2 ³/₈)
 Kress Collection, A-1194.456A

7. **Bombarda**
 Unknown Lady, perhaps of the
 family of Gabriele Fiamma.
 Lead, 7.0 (2 ³/₄)
 Kress Collection, A-1198.460A

8. **Bombarda**
 Isabella Mariani, wife of
 Gianfrancesco Carcass[. . .].
 Lead, 7.1 (2 ²⁵/₃₂)
 Kress Collection, A-1193.455A

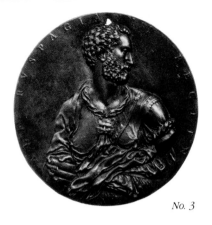

9. **Gian Antonio Signoretti,** active
 from 1540 at Reggio Emilia, died 1602
 Giulia Pratonieri of Reggio Emilia.
 Lead, 6.6 (2 ¹⁹/₃₂)
 Kress Collection, A-1191.453A

No. 9

10. **Gian Antonio Signoretti**
Gabriele Lippi of Reggio Emilia.
Lead, 7.2 (2 $^{27}/_{32}$)
Kress Collection, A–1190.452A

Among the Renaissance medals in the Kress Collection there is a distinct and extraordinary group of works which were produced during the later sixteenth century by artists active at Reggio in Emilia. The principal and most securely documented member of this Emilian school is Alfonso Ruspagiari, who was born in Reggio, where he spent his entire life and served as superintendent of the mint from 1571 until his death. Andrea Cambi II, a Cremonese goldsmith and medallist known as Bombarda, produced equally skillful medals in the same style between c. 1560 and 1575, and a third artist working in the same manner was Gian Antonio Signoretti, a die cutter and medallist active in Reggio for some sixty years.

The Emilian medals are characterized by a predominance of portraits of fashionable ladies, shown in elaborate, heavily jeweled, and sometimes fancifully classical costumes, and also by a peculiarly fluid and flickering technical treatment that strongly evokes the quality of the wax model. Another shared characteristic, to be observed here, is the frequently used convention of portraying the elegantly dressed and proportioned sitters, not as people, but rather as sculpture, with arms truncated and the artistically finished bust set up on a bracket. The self-consciously strange and deliberately confusing nature of this device is accentuated in such works as Ruspagiari's *Unknown Lady* (no. 2), where the female "bust" appears eerily to exchange glances with a briefly introduced male profile, or in the same master's *Self-Portrait* (no. 3), where a drawn, empty sleeve on the sitter's left side contrasts with the fully articulated right arm and right hand conspicuously holding a reed pipe and where also the sitter's sheer drapery voluptuously suggesting breasts is played off against the full curly beard of his langorous profile.

In comparison with other schools of Italian medals, the Emilian group is also unusual in that few examples bear reverses and the inscriptions are brief if they appear at all. It is tempting to speculate that these works constitute a playful parody on the serious nature of the commemorative medal and thereby epitomize in content as in style the special character of late mannerist art.

Circle of Guglielmo della Porta(?), Cup

Circle of Guglielmo della Porta (?),
Lombard-Roman, c. 1515?-1577
Cup with allegorical scenes
and shields of Este arms.
Bronze, 13.0 x 14.6 x 13.9
(5 ⅛ x 5 ¾ x 5 ½)
Widener Collection, A–126

The exquisite cup, emblazoned in front and back with the arms of the Este family, is one of the most beautiful decorated bronze utensils of the period. The rich and carefully worked abstract ornamentation organized in concentric bands, the handles which take the form of sphinxlike beings, and the delicate figural reliefs strongly recall the elaborate table furnishings and the narrative plaquettes made in papal Rome during the second half of the sixteenth century by the goldsmiths and bronze masters associated with the great inventive sculptor Guglielmo della Porta. It is highly probable that the bronze cup was commissioned from Rome by either Ercole II, Duke of Ferrara (1508-1559), toward the end of his life, or by his successor, Alfonso II (1533-1597).

Each quarter of the bowl of the cup is adorned with a figural design framed by ornamental garlands of fruit and leaves. The four images are neither mythological narratives nor standard allegories. Rather, they are original and enigmatic compositions of allegorical figures and motifs within landscape settings; they most likely constitute political allegories specifically germane to the Este rulers.

Florentine Medici Ware, Ewer

Detail of Ewer

Florentine Medici Ware
Ewer
1575-1587
Porcelain, 13.3 x 13.0 (5 ¼ x 5 ⅛)
Widener Collection, C–79

The small pitcher here exhibited is one of the most noteworthy early porcelains in America and is also, like many of the works displayed in this room, representative of the fascination with the exotic that permeated the taste of the late Renaissance courts. One of the most interesting and pivotal artistic patrons of the time was the Grand Duke of Tuscany, Francesco I de' Medici. Famed also for his interests in science, alchemy, and the bizarre, Francesco I sought to emulate the prized oriental porcelain occasionally imported into Europe. In 1574 he established two ceramic workshops in Florence for this purpose and soon after realized success with the development of the formula for the soft-paste porcelain known as Medici Ware. Only fifty some pieces of Medici Ware have come down to us. They are characteristically decorated with blue floral arabesques on a white background in imitation of Chinese blue-and-white porcelain (specimens of which are recorded in Medici inventories from the sixteenth century), and they are often marked with an image of Brunelleschi's dome on the Cathedral of Florence accompanied by Francesco's initial F. The present work is so marked on the bottom. It is distinguished among examples of Medici Ware for the high magnesium content of the blue glaze and its resulting brilliance.

Douglas Lewis

Late Renaissance, Baroque and Rococo Sculpture (GN 11 and GN 12)

These two galleries present a selection of small sculptures and decorative arts from the transitional style of the late Renaissance (the second half of the sixteenth century) to that of the early rococo (the beginning of the eighteenth century). The first gallery concentrates on Italy and Spain, while the second presents French art primarily of the seventeenth century.

The Holy Roman Empire and the Grand Duchy of Tuscany (GN 11)

With Alessandro de' Medici's creation as Duke of Florence in 1532, and that of his successor Cosimo I as Grand Duke in 1569, the Tuscan state embarked upon a long period as a significant Mediterranean power. Its increasingly sophisticated court became closely allied with those of Spain and the Holy Roman Empire; such connections are suggested here by medals in the following case, positioned near the center of the room.

Medals of Italy, Spain, and the Empire

1. **Pastorino de' Pastorini,** Sienese, 1508-1592
Lucrezia de' Medici, 1545-1561, daughter of Cosimo I, first wife of Alfonso II d'Este. Without reverse.
1558
Gilt bronze, 6.6 (2 $^{19}/_{32}$)
Kress Collection, A–1062.325A

No. 1

This popular and skillful artist was the author of more than two hundred medals. Born in Siena, he worked (from about 1540) in Parma, Ferrara, Novellara, Bologna, and Florence, where he finally settled in 1576.

2. **Pastorino**
Girolama Sacrata of Ferrara. Without reverse.
1560
Bronze, 6.2 (2 $^{7}/_{16}$)
Kress Collection, A–1068.331A

3. **Pastorino**
Beatrice da Siena. Reverse: sheaf of wheat.
Bronze, 4.0 (1 $^{9}/_{16}$)
Kress Collection, A–1056.319A

The relatively small size of this attractive medal recalls Pastorino's earliest style (as does the origin of its unknown sitter), but it displays the pearled border of his mature works.

4. **Pastorino**
 Unidentified Man, bust only, cut out from a medal. Without reverse.
 1557
 Gilt bronze, 3.7 (1 $^{15}/_{32}$) h.
 Kress Collection, A–1073.336A

5. **Pastorino**
 Francesco d'Este, 1516-1578, son of Alfonso I, Marquess of Massa. Without reverse.
 1554
 Bronze, 4.0 (1 $^9/_{16}$)
 Kress Collection, A–1061.324A

No. 5

This beautifully balanced design, with its superb portrait is often found combined with Pastorino's other uniface medals of the Este family, as for example with the following type, here displayed behind it.

6. **Pastorino**
 Ercole II d'Este, 1508-1559, 4th Duke of Ferrara 1534. Without reverse.
 1534
 Bronze, 3.9 (1 $^{17}/_{32}$)
 Kress Collection, A–1060.323A

7. **Pastorino**
 Eleonora of Austria, 1534-1594, Duchess of Mantua, wife 1561 of Guglielmo I Gonzaga. Without reverse.
 1561
 Bronze, 6.9 (2 $^{23}/_{32}$)
 Kress Collection, A–1063.326A

The sitter, daughter of Ferdinand I of Austria, exemplifies the frequent Italian-imperial alliances of the middle and late sixteenth century. A pink wax model of the portrait, also dated 1561, survives in a private collection.

8. **Pastorino**
 Francesco Visdomini of Ferrara, 1509-1573, humanist and Hebraist. Reverse: right hand issuing from a cloud, holding upright a flaming sword.
 1564
 Bronze, 6.7 (2 $^5/_8$)
 Kress Collection, A–1072.335A

No. 8, obverse *No. 8, reverse*

Pastorino's medal of this learned scholar, called the "Demosthenes of his times," is so delicately thin that (in addition to a roughly pierced hole for suspension) a gap has broken through the field.

9. **Pastorino**
 Isabella Manfro de' Pepoli of Bologna. Without reverse.
 1571
 Bronze, 6.5 (2 9/16)
 Kress Collection, A-1065.328A

10. **Pastorino**
 Girolama Farnese, daughter of Galeazzo Farnese, wife of Alfonso San Vitale, widowed 1560. Without reverse.
 1560
 Bronze, 6.4 (2 17/32)
 Kress Collection, A-1069.332A

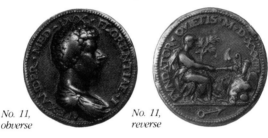

No. 11,
obverse

No. 11,
reverse

11. **Francesco Ortensi di Girolamo dal Prato,** Florentine, 1512-1562
 Alessandro I de' Medici, 1510-1537, 1st Duke of Florence 1531. Reverse: Peace holding olive branch, seated to right; with a torch she fires a pile of arms. Below, sign of Mars.
 1534
 Bronze, 4.3 (1 11/16)
 Kress Collection, A-1054.317A

This portrait of the first Medici duke, by a Florentine medalist, goldsmith, and painter, has a particularly fine reverse in which Peace (with an olive branch) burns the implements of war. The duke's relationship to this symbolic promise of reconciliation is somewhat compromised, however, by the artist's inclusion below of the sign of the celestial power chosen as Alessandro's protector, that is Mars.

12. **Domenico Poggini,** Florentine, 1520-1590
 Camilla Peretti, sister of Pope Sixtus V, died 1591. Reverse: façade of the Church of S. Lucia at Grottamare.
 1590
 Bronze, 4.7 (1 27/32)
 Kress Collection, A-1081.344A

The son of a gem cutter, Domenico Poggini worked as a sculptor, medallist, die cutter, and goldsmith; he also earned a reputation as a poet. His suavely academic medals date from 1552 to 1590; those for the Medici are mostly struck, though he did produce cast medals as well.

This lady's long life (her husband died in 1566 or earlier) culminated in her foundation of a collegiate church in this small town on the Adriatic coast.

13. **Domenico Poggini**
Niccolò Todini of Ancona, Captain of Castel Sant'Angelo, 1585-1591. Reverse: view of Castel Sant'Angelo.
1585-1590
Bronze, 4.4 (1 $^3/_4$)
Kress Collection, A–1082.345A

14. **Domenico Poggini**
Giulio Nobili, 1537-1612, Florentine senator. Reverse: nude female figure standing to front, holding scales; a swan at her side.
1570
Bronze, 4.2 (1 $^{21}/_{32}$)
Kress Collection, A–1080.343A

Nobili's medal seems reliably attributed to Poggini on the grounds of style.

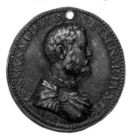

No. 15, obverse *No. 15, reverse*

15. **Domenico Poggini**
Cosimo I de' Medici, 1519-1574, Duke of Florence 1537, later Grand Duke of Tuscany 1569. Reverse: view of the Uffizi, with the Palazzo Vecchio in the background; in front, Equity holding scales and cornucopia.
1560
Struck bronze, 4.1 (1 $^{19}/_{32}$)
Kress Collection, A–1078.341A

In perhaps a more persuasive image of public benevolence than that of Duke Alessandro, his predecessor (see no. 11 above), Duke Cosimo—later in the decade to become the first Grand Duke of Tuscany—here introduces his great building project of the Uffizi with the allegorical figure of Equity and the inscription PVBLICAE COMMODITATI.

16. **Domenico di Angelo de' Vetri,** called **Domenico di Polo,** 1480-1547
Cosimo I de' Medici, 1519-1574, Duke of Florence 1537, later Grand Duke of Tuscany 1569. Reverse: Capricorn; above, eight stars.
1537(?)
Struck bronze, 3.5 (1 ³/₈)
Kress Collection, A-1052.315A

Giorgio Vasari, in his *Lives,* said that Domenico di Polo made this medal in 1537; although Cosimo was then only eighteen, he is already shown with a short beard. The constellation Capricorn, on the reverse, was chosen as Cosimo's personal device (see no. 18 below).

17. **Pier Paolo Galeotti,** called **Romano,** Roman, 1520-1584
Bianca Pansana Carcania. Reverse: an island in a stormy sea in which people are drowning; on the island a circular wall encloses a high rock, at foot of which is a kneeling figure.
Bronze, 5.5 (2 ⁵/₃₂)
Kress Collection, A-1086.349A

This excellent artist, who was known as Romano after his birthplace in the Eternal City, signed his medals P.P.R. He was brought to Florence as a pupil and associate by Benvenuto Cellini, whom he accompanied as well to Ferrara and to Paris. By 1550 Galeotti had settled in Florence, and his first dated medal is inscribed 1552; he made more than seventy others. He worked again for a short time in his native city as die cutter at the Papal Mint in 1575, and he was also patronized by sitters from Milan, Turin, and Genoa. His fine pictorial reverses are characterized by figural compositions of great delicacy and by the frequent inclusion of swirling water. He is represented by a significant group of medals in the Kress Collection, of which five are shown in this case.

18. **Romano**
Francesco Taverna, 1488-1560, Count of Landriano, Milanese jurisconsult. Reverse: in a landscape, a hound seated on the base of a column, looking up at the constellation Capricorn; in the background, columns of a temple.
c. 1554
Bronze, 5.6 (2 ⁷/₃₂)
Kress Collection, A-1097.360A

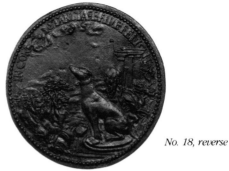

No. 18, reverse

This sensitive medal formed a pair with one of Taverna's wife Chiara, whose reverse shows the goddess Cybele, with an inscription invoking FERTILITAS. In a similar way here, her husband's medallic reverse traces happiness to "Constancy and Faith," while the hound (a symbol of these virtues) gazes on Capricorn, here perhaps to be taken both as a reference to masculine duties in marriage and also as the sitter's homage to Cosimo de' Medici (see no. 16 above).

19. **Italian,** mid-XVI century
 Cornelio Musso of Piacenza, a Franciscan, Bishop of Bitonto 1544, died 1574. Reverse: unicorn purifying a stream by dipping his horn in it; in background, landscape with shepherd and flock; below, shield of arms between two horns of plenty.
 Bronze, 6.0 (2 ³/₈)
 Kress Collection, A–1232.495A

This medal has been attributed, though not persuasively, to Galeotti. The very delicate reverse, with a shepherd and his flock in a landscape, refers to the pastoral activity of the sitter. The purifying function of the unicorn appears earlier on Lixignolo's similar medal of 1460 for Borso d'Este, in Gallery GN 6, and again among the medals on the south wall of this same room, in an Italian artist's commemoration of Francis I (*Fifteenth- and Sixteenth-Century France*, no. 21).

20. **Romano**
 Tommaso Marini of Genoa, Duke of Terranuova. Reverse: sun shining on the sea.
 Bronze, 5.2 (2 ¹/₁₆)
 Kress Collection, A–1091.354A

21. **Romano**
 Cassandra Marinoni, wife of Deifobo II Melilupi, died 1575. Reverse: circular colonnaded temple; city in background.
 Bronze, 5.7 (2 ¹/₄)
 Kress Collection, A–1093.356A

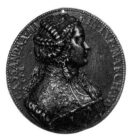
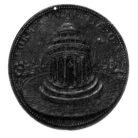

No. 21, obverse No. 21, reverse

This exceptionally beautiful design combines an elaborate but sensitive portrait with an idealized representation of Bramante's *Tempietto*, to suggest analogies between the godly life and "the temple of the body."

22. **Romano**
Girolamo Figino, XVI-century Milanese painter. Reverse: Minerva armed, standing to front; at her feet, instruments of music and sculpture.
Bronze, 3.7 (1 $^{15}/_{32}$)
Kress Collection, A–1087.350A

Here a remarkably fine portrait of a fellow artist is combined with an image of the vigilant intellect as generator of the arts.

23. **Italian,** mid-XVI century
Madonna and Child. Uniface plaquette.
Bronze, 4.7 x 4.1 (1 $^{27}/_{32}$ x 1 $^{19}/_{32}$)
Kress Collection, A–688.410B

24. **Jacopo Nizolla da Trezzo,** Milanese, 1515/19-1589
Juan de Herrera, c. 1530-1597, Architect of the Escorial. Reverse: Architecture seated, holding compasses and square; architectural background, with a domed chapel (the Escorial).
1578
Bronze, 5.1 (2)
Kress Collection, A–1177.440A

One of the finest of all sixteenth-century medallists, Jacopo da Trezzo also had one of the highest contemporary reputations. Born in Milan and trained as a gem engraver in the Miseroni workshop (see the previous gallery, GN 10), Trezzo was already favorably mentioned in the first edition of Giorgio Vasari's *Lives,* in 1550. His first medal dates from about this time (no. 27 below), after which the artist practiced in Milan (where he knew the work of Leone Leoni), in The Netherlands (1555-1559), and in Spain, especially on jewelled tabernacles and reliquaries for the church of the Escorial (see immediately below). He died in Madrid.

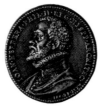

No. 24, obverse *No. 24, reverse*

As a reverse to this medal's humane portrait of Herrera, "Architect of Philip II of Spain," Trezzo incorporated a brilliant allegory of Architecture seated within Herrera's masterpiece, the Escorial—thus identified as the chosen seat of the arts—with her gaze directed toward its central feature, the great domed church which Trezzo himself helped to decorate.

25. **Jacopo da Trezzo**
Ascanio Padula. Reverse: Apollo holding a bow and a lyre; on left, a blazing tripod; on right, a raven perched on a cauldron.
1577
Bronze, 5.0 (1 $^{31}/_{32}$)
Kress Collection, A–1178.441A

26. **Jacopo da Trezzo**
Philip II, 1527-1598, King of Spain 1556. Without reverse.
1555
Lead, 7.2 (2 $^{27}/_{32}$)
Kress Collection, A–1174.437A

27. **Jacopo da Trezzo**
The Fountain of the Sciences. Uniface plaquette.
c. 1550
Bronze, 8.1 (3 $^{3}/_{16}$)
Widener Collection, A–1559

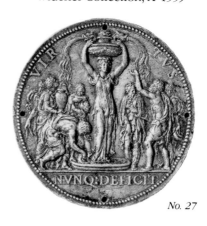

No. 27

This splendid plaquette, one of the principal treasures of the Widener Collection, is a uniface example of Trezzo's finest reverse, made about 1550 for his medal of an engineer of Cremona, Gianello della Torre. It represents

humane learning as the source of virtue—which, as the inscription points out, never fails, no matter how ardently men (of all ages) may partake of it. The conception is simple and grand, even Augustan in its controlled yet festive classicism. It has justly been said to relate sixteenth-century medallic art to the reigning style of Michelangelo.

28. **Jacopo da Trezzo**
 Ippolita Gonzaga, 1535-1563, daughter of Ferdinando. Reverse: Aurora riding through the heavens on a chariot drawn by a winged horse, carrying torch, and scattering flowers.
 1552
 Bronze, 6.9 (2 $^{23}/_{32}$)
 Kress Collection, A-1175.438A

The rather heavy portrait of this medal (for a lady only seventeen!) is generally recognized as having been borrowed by Trezzo from a prototype (Ippolita at age sixteen) by Leoni; but an earlier unattributed medal of the sitter, aged fifteen, is perhaps more nearly in Trezzo's style than Leoni's. The characteristic figure of Aurora, on the present reverse, is closely paralleled in the personification of Ippolita on that earliest medal of the series.

 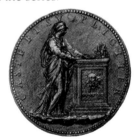

No. 29, obverse *No. 29, reverse*

29. **Jacopo da Trezzo**
 Isabella Capua, Princess of Malfretto, wife 1529 of Ferrante Gonzaga, died 1559. Reverse: female figure at a flaming altar, on the side of which the sun's face, and NVBIFVGO.
 Bronze, 7.0 (2 $^3/_4$)
 Kress Collection, A-1176.439A

The combined delicacy and grandeur of this medal, both front and back, shows Trezzo at his best. The beautifully arrayed princess, in "chaste supplication" before a classical altar, invokes the sun to chase the clouds from her life.

30. **Italian,** mid-XVI century
 Head of a Girl. Uniface plaquette.
 Bronze, 5.3 x 4.1 (2 $^3/_{32}$ x 1 $^{19}/_{32}$)
 Kress Collection, A-735.457B

31. **Gasparo Romanelli,** Aquilan, known active 1560-1609 in Florence
Pietro Vettori the Younger, 1499-1585, Florentine scholar. Reverse: an olive branch.
Bronze, 4.5 (1 $^{25}/_{32}$)
Kress Collection, A-1098.361A

Five medals of this sitter (who published works on olive cultivation) are attributed to the medallist and goldsmith Gasparo Romanelli, though only one, of 1580, is signed by him. The earlier of the two examples here may possibly date from 1573, though the sitter's age is slightly exaggerated in both these inscriptions.

32. **Gasparo Romanelli**
Pietro Vettori the Younger, 1499-1585, Florentine scholar. Reverse: Minerva holding olive branch and spear.
1574
Struck bronze, 3.8 (1 $^1/_2$)
Kress Collection, A-1099.362A

33. **Gian Federigo Bonzagni,** Parmesan, known active 1547-c. 1586
Pierluigi Farnese, 1503-1547, 1st Duke of Parma and Piacenza 1545. Reverse: bird's eye view of the citadel of Parma, with gate opening on a stream.
1545-1547
Struck bronze, 4.0 (1 $^9/_{16}$)
Kress Collection, A-1112.375A

Son of Gian Francesco Bonzagni of Parma, Gian Federigo worked in Rome from 1554 as assistant to his brother Gian Giacomo, and to Alessandro Cesati, at the Papal Mint. He made more than fifty medals, which are dated between 1547 and 1575.

So many specimens of this medal survive as to suggest that Pierluigi Farnese may have used it to popularize his foundation at Parma and Piacenza of another dynastic court, analagous to that created by the Medici in Florence in the preceding decade.

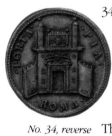

34. **Gian Federigo Bonzagni**
Pius IV (Giovanni Angelo Medici, 1499-1565), Pope 1559. Reverse: the Porta Pia at Rome.
1561
Struck bronze, 3.1 (1 $^7/_{32}$)
Kress Collection, A-1109.372A

No. 34, reverse This important small medal records an early design for Michelangelo's last work, the Porta Pia (1561-1564); the final design was considerably elaborated.

35. **Gian Federigo Bonzagni**

Ippolito II d'Este, 1509-1572, son of Alfonso I d'Este, Cardinal 1538. Without reverse.
Bronze, 4.6 (1 $^{13}/_{16}$)
Kress Collection, A–1111.374A

The so-called hollow casting of this uniface medal made its reverse, after appropriate chasing, an exact negative of the obverse. Such a treatment became especially popular in France (see next gallery, GN 12), and may possibly have been used to create impressions in the proper sense in sealing wax.

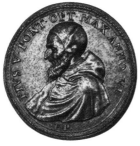

No. 36, obverse *No. 36, reverse*

36. **Gian Federigo Bonzagni**

Pius V (Michele Ghislieri, 1504-1572), Pope 1566. Reverse: the Battle of Lepanto; on a galley an angel with cross and chalice; God hurling lightning from above. 1571
Struck silver, 3.7 (1 $^{15}/_{32}$)
Kress Collection, A–1110.373A

This finely detailed silver medal commemorates the allied victory of the Papal, Venetian, and Spanish fleets over the Turkish armada off Lepanto, in the Gulf of Corinth, on 7 October 1571. The reverse attributes the triumph of Christian arms to the direct intervention of God.

37. **Lorenzo Fragni,** Parmesan, 1548-1618

Sixtus V (Felice Peretti, 1521-1590), Pope 1585. Reverse: Securitas seated holding a fleur-de-lis sceptre, her upraised head resting on her right hand; beside her, a flaming altar.
Struck bronze, 3.7 (1 $^{15}/_{32}$)
Kress Collection, A–1115.378A

The nephew and pupil of Gian Federigo Bonzagni (above), Fragni worked beside his master in the Papal Mint from 1572 to 1586. The reverse of this medal is borrowed from another of their associates there, Alessandro Cesati, who probably invented it for Pope Paul III.

38. **Italian,** XVI century
Enrico Orsini. Reverse: bees flying around a hive.
Bronze, 3.5 x 2.8 (1 3/8 x 1 3/32)
Kress Collection, A–1234.496A

39. **Italian,** XVI century
Giulia Orsini. Without reverse.
Bronze, 5.2 (2 1/16)
Kress Collection, A–1235.497A

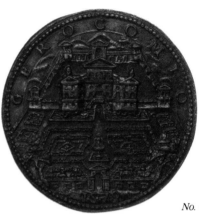

No. 40, reverse

40. **Federigo Coc...**
Prospero Publicola Santacroce of Rome, 1514-1589, Cardinal 1565. Reverse: bird's-eye view of the villa at Gericomio.
1579
Bronze, 5.4 (2 1/8)
Kress Collection, A–1114.377A

The artist may be identical with a Federigo Cocciolo who is documented as a seal engraver between 1560 and 1564 (and who might thereafter have taken up medal making), or with a Federigo de Cocchis who was a member somewhat later of the Roman guild of goldsmiths. Three medals of Pope Gregory XIII (1572-1585) bear the same signature, while one other secular issue refers to an event in 1565. The artist's known medallic activity is therefore circumscribed between that date and 1579 (see below) or 1585; both of the names preserved in the documents may well refer to the same individual.

Cardinal Santacroce built his retirement villa in 1579 at Gericomio, just southeast of Hadrian's Villa, between Tivoli and Palestrina. The image is valuable to the history of architecture and of horticulture, for such complete depictions of sixteenth-century villas and their gardens are very rare.

41. **Italian,** XVI century
 Beatrice Roverella, wife of Ercole Rangoni, died 1573. Reverse: three-masted ship, without sails, in a stormy sea.
 Bronze, 6.1 x 5.8 (2 $^{13}/_{32}$ x 2 $^{9}/_{32}$)
 Kress Collection, A–1237.499A

Only one other medallic portrait of such idiosyncratic rectangular shape is known; the lack of alignment of the obverse and reverse is here doubly curious.

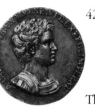

No. 42, obverse

42. **Camillo Mariani,** Vicentine, 1556-1611
 Aulus Caecina Alienus, general of Vitellius A.D. 68. Reverse: across field, G. E.
 Bronze, 5.0 (1 $^{31}/_{32}$)
 Kress Collection, A–1216.478A

This prolific and talented artist (primarily a sculptor in stucco and stone) was a Vicentine protégé of Vicenzo Scamozzi, by whom he was recommended to Urbino and thence to Rome. He brought to the papal capital a brilliantly developed academic classicism, which in his Roman phase he strikingly developed in the direction of the emerging baroque. This medal forms part of a sequence that he devoted to ancient worthies, who had supposedly been connected with his native Vicenza.

43. **Attributed to Romano**
 Barbara Borromeo, wife 1555 of Camillo Gonzaga, died 1572. Reverse: two summits of Pindus, on each a flaming vase; on left, Pegasus flying.
 1555
 Bronze, 4.9 (1 $^{15}/_{16}$)
 Kress Collection, A–1225.487A

44. **Gaspare Mola,** Lombard, c. 1580-1640
 Vincenzo Gonzaga, 1562-1612, 4th Duke of Mantua 1587. Reverse: Saint George and the dragon.
 Bronze, 4.3 (1 $^{11}/_{16}$)
 Kress Collection, A–1100.363A

Born at Como, Mola worked as a goldsmith in Milan and as a die cutter in Florence from about 1608 to 1610. Over the next four years he worked at the mints in Modena and Guastalla, then settled in Rome, where he became master of the Papal Mint in 1625. Some of his fine wax models for coins are preserved in the British Museum. Mola was also an excellent sculptor of large-scale reliefs and an accomplished armorer.

45. **Master M.A.S.,** active mid-XVI century
Ercole Teodoro Trivulzio, Prince of the
Holy Roman Empire and of Valle Misol-
cina, Count of Mesocco 1656-1664. With-
out reverse.
Bronze, 4.1 (1 $^{19}/_{32}$)
Kress Collection, A-1218.480A

This artist may possibly be identical with Maria
Aurelio Soranzo, master of the Venetian Mint
in 1659.

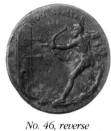

No. 46, reverse

46. **Manner of Antonio Abondio,** Trentine,
1538-1591
Jacopo Antonio Sorra. Reverse: Sorra,
nude, shooting at a mark affixed to a tree;
two arrows have missed the target; above,
NON SEMPER.
1561
Bronze, 5.0 (1 $^{31}/_{32}$)
Kress Collection, A-1206.468A

Born at Riva on Lake Garda, Abondio worked
from 1552 to 1565 in Italy, where he studied
artists of the Milanese, Emilian, and Florentine
schools. Thereafter he was active at the impe-
rial courts (Vienna or Prague), as well as in
northern Italy, Bavaria, The Netherlands, and
Spain. He enormously influenced the later
sixteenth- and seventeenth-century northern
medallists.

The reverse of this graceful and witty medal
presents the sitter's emblem of an unlucky
marksman missing a target, under the rueful
motto NON SEMPER—"One can't always win."

47. **Antonio Abondio**
Johann Baron von Khevenhüller, 1538-
1606. Reverse: Minerva leading Hercules
to left; he gestures farewell to Vice who
slinks away to right; hilly landscape back-
ground.
c. 1571
Bronze, 5.3 (2 $^{3}/_{32}$)
Kress Collection, A-1204.466A

Abondio traveled to Spain in 1571 with the
sitter, who had been appointed imperial ambas-
sador in Madrid.

48. **Antonio Abondio**
Rudolph II, 1552-1612, Holy Roman Em-
peror 1576. Reverse: eagle flying upward
into clouds, which disclose a radiant
wreath.
Silver, 4.5 (1 $^{25}/_{32}$)
Kress Collection, A-1203.465A

No. 48,
obverse

No. 48,
reverse

This bold and impressive medal of the emperor (which in some versions is signed AN AB on the edge behind the bust) attractively displays Abondio's accomplished skill at wax modelling.

49. **Antonio Abondio**
Caterina Riva. Without reverse.
Before 1565
Lead, 7.0 (2 ³/₄)
Kress Collection, A–1205.467A

This beautiful signed medal, from Abondio's Italian period, clearly shows the strong influence upon him of Emilian medallists such as Ruspagiari, Signoretti, and Bombarda (see the preceding gallery, GN 10).

50. **Felice Antonio Casoni,** Anconan, 1559-1634
Lavinia Fontana, 1552-1612, Bolognese painter. Reverse: Allegory of Painting.
1611
Bronze, 6.5 (2 ⁹/₁₆)
Kress Collection, A–1215.477A

Born at Ancona and trained in the academic school of Bologna, Casoni was working independently there by 1592 (and later in Rome) as a wax modeller, medallist, sculptor, and architect.

51. **Antonio Francesco Selvi,** Florentine, 1679-1753
Joanna of Austria, Grand Duchess of Tuscany, first wife 1565 of Francesco I de' Medici, died 1578. Without reverse.
1740
Bronze, 8.6 (3 ³/₈)
Kress Collection, A–1221.483A

One of the last of the major Italian medallists in the Renaissance tradition, Selvi produced over a hundred medals, of which seventy-six form part of a series commemorating the Medici. Announced in 1740, the sequence included this portrait—based, as were all its companions, on evidence from earlier medals, paintings, prints, and drawings.

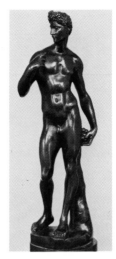

52. **Circle of Vincenzo Danti,** Florentine, third quarter XVI century(?)
Bacchus
Bronze, 18.1 (7 ¹/₈) h.
Kress Collection, A–179.17C

This figure is a reversed adaptation of Michelangelo's David of 1503, yet it shows highly developed mannerist characteristics, consonant with a date of production after mid-century. Since Vincenzo Danti's statue of Cosimo I de' Medici in the Bargello, Florence, uses the same pose, there is some possibility that the statuette may be due to him. Other nude figures of comparable size by Danti may be studied in his great *Deposition* relief, immediately adjacent on the north wall.

53. **Italo-Netherlandish** or **Italo-French,** second half XVI century
Woman Cutting Her Nails
Bronze, 8.2 (3 ⁷/₃₂) h.
Kress Collection, A–177.15C

This attractive bronze forms part of a group of bathing female figures probably made by an artist trained in Florence in Giovanni Bologna's workshop. His facial types betray a northern origin, but whether he may have been French or Flemish is unknown.

54. **Italian, possibly Florentine,** second quarter XVI century
Male Nude with Raised Left Arm
Bronze, 11.4 (4 ¹/₂) h.
Kress Collection, A–178.16C

The hands of this figure may possibly have been linked by a chain and ring (as indicated by traces of holes in the objects held in both hands), in which case he may have represented a gladiator. A parallel figure with a vase in Berlin may have been made in the same shop.

Case with Ecclesiastical Bronzes
(North Wall)

Italian, XVI century
Pietà
Bronze, 9.2 x 7.2 (3 $^5/_8$ x 2 $^{27}/_{32}$)
Widener Collection, A–1552

Spanish, XVI century
Kneeling Supplicant
Gilt bronze, 10.3 (4 $^1/_{16}$) h.
Kress Collection, A–180.18C

Spanish, XVI century
Kneeling Supplicant
Gilt bronze, 9.8 (3 $^{13}/_{16}$) h.
Kress Collection, A–181.19C

These two figures of kneeling supplicants, finely chased and gilded, may originally have been placed at the center of a large alms plate. A complete example of such a liturgical object, from Cordova, survives in the Los Angeles County Museum: its silver-gilt figures are closely analagous to these.

Italian Sculpture from Giambologna to Foggini

Vincenzo Danti, Florentine-Umbrian, 1530-1576
The Descent from the Cross
c. 1560
Bronze, 44.5 x 47.1 (17 $^1/_2$ x 18 $^1/_2$)
Widener Collection, A–105

This superb relief, one of a small number of masterpieces by Danti in the difficult genre of low-relief bronze casting, helps to confer upon its artist the major distinction of being

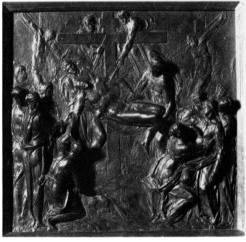

Danti, The Descent from the Cross

the only truly interesting Florentine relief sculptor between the young Michelangelo and the early career of Giovanni Bologna. Indeed, during the first three-quarters of the sixteenth century the best Italian reliefs were those created in Venice by a transplanted Florentine, Jacopo Sansovino. Danti's wonderful *Deposition,* almost comparable to certain of Jacopo's reliefs in its beauty and importance, demonstrates what a resident central Italian artist could make of the same tradition. Partly dependent upon the pictorial styles of the high maniera (its swooning elegance, for example, recalling such a mannerist painter as Rosso Fiorentino), it very likely demonstrates as well a knowledge of Sansovino's Venetian practice of drawing the background of the relief only lightly in the wax and letting the forms emerge progressively for their fullest emotive effect.

Florentine
Farnese Hercules
After 1540
Bronze, 56.8 x 27.3 x 25.4
(22 $^3/_8$ x 10 $^3/_4$ x 10)
Gift of Stanley Mortimer, A-1701

An important Antique sculpture was unearthed in the Baths of Caracalla in 1540, and named the *Farnese Hercules* after the princely Roman family who acquired it (and with whose collection it passed eventually to the Naples Museum). The present bronze is one of the earliest, largest, and finest of all sixteenth-century reductions after the marble, and thus a highly important touchstone against which to measure the quality of Florentine bronze casting at mid-century.

Giovanni Bologna, Flemish-Florentine, 1529-1608
Sleeping Nymph with Satyr
Probably before 1577
Bronze, 20.6 x 31.7 (8 $^1/_8$ x 12 $^7/_{16}$)
Anonymous Loan (February–April 1983)

Certainly the finest Florentine sculptor of small bronzes during the Late Renaissance, Giovanni Bologna (whose name refers to his origins near Boulogne) was also one of the artists who most intimately influenced the emergence of the succeeding taste of the baroque. In a series of his bronzes, presented on the pedestal near the center of this room, the qualities of his style are manifest: a suavely elaborated complexity of pose, offset by richly volumetric forms and artfully balanced rhythms of composition.

Giovanni Bologna, Flemish-Florentine, 1529-1608
Mars
c. 1578
Bronze with burnished patina, 37.5 (14 ³/₄) h.
Anonymous Loan (May–July 1983)

Circle of Pietro Tacca, Florentine, 1577-1640
Rape of a Sabine
c. 1590-1610
Bronze, 46.0 (18 ¹/₈) h.
Anonymous Loan (August–October 1983)

Pietro Tacca, Florentine, 1577-1640
The Pistoia Crucifix
Before 1616
Bronze, 86.9 x 79.0 x 20.6 (34 ¹/₄ x 31 ¹/₈ x 8 ¹/₈)
Ailsa Mellon Bruce Fund, A-1753

One of the principal sculptural masters of the transition from Renaissance to baroque, Pietro Tacca succeeded Giovanni Bologna in 1609 as grand-ducal sculptor to the Florentine court. In this capacity he made an equestrian monument to Philip III, sent as a Medici gift to Spain in 1616. With it Tacca sent his own offering, a bronze Crucifix for the Escorial. The National Gallery's example—one of the most important late Renaissance bronzes in America—is an identical cast, contemporaneously made for the church of Santa Maria degli Angeli in Pistoia. With its swaying rhythms recalling Giovanni Bologna, but set off by the concentrated pathos of its fallen head, Tacca's *Pistoia Crucifix* epitomizes the new directions of Italian art just after 1600.

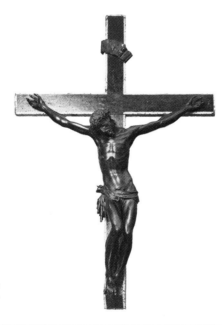

Tacca,
The Pistoia
Crucifix

Alessandro Algardi, Bolognese-Roman, 1595-1654
Saint Matthias
c. 1640
Terracotta, 38.0 x 32.4 x 19.8
(15 x 12 3/4 x 7 3/4)
Ailsa Mellon Bruce Fund, A–1736

Algardi was the principal sculptural and architectural competitor of Gianlorenzo Bernini. But, in contrast to the latter's often exuberant style, Algardi practiced a carefully restrained academic manner which has been characterized as "high baroque classicism." His beautiful terracotta sketch for a head of *Saint Matthias* perfectly evokes this mode: consciously derived from prototypes in Roman Antiquity, it still presents the vigorous surface modeling and controlled intensity of expression—as for example in the parted lips—which bespeak the new emotive power of baroque religious art.

Giovanni Battista Foggini, Florentine, 1652-1725
Bacchus and Ariadne
c. 1690(?); cast c. 1711-1724
Bronze, 39.1 x 32.9 x 23.9
(15 3/8 x 13 x 9 3/8)
Ailsa Mellon Bruce Fund, A–1756

Giuseppe Piamontini, Florentine, 1664-1742
Venus and Cupid
1711
Bronze, 37.0 x 25.4 x 22.0
(14 9/16 x 10 x 8 5/8)
Ailsa Mellon Bruce Fund, A–1757

These two pendant groups commemorating the loves of the gods were probably cast as a pair, though they derive from inventions by different artists. Foggini's original terracotta model for the *Bacchus and Ariadne* is recorded in a document around the turn of the eighteenth century, but the matching *Venus and Cupid* is a reduction from a full-size marble of 1711 by his slightly younger contemporary, Piamontini. Its terracotta model was acquired by the Berlin Museums, and small bronzes made from it are known to have been exhibited by Piamontini as early as 1724. Both works, through their combination of flickering chiaroscuro with elaborate surface detailing, stand as perfect exemplars of the twilight of the Florentine late baroque.

Renaissance France (GN 12)

This gallery surveys the classical style in France, from its beginnings in fifteenth-century regional courts through its culmination in the long reign of Louis XIV (1643-1715). French Renaissance art is characterized throughout by a greater austerity and formality than its Italian counterparts, and yet these tendencies are balanced by a linear delicacy that makes French classic art both immediately appealing and widely accessible.

Fifteenth- and Sixteenth-Century France

The large medals case between this room and the last Italian gallery (GN 11) opens with a pair of significant milestones— two large medals representing early heroes of Christianity, Constantine the Great (no. 1) and the Emperor Heraclius (no. 2), whose programmatically neo-Antique forms predate by a full generation Pisanello's similar revivals in Italy (see gallery GN 4).

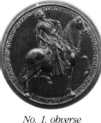

No. 1, obverse

1. **Burgundian or North French**
 Constantine the Great, Roman Emperor 307-337, on horseback. Reverse: Fountain of Life, surmounted by a cross; on left, draped female figure representing the Church; on right, seminude female figure representing Paganism.
 c. 1400-1402(?)
 Bronze, 9.5 (3 ³/₄)
 Kress Collection, A–1263.524A

This and the following medal are most likely to have been produced in Paris, probably by Michelet Saulmon, in the late 1390s or in 1400; the Duc de Berry acquired specimens of them in gold, between 1400 and 1402.

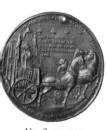

No. 2, reverse

2. **Burgundian or North French**
 Heraclius I, Roman Emperor 610-641. Reverse: Heraclius holding a cross, seated in a car drawn to right by three horses led by man with forked stick; in field, Greek inscription "Glory to God in the Highest," etc.
 c. 1400-1402(?)
 Bronze, 9.4 (3 ¹¹/₁₆)
 Formerly Molthein Collection, 129
 (Anonymous Loan)

A companion to the preceding medal, this design commemorates Heraclius' recovery of the True Cross from the Persians in 627.

3. **Giovanni di Salvatore Filangieri di Candida (?),** Italian, known active 1472-1495
Antoine, 1421-1504, Grand Bastard of Burgundy. Reverse: Barbacane discharging its fiery contents; in field, banner and device of Antoine; all in wreath.
1472-1480
Bronze, 4.4 (1 ³/₄)
Kress Collection, A–962.224A

Candida was born of a noble Neapolitan family but spent his career as a diplomat in northern courts. In 1472 he became secretary to Charles the Bold, Duke of Burgundy, then in 1477 (the year of their marriage) to Maria of Burgundy and Maximilian of Austria. He settled at the court of Louis XI of France in 1480 and became a royal councilor to King Charles VIII in 1491. Although he did sign certain medals, neither this nor the following are so authenticated, and some or all of them may be by other artists whom he influenced.

The device of the sitter, *Nul ne s'y frotte* ("Let none touch"), appears again a century later on the reverse of the great Limoges platter (no. 30) at the top center of this case.

4. **Giovanni Candida (?)**
Maximilian I, 1459-1519, Archduke of Austria 1459, afterwards Emperor 1493. Reverse: *Maria of Burgundy,* his wife 1477, died 1482; at left, two M's interlaced and crowned.
1477
Bronze, 4.8 (1 ⁷/₈)
Kress Collection, A–963.225A

This very attractive medal was made for the marriage of this royal couple and survives in a large number of examples.

5. **Giovanni Candida (?)**
Robert Briçonnet, President of the Court of Inquiry. Reverse: Briçonnet's device.
1488-1493
Bronze, 6.1 (2 ¹³/₃₂)
Kress Collection, A–966.228A

6. **Giovanni Candida (?)**
Giuliano della Rovere, 1443-1513, afterwards Pope Julius II, 1503. Reverse: *Clemente,* his brother, Bishop of Mende 1483-1504.
c. 1494-1499
Bronze, 5.9 (2 ⁵/₁₆)
Kress Collection, A–968.230A

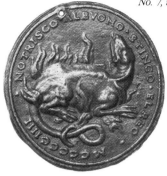

7. **Giovanni Candida (?)**
François de Valois, 1494-1547, afterwards
King Francis I of France 1515. Reverse:
salamander in flames.
1504
Bronze, 6.5 (2 ⁹/₁₆)
Kress Collection, A–970.232A

This medallic reverse presents the first appear-
ance of Francis I's famous device of a sala-
mander amid flames, destined to become one
of the most celebrated emblems of the six-
teenth century. The Italian motto, *Notrisco al
buono / stingo* (or elsewhere *stringo*) *el reo,*
provides the sense: "I nourish the good but
extinguish (or crush) the guilty." As the sala-
mander was legendarily thought to pass un-
harmed through flames, which its passage
extinguished, so the king's very presence
would obliterate evil and promote good. The
more standard abbreviated motto was later to
become simply *Nutrisco et extingo.*

8. **Giovanni Candida (?)**
Nicolas Maugras, Bishop of Uzès 1483-
1503. Reverse: arms of Maugras, over a
crozier.
c. 1503
Bronze, 8.4 (3 ⁵/₁₆)
Kress Collection, A–967.229A

9. **Giovanni Candida (?)**
Raimondo Lavagnoli, Commissary of Sax-
ony in XI or XII century. Reverse: arms of
Lavagnoli.
Bronze, 5.8 (2 ⁹/₃₂)
Kress Collection, A–965.227A

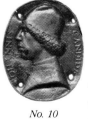

10. **Giovanni Candida (?)**
Giovanni Candida, the medallist. Without
reverse.
Bronze, 5.8 x 4.8 (2 ⁹/₃₂ x 1 ⁷/₈)
Kress Collection, A–960.222A

No. 10

This handsome portrait of the medallist may
be by his own hand, though it has stylistic
affinities—especially in the curved truncation

of the bust—to the sensitive and sympathetic portraits of Lysippos Junior (in gallery GN 5, *Antique Revivals in Rome,* nos. 10-11). It is the only recorded example.

11. **Louis le Père,** active 1456-1500, **Jean le Père,** active 1492-1534/37, and **Nicolas de Florence**
 Charles VIII, 1470-1498, King of France 1483. Reverse: *Anne of Brittany,* his wife 1491, died 1514, crowned and wearing ermine robe; field decorated (in halves) with fleurs-de-lis and ermines; below, in margin, a lion.
 1493-1494
 Struck bronze, 4.0 (1 $^{9}/_{16}$)
 Kress Collection, A–1265.526A

On 15 March 1494 the city of Lyon presented to the king and queen 100 gold specimens of this medal, modeled by Jean le Père, and cut in dies by his father Louis and his brother-in-law Nicolas de Florence.

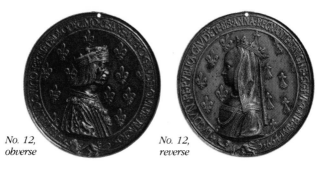

No. 12, obverse

No. 12, reverse

12. **Nicolas Leclerc,** active 1487-1507 in Lyon, and **Jean de Saint-Priest,** active 1490-1516 in Lyon
 Louis XII, 1462-1515, King of France 1498. Reverse: *Anne of Brittany,* his wife 1498, died 1514, bust to left, crowned and veiled, on field decorated with ermines; below, lion of Lyon.
 1499/1500
 Bronze, 11.4 (4 $^{15}/_{32}$)
 Kress Collection, A–1266.527A

Queen Anne (whose remarriage in 1498 afforded her second husband his royal title, as King Louis XII) was offered another gold medal, much grander than the preceding, when she entered Lyon for the second time in March of 1500. This beautiful masterpiece was designed by her court painter Jean Perréal, modeled by Leclerc and Saint-Priest, and cast by Jean le Père (see no. 11 above). Many bronze casts of it are preserved, including the fine example shown here and a gilt specimen in the Widener Collection; a silver cast in a German private collection is dated 1603.

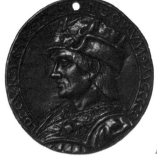

No. 13

13. **French**
Louis XII, 1462-1515, King of France 1498.
Without reverse.
1500
Bronze, 5.9 (2 5/16)
Kress Collection, A–1268.529A

This magnificent portrait, one of the handsomest of the French Renaissance, was inspired by an Italian medal of King Louis' predecessor, Charles VIII. It may be compared with the quite different representations of the same sitter on the preceding and following medals.

14. **Italian**
Louis XII, 1462-1515, King of France 1498. Reverse: seated woman at left, head in hand; toward her runs seminude woman pursued by veiled woman with raised dagger, followed in turn by Mars on horseback, holding torch and whip and accompanied by two hunting leopards; above, in clouds, thunder-bearing Jupiter.
1513
Bronze, 7.1 (2 25/32)
Kress Collection, A–1044.306A

Oddly enough this medal, with its proud portrait, seems to commemorate the Italian defeat of French arms in 1513. A vengeful Mars pursues the veiled fury of French military power, while beyond her fleeing victim France herself mourns the outcome.

15. **Jean Marende,** French, known active
c. 1502-1504
Philibert II le Beau, Duke of Savoy 1497-1504, and Margaret of Austria, his wife 1501, died 1530. Reverse: shield impaling arms of Philibert with those of Margaret; in margin, Savoy knots and marguerites, and across field the Savoy motto FERT.
1502
Bronze, 10.3 (4 1/16)
Kress Collection, A–1267.528A

This impressive medal was one of two versions made by Marende as town goldsmith of Bourg-

en-Bresse, for presentation to Margaret of Austria as Duchess of Savoy, during her visit to the town on 2 August 1502. The heavily bordered flat fields of this model were intended for enameling in the champlevé technique (see gallery GN 2), and some specimens preserve this treatment.

16. **French,** early XVI century
 Antoine, Duke of Lorraine 1508-1544. Reverse: *Renée de Bourbon,* his wife 1515, died 1539, to left, wearing coif with veil.
 Gilt bronze, 4.2 (1 $^{21}/_{32}$)
 Kress Collection, A–1278.539A

This medal, with its curiously stylized portraits, has been attributed to Florentin Olriet, die engraver in the mint at Nancy.

17. **Italian or French,** XVI century
 Isabelle de Valois, 1545-1568, third wife of Philip II of Spain. Without reverse.
 Lead, 8.5 (3 $^{11}/_{32}$)
 Kress Collection, A–1287.548A

This lady's portrait is perhaps derived from a source similar to her image on a wax medallion by Giampaolo Poggini, now at Breslau; the inscription on this example is not contemporary. A medal of her husband, King Philip II of Spain, is exhibited as no. 26 in the case in the preceding gallery, GN 11.

18. **French,** XVI century
 Charles IX, 1550-1574, King of France 1560. Without reverse.
 Lead, 9.0 (3 $^{17}/_{32}$)
 Kress Collection, A–1288.549A

This is actually a medal of King Charles' brother and short-lived predecessor, Francis II (1559-1560), from which the original inscription has been removed, and this incised version substituted; the fraternal portrait was left unchanged.

19. **Italian or French,** early XVI century
 Tommaso Guadagni, Florentine consul at Lyon 1505, municipal councilor 1506-1527, councilor of Francis I 1523. Reverse: shield of arms of Guadagni.
 Bronze, 10.3 (4 $^1/_{16}$)
 Kress Collection, A–1273.534A

No. 20, obverse

20. **French,** XVI century
 Michel de l'Hôpital, Chancellor of France 1560-1568. Reverse: a tower on a rock in the sea, struck by lightning.
 Bronze, 3.5 (1 $^3/_8$)
 Kress Collection, A–1291.552A

The original versions of this medal were struck, whereas this specimen is cast, thereby possibly indicating a slightly later date of production.

No. 21, reverse

21. **Italian,** early XVI century
Francis I, 1494-1547, King of France 1515.
Reverse: unicorn purifying a stream by dipping its horn in it; alongside, trophy of arms at the foot of a mountain.
Struck bronze, 3.9 (1 $^{17}/_{32}$)
Kress Collection, A–1276.537A

This medal seems clearly to be Italian, though a tentative ascription to Pomedelli may be less likely. Its beautiful allegory of the ruler as peacemaker and purifier refers back to Lixignolo's similar medal of 1460 for Borso d'Este, in gallery GN 6; its central image of the unicorn cleansing the stream is repeated on a medal in the preceding room (GN 11, medal no. 19).

22. **French**
Francis I, Henry II, and Francis II, Kings of France 1515-1547, 1547-1559, and 1559-1560, jugate to left. Without reverse.
1559-1560
Bronze, 3.8 (1 $^1/_2$)
Kress Collection, A–1285.546A

The reverse proper to this impressive medal should show Filiberto II of Savoy and his consort Margherita of Austria, with his brother and successor Carlo III—during whose reign (1536) Francis I (and his successors to 1559) occupied most of Piedmont.

23. **French,** late XV century
Herod and Herodias. Uniface plaquette.
Bronze, 3.7 (1 $^{15}/_{32}$)
Kress Collection, A–696.418B

This small cap badge is based on a relief in the choir screen at Amiens, also showing Herodias with the head of John the Baptist before Herod.

24. **French,** XVI century
Henry II, 1519-1559, King of France 1547.
Reverse: Perseus rescuing Andromeda.
Bronze, 4.9 (1 $^{15}/_{16}$)
Kress Collection, A–1284.545A

An earlier and crisper version of this medal has been attributed, though without much probability, to Alessandro Cesati; the present version is probably French.

25. **French,** early XVI century
Francis, Dauphin, eldest son of Francis I, Duke of Brittany 1532-1536. Without reverse.
Bronze, 5.2 (2 $^{1}/_{16}$)
Kress Collection, A–1277.538A

The obverse (of which a second uniface specimen is known) is sometimes joined to a reverse of Hercules fighting the Hydra.

26. **Pierre II Woeriot de Bouzet,** French, 1532-c. 1596
Simon Costière of Lyon, 1469-after 1572. Without reverse.
1566
Bronze, 6.7 (2 $^{5}/_{8}$)
Kress Collection, A–1283.544A

The portrait of this extraordinarily long-lived goldsmith (who is said to have reached 104) is by a fellow artist of that craft in Lyon.

27. **French,** XVI century
Jean Viret, scholar and mathematician, died 1583. Without reverse.
Bronze, 6.7 (2 $^{5}/_{8}$)
Kress Collection, A–1293.554A

A larger version of this portrait, in black stone, gives the sitter's age as 72.

28. **French**
Virgil Suspended in a Basket. Uniface plaquette.
c. 1510
Bronze, 5.4 (2 $^{1}/_{8}$)
Kress Collection, A–697.419B

This amusing cap badge depicts the legend (republished in this period) that Virgil, enamored of a princess, was hoisted in a basket to her tower but then was left suspended to the gaze of passers-by.

29. **Regnault Danet,** active 1529-1538 in Paris
Unknown Man. Reverse: *Unknown Woman,* to left in coif.
Bronze, 3.6 (1 $^{13}/_{32}$)
Kress Collection, A–1279.540A

Traditionally said to represent Pierre Briçonnet and his wife Anne Compaing, this double portrait is by the same hand as one of Regnault Danet (the goldsmith-medallist and probable author) with his wife Marguerite.

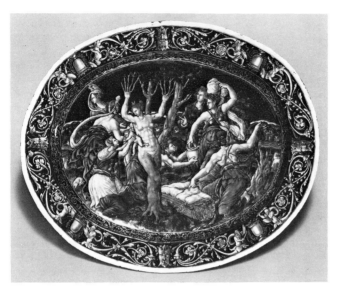

No. 30

30. **Jean de Court(?),** French (Limoges), known active 1553-c. 1585
Oval Dish with the Birth of Adonis. Reverse: bust of a woman to left, in frame supported by cupids and sphinxes; inscribed in tablet below, NVL NE SY FROTE. Painted enamel on copper, 37.6 x 46.8 (14 $^{13}/_{16}$ x 18 $^{13}/_{32}$)
Widener Collection, C–15

This spectacular enameled dish, although one of the handsomest and most elaborate of its type, has proved hard to attribute since it is apparently unsigned. Most recent opinion assigns it tentatively to the Master I.C. (or I.D.C.), evidently identical with the painter Jean de Court, whose princely patronage began in 1553, who was court painter to Mary Queen of Scots (widow of Francis II) in 1562-1567, and who succeeded François Clouet as painter to Charles IX in 1572. The subject of the Birth of Adonis is likewise hard to parallel in other Limoges enamels and must represent a rare adaptation from Ovid's *Metamorphoses.* The inscribed motto belonged originally to Antoine of Burgundy, on whose medal of a century earlier it appears in this same case (no. 3 above).

31. **Martial Courteys,** French (Limoges), c. 1540s?-1592
Large Oval Dish with a scene from the Apocalypse; inscribed at center with the artist's initials M.C. Reverse: four Herms with laurel branches, in frame supporting animals, urns, and masks.
Painted enamel on copper, 40.1 x 55.4 (15 $^{25}/_{32}$ x 21 $^{13}/_{16}$)
Widener Collection, C–16

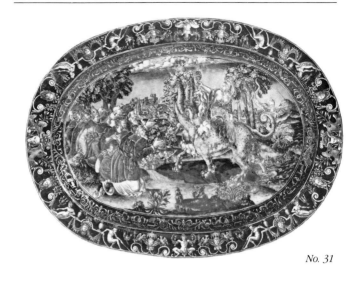

An inscription beneath the kneeling emperor on the left identifies this visionary scene as deriving from chapter XVII of the Book of Revelations: it represents the "whore of Babylon" seated on a beast with seven heads and ten horns, idolatrously worshipped by every rank of pre-Christian humanity. It constitutes an allegory of the fall of Rome. Martial Courteys was second son of Pierre I and brother of Pierre II and Pierre III, all of whom had appointments from the royal family, especially Henry IV and Catherine de Bourbon.

32. **French (Saint-Porchaire),** c. 1555
 Coupe with the Arms of France
 Henry II Ware, 13.6 (5 $^3/_8$) h.
 Widener Collection, C–76

33. **French (Saint-Porchaire),** c. 1555
 Candlestick with masks and Cupids
 Henry II Ware, 29.8 (11 $^3/_4$) h.
 Widener Collection, C–77

34. **French (Saint-Porchaire),** c. 1555
 Salt Cellar
 Henry II Ware, 11.1 (4 $^3/_8$)
 Widener Collection, C–78

These very delicate table ornaments are made of a thin soft-paste porcelain named for the reign of King Henry II (1547-1559), during which the technique was perfected. Their decoration forms a kind of three-dimensional prototype to the grotesques of painted ornament on the Limoges platters (nos. 30 and 31 above) and well represents the elaborate decorative fantasy of the School of Fontainebleau.

Late Sixteenth- and Seventeenth-Century France

1. **Nicolas Gabriel Jacquet,** French, active 1601-1630
Pomponne de Bellièvre, 1529-1607, Chancellor of France 1599. Reverse: female figures of Justice and Piety at a flaming altar.
1601
Bronze, 5.5 (2 $^{5}/_{32}$)
Kress Collection, A–1312.573A

Probably connected with a family of sculptors from Grenoble, Nicolas Jacquet made some thirty medals between 1601 and 1630; this work thus inaugurates his medallic career.

2. **Philippe Laliame,** French, active 1600-1628 in Lyon
Nicolas de Langes, 1525-1606, President of the Seneschal's Court, Lyon. Reverse: Apollo leaning on olive tree trunk and holding lyre; on each side, obverse and reverse of coin of Augustus.
1603
Bronze, 5.1 (2)
Kress Collection, A–1313.574A

In the style of early medallic publications, this "literary" reverse (whose inscription quotes Virgil, *Aeneid* III:102) presents on either side of Apollo the obverse and reverse of an Augustan coin.

3. **Guillaume Dupré,** French, c. 1576-1643
Henry IV, 1553-1610, King of France 1589, and *Marie de' Medici,* 1573-1642, his wife 1600, jugate to right. Reverse: Henry as Mars, on left joining hands with Marie as Minerva, on right; between them, nude infant Louis XIII, his foot on a dolphin, putting on his father's helmet; above, eagle flying down with crown.
1603
Gilt bronze, 6.8 (2 $^{11}/_{16}$)
Kress Collection, A–1295.556A

The finest of all French medallic portraitists, Dupré is also the most brilliant practitioner of the High Renaissance medal in France. He was as well an accomplished gem and die engraver, being in charge of the Paris Mint from 1604 to 1639. His medals at their best are astonishingly detailed, as well as being delicately and finely cast. He is well represented in the Kress and Widener Collections, whose nearly 700 European Renaissance medals his works bring to a triumphant close.

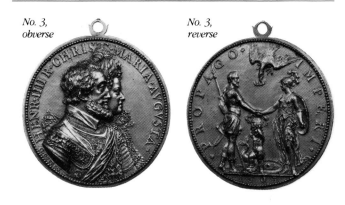

Every detail of this exquisite object may be said to exemplify the art of the French Renaissance medal at its highest level of achievement. The proud and splendid busts commemorate the marriage of the royal pair on 10 December 1600, while the grandly balanced and spacious reverse proclaims the benefit to the state of the birth of the Dauphin, on 27 September 1601. Sir Peter Paul Rubens used this reverse as a model for his painting of Henry IV departing for Germany, in his series of canvases commissioned by Marie de' Medici for the gallery of the Luxembourg Palace in Paris, in 1622-1625.

4. **Guillaume Dupré**
 Jean-Louis de Nogaret de Lavalette, 1554-1642, Duke of Epernon, Colonel General of Infantry. Reverse: seated lion, watched by a fox from his den at left, looks up at a Fury holding two torches on right.
 1607
 Bronze, 5.5 (2 $^5/_{32}$)
 Kress Collection, A–1296.557A

5. **Guillaume Dupré**
 Louis XIII, 1601-1643, King of France 1610. Reverse: the young Louis, nude, holding orb, standing on left, facing Minerva (Marie de' Medici) who holds olive branch and thunderbolt.
 1610
 Bronze, 5.6 x 4.2 (2 $^7/_{32}$ x 1 $^{21}/_{32}$)
 Kress Collection, A–1298.559A

On the reverse of this beautiful oval medal marking the accession of the nine-year-old Louis XIII, the king as a nude youth is exposed by wisdom to the arts of peace and war—symbolised by his mother the queen, as Minerva, with an olive branch and thunderbolt.

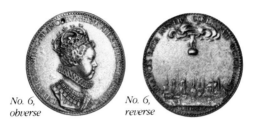

No. 6,
obverse

No. 6,
reverse

6. **Nicolas Briot,** 1579/80-1646
Louis XIII, 1601-1643, King of France 1610.
Reverse: hand issuing from clouds, hold-
ing the sacred ampulla over the city of
Rheims.
1610
Struck silver, 4.8 (1 ⅞)
Kress Collection, A–1294.555A

Briot came to Paris in 1601/02, became die
engraver at the royal mint in 1605, then moved
to London in 1625, where he died. His expe-
rience with coins is reflected in the use of dies
and precious metal for this restrained and del-
icate commemoration of young Louis' corona-
tion at Rheims.

7. **Guillaume Dupré**
Louis XIII, 1601-1643, King of France 1610.
Reverse: female figure of Justice seated to
right with sword and scales.
1623
Bronze, 6.0 (2 ⅜)
Kress Collection, A–1305.566A

Among the most frequently encountered of
Dupré's medals, this rich yet simple design is
one of his best. The omission of the king's
moustache and beard (both incorporated on
the portrait of the same year immediately
below) contributes to the economy and gran-
deur of the design.

8. **Guillaume Dupré**
Louis XIII, 1601-1643, King of France 1610.
Reverse: *Anne of Austria,* 1601-1666, his
wife 1615, to right in court dress with large
ruff.
Obverse 1623, reverse 1620
Bronze, 6.6 (2 ¹⁹/₃₂)
Kress Collection, A–1304.565A

9. **Manner of Guillaume Dupré**
Henry IV, 1553-1610, King of France 1589.
Without reverse.
Bronze, 10.2 (4)
Kress Collection, A–1297.558A

This design has traditionally been classed
among the works of Dupré, though its pub-
lished specimens are unsigned, and the orthog-
raphy of its inscription is idiosyncratic.

10. **Guillaume Dupré**
Henri de Bourbon, 1588-1646, Prince of Condé, first Prince of the Blood. Reverse: *Charlotte-Marie de Montmorency,* his wife 1609, died 1650, to right in court dress.
1611
Bronze, 5.6 (2 $^{7}/_{32}$)
Kress Collection, A-1299.560A

11. **French**
Jean de Saulx, Viscount of Tavanes and Lugny, Marquess of Mirebet (died 1629?). Reverse: rampant lion on chain; crown at right, flame at left.
1614
Bronze, 7.5 (2 $^{15}/_{16}$)
Kress Collection, A-1320.581A

This beautiful medal is apparently unique; the extraordinarily sophisticated and sympathetic portrait is unfortunately unsigned.

12. **Guillaume Dupré**
Pierre Jeannin, 1540-1622, Councilor of the King, Superintendent of Finances. Without reverse.
1618
Bronze, 19.0 (7 $^{15}/_{32}$)
Kress Collection, A-1303.564A

The rounded, flowing forms of this heavy cast are a typical demonstration of the (by this time) old-fashioned *cire perdue* or lost wax process: the design was worked up in a thick wax disk, traces of whose modeling can still be seen on the reverse. Compare the radically more advanced technology of the following specimen.

13. **Guillaume Dupré**
Francesco IV Gonzaga, 1586-1612, 5th Duke of Mantua 1612. Without reverse.
1612 (this example cast 1654 by J.B. Keller, Paris)
Bronze, 16.3 (6 $^{13}/_{32}$)
Kress Collection, A-1300.561A

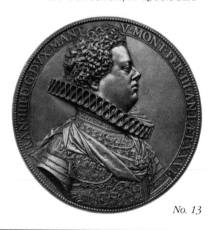

No. 13

The jewellike precision of this medal is achieved through its casting as a thin, hollow shell (albeit some forty years after its invention), and the resulting tour de force of the founder's art is proudly inscribed on the reverse "J.B. KELLER, 1654." Keller and his brother Johann Jakob were the best foundrymen of their day and cast even bronze equestrian monuments.

14. **Guillaume Dupré**

 Nicolas Brulart de Sillery, died 1624, Chancellor of France 1607. Reverse: Apollo driving the Sun's car across the sphere of the heavens.
 1613
 Bronze, 7.3 (2 ⁷/₈)
 Kress Collection, A–1302.563A

15. **Jean Darmand,** called **Lorfelin,**

 c. 1600-1669
 Anne of Austria, 1601-1666, wife 1615 of King Louis XIII of France. Reverse: in clouds, crown surrounded by stars; below, flowers growing.
 1642
 Bronze, 5.1 (2)
 Kress Collection, A–1314.575A

Lorfelin succeeded Nicolas Briot (no. 6 above) as engraver to the Paris Mint, 1630-1646. His refreshingly spare and simple medal of Queen Anne alludes in part to the much-desired birth four years earlier of the dauphin, who was to become King Louis XIV in the following year.

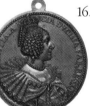

No. 16

16. **Guillaume Dupré**

 Christine of France, died 1663, Duchess of Savoy, wife of Victor Amadeus 1619, regent 1637-1648. Without reverse.
 1635
 Bronze, 5.5 (2 ⁵/₃₂)
 Kress Collection, A–1310.571A

The full medal has a reverse showing a diamond pin with the motto PLVS DE FERMETE QVE DECLAT. One reason for producing a finely finished thin cast of the obverse alone may be provided by this specimen's integral suspension loop: the greater lightness made such medallic portraits much easier to wear.

17. **Guillaume Dupré**

 Maria Magdalena, died 1636, Grand Duchess of Tuscany, wife of Cosimo II de' Medici 1589. Without reverse.
 1613
 Bronze, 9.3 (3 ²¹/₃₂)
 Kress Collection, A–1301.562A

18. **Guillaume Dupré**
 Marie de' Medici, 1573-1642, wife 1600 of
 King Henry IV of France. Without reverse.
 1624
 Bronze, 10.3 (4 $^1/_{16}$)
 Kress Collection, A–1307.568A

See note to no. 16 above. The retrograde
inscription on this medal offers another expla-
nation of the utility of such thin casts, already
advanced à propos of an incuse specimen in
the preceding gallery (GN 11, medal no. 35):
they may possibly have been used for making
impressions, either positive or negative, in
sealing wax.

19. **Guillaume Dupré**
 Marie de' Medici, 1573-1642, wife 1600 of
 King Henry IV of France. Reverse: the
 queen standing center, as Mother of the
 Gods, with orb and sceptre, lion beside
 her; around her, five other deities; in
 clouds above, car drawn by two lions.
 1624
 Bronze, 5.4 (2 $^1/_8$)
 Kress Collection, A–1306.567A

20. **Abraham Dupré,** French, 1604-1647
 Jacques Boiceau, Lord of the Barauderie,
 Intendant of the King's Gardens, 1624.
 Reverse: landscape with caterpillars crawl-
 ing on the ground; in the air, butterflies.
 1624
 Bronze, 7.2 (2 $^{27}/_{32}$)
 Kress Collection, A–1311.572A

The son and pupil of Guillaume Dupré, Abra-
ham worked in Savoy as a cannon founder
from 1626 to 1639; in the latter year he suc-
ceeded his father as director of the Paris Mint.
This very beautiful medal of the royal horti-
culturist, which he made at age twenty, exem-
plifies his great inherited and natural talent.

21. **French**
 Noël Brulart de Sillery, Knight of Saint
 John 1632. Reverse: achievement of Bru-
 lart, shield placed on a Cross of Malta and
 surrounded by collar of the order.
 1632
 Silver, 5.1 (2)
 Kress Collection, A–1317.578A

No. 21, obverse The sitter in this accomplished but anony-
mous medal displays his family resemblance
to the subject of Dupré's medal of twenty years
earlier, on the right edge of the case (no. 14).

22. **Jean Warin,** French, c. 1604-1672

Antoine Ruzé, 1581-1632, Marquis of Effiat and of Longjumeau, Superintendent of Finances 1626. Reverse: Hercules helping Atlas to bear the globe.
1629
Bronze, 6.5 (2 ⁹/₁₆)
Kress Collection, A–1308.569A

Warin (or Varin) was from Liège and worked in Rochefort around 1615, then in his native town and Sedan around 1623. He went to Paris about 1627, where he was employed by the mint in 1629 and where he died. This and the following masterpiece brilliantly represent his skill in casting, although he made excellent struck medals as well.

The intricately rich and volumetric forms of this splendid medal seem to have been conceived in silver, for only a cast in that material, in the British Museum, is signed: the present example is a contemporaneous bronze replica, and (with all such others) has heretofore been attributed to Guillaume Dupré.

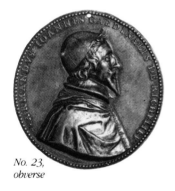 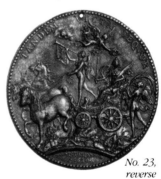

No. 23, obverse

No. 23, reverse

23. **Jean Warin**

Armand-Jean Duplessis, Cardinal Richelieu, 1585-1642, Cardinal 1622. Reverse: the figure of France seated in a chariot drawn by four horses, Fortune chained to the chariot, and Fame standing on the chariot, guiding the horses and trumpeting.
1630
Bronze, 7.8 (3 ¹/₁₆)
Kress Collection, A–1672

Like Warin's medal of Ruzé from the preceding year (no. 22 above), his commemoration of Cardinal Richelieu is grand and imposing through the monumentality of its portrait, while being elaborate and even festive in the brilliant composition of the reverse. The conception of Fame and Achievement perpetually rewarding France, while Fortune herself is indissolubly bound to the progress of the French state is worthy of the ambitions of this great prince of the Church.

No. 24

24. **Léonard Limosin,** French (Limoges)
c. 1505-1575/77
Round Dish with the Wedding Feast of
Cupid and Psyche. Reverse: bust of a
woman to left, in frame supporting eagle,
satyrs, Psyche heads, and festoons.
c. 1560
Painted enamel on copper, 42.6 (16 ¾)
Widener Collection, C–18

The greatest enamel painter of the School of
Fontainebleau, Léonard Limosin was probably
trained in Limoges in the workshop of Nardon
and Jean I Pénicaud and was evidently enjoy-
ing court patronage by 1536, when he may
have produced enameled plaques after draw-
ings by Rosso Fiorentino for the decoration of
the gallery of Francis I. He and his shop pro-
duced over a thousand enamels whose sub-
jects often include Italian mannerist elements
derived from Rosso and Primaticccio, but of
which Léonard himself was frequently the
inventor. He is especially known for his por-
traits, for which see the excellent signed and
dated example in the case on the west wall
(no. 2).

This splendid dish is definitively attributed
to Limosin through its near identity with a
similarly decorated and signed example in the
Walters Art Gallery, Baltimore (44.209), as well
as a third in the Royal Scottish Museum, Edin-
burgh (1885.33). The present example is
superlative in its delicate technique and finish
and brilliantly represents this greatest decora-
tive master of the School of Fontainebleau.

25. **French**
 Antoine de Lomenie, 1560-1638, Councilor
 and Secretary of State. Reverse: above a
 landscape, Sun in car driving along the
 Zodiac, accompanied by Mercury.
 1630
 Bronze, 4.8 (1 7/8)
 Kress Collection, A-1319.580A

This handsome reverse, in which the sitter's
Mercurian eloquence is symbolized as faith-
fully guiding his Sun-like sovereign, may be
based in large part on Guillaume Dupré's
reverse for no. 14, immediately adjacent.

26. **French,** XVII century
 Joachim de Châteauvieux, Count of Con-
 folens, died 1615. Without reverse.
 Bronze, 4.5 (1 25/32)
 Kress Collection, A-1318.579A

27. **French**
 Nicolas de Bailleul, died 1662, Provost of
 the Merchants, Paris, 1622-1628. Reverse:
 nymph of the Seine reclining in a land-
 scape, resting right arm on urn from
 which water flows.
 1623
 Bronze, 5.2 (2 1/16)
 Kress Collection, A-1316.577A

This represents a late but beautiful return to
the tradition of idyllic landscapes for medallic
reverses, a style developed especially by
Romano and Trezzo in the preceding century
(see GN 11).

Limoges Enamels Case (West Wall)

1. **Franco-Flemish,** XV century
 Pax: The Annunciation. Inscribed on
 scroll and again on frame AVE MARIA GRATIA
 PLENA · DNS TECV
 Shell, 21.6 x 14.6 (8 1/2 x 5 3/4)
 Widener Collection, C-10

This Annunciation scene, carved on a shell, is
set into a later frame called a Pax (possibly of
Italian manufacture) and equipped with a
handle by which it would be presented to
communicants during the Mass.

2. **Léonard Limosin,** French (Limoges),
 c. 1505-1575/77
 Portrait of a Man, inscribed lower right
 with the artist's initials · LL · 1540 ·
 1540
 Painted enamel on copper, 11.1 x 9.5
 (4 3/8 x 3 3/4)
 Widener Collection, C-17

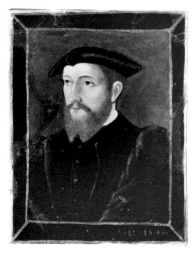

Over 130 such enameled portraits survive by Limosin (for whose career see no. 24 in the case *"Late Sixteenth- and Seventeenth-Century France,"* in the south wall of this room). This example, signed and dated 1540, is close in style and costume to one dated 1546 in The Frick Collection, New York (16.4.17), which has also been thought possibly to represent a Calvinist theologian.

3. **Jean I Pénicaud,** French (Limoges), c. 1480(?)-after 1541
 The Last Supper, inscribed lower right with the artist's initials I C, in an interlace. Painted enamel on copper, 29.7 x 25.1 (11 $^{11}/_{16}$ x 9 $^{7}/_{8}$)
 Widener Collection, C–14

Sons of Nardon Pénicaud, Jean and his brothers Léonard and Pierre carried on the work of this earliest major workshop of Limoges enamel painting. This large plaque of *The Last Supper,* though damaged and repainted at lower left, is one of eight signed works by the artist that are known and is typical in possibly being based on German prints.

4. **Jean I Pénicaud**
 Triptych: Pietà with Saint Peter and Saint Paul
 Painted enamel on copper, 21.7 x 32.7 (8 $^{17}/_{32}$ x 12 $^{7}/_{8}$)
 Widener Collection, C–13

This work, reliably attributed to Jean Pénicaud, is based on a similar *Pietà between Saint Catherine and Saint Sebastian* by the Master of the Triptych of Louis XII, in the Walters Art Gallery, Baltimore (44.91).

Free-standing Sculptures from the Reign of Louis XIV

The four bronzes exhibited on pedestals in the corners of this room continue the history of French cabinet sculpture into the reign of one of its most important monarchs, Louis XIV (1638-1715, King of France 1643). The "Sun King" conceived the arts as instruments of policy and persuasion for the state. Under him were established active Departments of Buildings and Gardens, and the Royal Academy of Painting and Sculpture, with flourishing schools in Paris and Rome for young artists on prize fellowships. The bronzes in this room aptly reflect the major preoccupations of Louis' reign—dynastic memorials and works of private religious devotion. As the outward trappings of the imperial monarchy became ever grander but more mechanical, the king's own interests, always speculative and visionary, focused more directly on the major force in seventeenth-century European life: the Counter-Reformation church, and its promise of heavenly salvation.

Nicolas Legendre, French, 1619-1671
The Penitent Magdalene
1664; probably cast 1664-1671
Bronze, 18.5 x 19.9 x 49.5 (7 $^{3}/_{8}$ x 8 x 19 $^{1}/_{2}$)
Andrew W. Mellon Fund, A–1740

An artist of modest fame but highly accomplished technique, Legendre (whose *Magdalene* is on the northeast pedestal) was a colleague of the great Charles Le Brun, who, as director of the royal artistic enterprises and painter to the king, was arbiter of artistic policy during the most active years of Louis XIV.

Legendre was also a friend of the greatest sculptor of his day, François Girardon, whose private collection of small bronzes was documented in a series of engravings devoted to his sculpture cabinets, a suite of small galleries, richly installed. In one of those images we see this same figure of Legendre's, perhaps even this identical example, as the bronze seems to be unique. Its dreamily repentant saint has lost the large cross that she formerly held across her lap (as we see in the print), one more motif in the series of *mementi mori* with which she is surrounded and with which she focuses her own and our attention on the transitoriness of life.

After Martin van den Bogaert, called **Desjardins,** French, 1637-1694
Louis XIV, "The Sun King"
1683-1693, cast 1698-1699
Bronze, 56.6 x 21.9 x 40.0
(22¼ x 8 ⅝ x 15 ¾)
Andrew W. Mellon Fund, A–1742

This equestrian bronze (on the southwest pedestal) is the finest of some dozen surviving small statuette reductions of Desjardins' colossal equestrian figure of Louis XIV for Place Bellecour in Lyon. The original monument was destroyed during the French Revolution, but its beauty and popularity are well attested by the large number of excellent small-scale replicas. This example (almost uniquely) can be dated with some precision to 1698-1699, since it was cast as a pendant to the parallel bronze of Louis' son, *The Grand Dauphin,* who was briefly appointed to quasi-sovereign governorships in those years, and thus momentarily merited such a grand monument as these splendid bronzes suggest. To update Desjardins' by then decade-old image, it is possible that the unknown founder of these miniature masterpieces (perhaps Desjardins' nephew Jacques) may have grafted a more contemporary face from a rival Parisian monument by Girardon upon this beautiful reduction of Desjardins' commemorative bronze in Lyon.

After Desjardins, Louis of France, The Grand Dauphin

After Martin van den Bogaert, called Desjardins

Louis of France, The Grand Dauphin
1688-1693, cast 1698-1699
Bronze, 57.0 x 21.3 x 41.8
(22 ³/₈ x 8 ³/₈ x 16 ¹/₂)
Andrew W. Mellon Fund, A–1741

Louis (or "Monsieur"), the Grand Dauphin, predeceased his father, and thus never held sovereign rank. Equestrian monuments to nonsovereigns are essentially nonexistent in the baroque world, so that the dauphin's appointment in 1698-1699 as prince-designate of Naples and Milan affords the unique justification for his being celebrated—even in miniature or in model form—on a monument of this type (on the northwest pedestal). The unknown master craftsman (perhaps Jacques Desjardins, nephew of his famous teacher) who delicately adapted the forms of Desjardins' Lyon monument for this new conception advertised the borrowing directly, by pairing this superb statuette with an exact reduction of the king's monument on a similar base (the only such pair known). The dauphin's image is subtly distinguished by the presence of his emblematic dolphins on the embroidered saddle cloth, and through equally subtle variations in pose and gaze. The linear delicacy and *préciosité* of French bronze casting is nowhere better exemplified than in these fabulous objects, whose surface chisel-work and lacquer patinas almost perfectly preserve their original appearance.

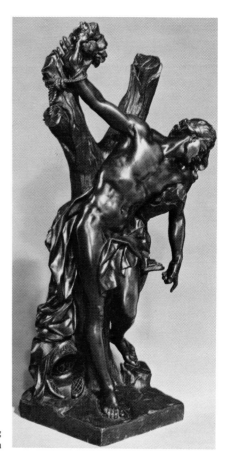

Coudray,
Saint Sebastian

François Coudray, French, 1678-1727
Saint Sebastian
1712
Bronze, 90.5 x 36.8 x 37.6
(35 ⅝ x 14 ½ x 14 ¹³/₁₆)
Ailsa Mellon Bruce Fund, A–1751

Coudray presented a marble version of this beautiful figure (whose unique bronze is on the southeast pedestal) as his *morceau de reception* or diploma piece at the Royal Academy in 1712. It well represents the emerging shift in taste from ponderous dramas of high emotional intensity (in baroque art) to more detached, low-key exercises in elegant form (such as came to characterize the rococo). Here the powerful musculature and complicated pose of the martyred saint bespeak baroque antecedents; but his sinuous, almost languorous attitude—combined with his flowing locks and averted eyes—prefigure the studied gracefulness of the rococo.

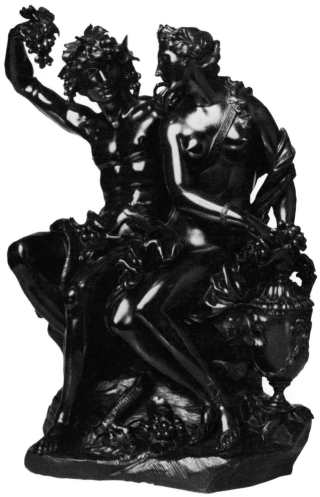

Foggini, Bacchus and Ariadne *(see description on p. 194)*

Bibliography

Recent* Sources and Suggested Further Reading

Small Bronzes and Related Sculpture

Agghazy, Maria G. "Plaquette en bronze avec la représentation d'une scène bachique," *Bulletin du Musée Hongrois des Beaux-Arts,* 54, 1980, 67-72.

Allentown Art Museum. *The Charles C. Dent Collection of Renaissance Bronzes and other Statuary,* 28 January-30 April, 1967.

Allison, Ann. "Four New Busts by Antico," *Mitteilungen des Kunsthistorischen Institutes in Florenz,* 20, 1976, 213-224.

Androsov, Sergey O. "Tre bronzi veneziani dell'inizio del XVI sec. all'Ermitage," *Arte Veneta,* 30, 1976, 158-163.

Androsov, Sergey O. and L.I. Faenson. *Italienische Bronzen der Renaissance (aus der Sammlung der Staatlichen Ermitage in Leningrad),* Leningrad, Ermitage, 8 July–4 August 1977, Berlin, Staatliche Museen DDR, 24 August–4 December 1977.

Androsov, Sergey O. "Bemerkungen zu Kleinplastiken zweier Austellungen (Leningrad, 1977–Budapest, 1978)" *Acta Historiae Artium,* 26, 1980, 143-157.

Arts Council of Great Britain. *Giambologna, 1529-1608: Sculptor to the Medici,* ed. Charles Avery and Anthony Radcliffe, London, 1978.

Arts Council of Great Britain. *Italian Bronze Statuettes,* ed. John Pope-Hennessy, London, 1961.

Arts Council of Great Britain. *Meesters van het brons der Italiaanse Renaissance,* Amsterdam, 1961.

Association Royale des Demeures Historiques de Belgique. *Catalogue de l'Exposition de Bronzes de la Renaissance de Donatello à François Duquesnoy conservés dans les collections privées belges,* Château de Laarne, September-October 1967.

Avery, Charles. *Florentine Baroque Bronzes and Other Objects of Art,* Royal Ontario Museum, Toronto, January 1975.

Avery, Charles. *Florentine Renaissance Sculpture,* London, 1970.

Avery, Charles. "Giambologna's Sketch-models and His Sculptural Technique," *The Connoisseur,* 199, September 1978, 3-11.

Avery, Charles. "Giuseppe de Levis of Verona: A Bronze Founder and Sculptor of the Late Sixteenth Century, I—Bells and Mortars," *The Connoisseur,* 181, November 1972, 179-188.

Avery, Charles. "Giuseppe de Levis of Verona: A Bronze Founder and Sculptor of the Late Sixteenth Century, II—Figure Style," *The Connoisseur,* 182, February 1973, 87-97.

Avery, Charles. "Giuseppe de Levis of Verona: A Bronze Founder and Sculptor of the Late Sixteenth Century, III—Decorative Utensils and Domestic Ornaments," *The Connoisseur,* 185, February 1974, 123-129.

Avery, Charles. *Studies in European Sculpture,* London, 1981.

Avery, Charles. "Two Ornamental Bronzes from the Medicean Grand-Ducal Workshop around 1600," *The Burlington Magazine,* 124, July 1982, 429-430.

*References have been limited to publications from the past twenty-five years.

Aznar, José Camón. "Bronces de Riccio en el Museo Lázaro Galdiano," *Goya,* 113, 1973, 226-271.

Balogh, Jolán. *Katalog der Ausländischen Bildwerke des Museums der Bildenden Künste in Budapest: IV.–XVIII. Jahrhundert,* Budapest, 1975.

Barañano, Kosme Maria de. "La Medalla de Leon Bautista Alberti por Mateo de Pasti," *Goya,* 156, 1980, 336-337.

Barañano, Kosme Maria de. "La Medalla de Alejandro Tartagno por Sperandeo de Mantua," *Goya,* 160, 1981, 220-221.

Baxandall, Michael. "Dialogue on Art from the Court of Leonello d'Este: Angelo Decembrio's *De politica litteraria* Pars LXVIII," *Journal of the Warburg and Courtauld Institutes,* 26, 1963, 304-326.

Baxandall, Michael. "Guarino, Pisanello and Manuel Chrysoloras," *Journal of the Warburg and Courtauld Institutes,* 28, 1965, 187-204.

Boucher, Bruce. "Sansovino's Medici Tabernacle and Lotto's Sacramental Allegory: New Evidence on their Relationship," *Apollo,* 114, September 1981, 156-161.

Bowdoin College Museum of Art. *The Salton Collection: Renaissance and Baroque Medals and Plaquettes,* Brunswick, Maine, 1965.

Bowron, Edgar Peters. *Renaissance Bronzes in the Walters Art Gallery,* Baltimore, c. 1978.

Bush, Virginia L. "Leonardo's Sforza Monument and Cinquecento Sculpture," *Arte Lombarda,* n.s. 50, 1978, 47-68.

Callmann, Ellen. *Beyond Nobility: Art for the Private Citizen in the Early Renaissance,* Allentown Art Museum, 28 September 1980–4 January 1981.

Camesasca, Ettore. "Piccoli Bronzi (Toscana)," *Sguardi sul Mondo,* 5, 23, 1959, 34-41.

Cappelli, Adriano. *Cronologia…per verificare le date storiche* (3rd rev. ed.), Milan, 1969.

Cessi, Francesco. *Andrea Briosco detto il Riccio scultore (1470-1532),* Trent, 1965.

Chiarini, Marco. "Il Battesimo di Cristo di Giovanni Battista Foggini," *Bollettino d'Arte,* 61, 1976, 262-263.

Ciardi Dupré dal Poggetto, Maria Grazia. *I bronzetti del Rinascimento,* Milan, 1967.

Ciardi Dupré dal Poggetto, Maria Grazia. "I bronzetti toscani del Quattrocento," *Antichità Viva,* 18:2, 1979, 28-35.

Davis, Charles. "Alari from the Shop of 'Andrea dai bronzi': A Notice for Andrea Bresciano," *Arte Veneta,* 30, 1976, 163-167.

Davis, Charles. "Aspects of Imitation in Cavino's Medals," *Journal of the Warburg and Courtauld Institutes,* 41, 1978, 331-334.

De Coo, Joz. *Museum Mayer van den Bergh, Catalogus 2: Beeldhouwkunst, Plaketten, Antiek,* Antwerp, 1969.

Detroit Institute of Arts and the City of Florence. *The Twilight of the Medici: Late Baroque Art in Florence, 1670-1743,* The Detroit Institute of Arts 27, March–2 June 1974, and Palazzo Pitti, Florence, 28 June–30 September 1974.

Draper, James David. "Andrea Riccio and his Colleagues in the Untermyer Collection: Speculations on the Chronology of his Statuettes and on Attributions to Francesco da Sant'Agata and Moderno," *Apollo,* n.s. 107, no. 193, March 1978, 170-180.

Draper, James David. "Giuseppe Piamontini's *Amore in Braccio a Venere*," *Antichità Viva*, 13, 6, 1974, 44-45.

Draper, James David, ed. Wilhelm Bode, *The Italian Bronze Statuettes of the Renaissance*, New York, 1980.

Fischer, Jacques. *Sculpture in Miniature: The Andrew S. Ciechanowicki Collection of Gilt and Gold Medals and Plaquettes*, The J.B. Speed Art Museum, Louisville, 20 October–23 November 1969.

Fischer, Jacques. *The French Bronze, 1500-1800*, New York, 1968.

The Frick Collection. *Severo Calzetta, called Severo da Ravenna*, New York, 1978.

Gallo Colonni, Gabriella. "Note su Alessandro Algardi a Genova," *Arte Lombarda*, 10:2, 1965, 161-168.

Gramberg, Werner. "Die Hamburger Bronzebüste Paul III. Farnese von Guglielmo della Porta," *Festschrift für Erich Meyer zum Sechzigsten Gerburstage*, Hamburg, 1959, 160-172.

Gramberg, Werner. "Guglielmo della Porta, Coppe Fiammingo und Antonio Gentili da Faenza: Bemerkungen zu sechs Bronzereliefs mit Szenen aus Ovids *Metamorphosen* im Museum für Kunst und Gewerbe Hamburg," *Jahrbuch der Hamburger Kunstsammlungen*, 5, 1960, 31-52.

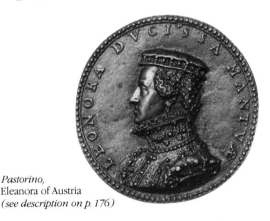

Pastorino,
Eleanora of Austria
(see description on p. 176)

Hackenbroch, Yvonne. *Bronzes, Other Metalwork and Sculpture in the Irwin Untermyer Collection*, New York, 1962.

Hackenbroch, Yvonne. "Italian Renaissance Bronzes in the Museum of Fine Arts at Houston," *The Connoisseur*, 177, June 1971, 121-129.

Hackenbroch, Yvonne. "Samson and the Philistines by Pierino da Vinci," *The Connoisseur*, 142, December 1958, 198-201.

Hall, Michael. "Reconsiderations of Sculpture by Leonardo da Vinci: A Bronze Statuette in the J.B. Speed Art Museum," *J.B. Speed Art Museum Bulletin*, 29, November 1973, 1-61.

Heimbürger Ravalli, Minna. *Alessandro Algardi scultore*, Rome, 1973.

Herzner, Volker. "Donatellos Madonna vom Paduaner Hochaltar— Eine 'Schwarze Madonna'?" *Mitteilungen des Kunsthistorischen Institutes in Florenz*, 16:2, 1972, 143-152.

Herzner, Volker. "Donatellos 'pala over ancona' für den Hochaltar des Santo in Padua: Ein Rekonstruktionsversuch," *Zeitschrift für Kunstgeschichte*, 33:2, 1970, 89-126.

Herzner, Volker. "Die Kanzeln Donatellos in San Lorenzo," *Münchner Jahrbuch der Bildendenkunst*, 23, 1972, 101-164.

Herzog Anton Ulrich-Museum. *Italienische Bronzen*, Brunswick, 1972.

Hill, Sir George. *Medals of the Renaissance* (revised and enlarged by Graham Pollard), London, 1978.

Honour, Hugh. "Florentine Baroque Bronzes in an English Private Collection," *The Connoisseur*, 159, June 1965, 85-89.

Hyman, Isabelle. "Examining a Fifteenth-Century 'Tribute' to Florence," *Art the Ape of Nature: Studies in Honor of H.W. Janson*, New York, 1981, 105-126.

Jestaz, Bertrand. "Un bronze inédit de Riccio," *La Revue du Louvre*, 25, 1975, 156-162.

Jestaz, Bertrand. "Une statuette de bronze: Le Saint Christophe de Severo da Ravenna," *La Revue du Louvre*, 23, 1973, 67-78.

Joannides, Paul. "Two Bronze Statuettes and Their Relation to Michelangelo," *The Burlington Magazine*, 124, January 1982, 3-8.

Jones, Mark. *The Art of the Medal*, London, 1979.

Kaufmann, Thomas Dacosta. "Empire Triumphant: Notes on an Imperial Allegory by Adriaen de Vries," *Studies in the History of Art*, 8, 1978, 63-75.

Klawans, Zander H. *Imitations and Inventions of Roman Coins: Renaissance Medals of Julius Caesar and the Roman Empire*, Santa Monica, California, 1977.

Kunsthistorisches Museum, Wien. *Katalog der Sammlung für Plastik und Kunstgewerbe: II. Teil: Renaissance*, Vienna, 1966.

Kunstmuseums Düsseldorf. *Medaillen und Plaketten*, Düsseldorf, 1970.

Landais, Hubert. *Les Bronzes italiens de la Renaissance*, Paris, 1958.

Lankheit, Klaus. *Florentinische Barockplastik: Die Kunst am Hofe der letzten Medici*, Munich, 1962.

Leeuwenberg, Jaap and Willy Halsema-Kubes. *Beeldhouwkunst in het Rijksmuseum*, Amsterdam, 1973.

Leithe-Jasper, Manfred. "Beiträge zum Werk des Agostino Zoppo," *Jahrbuch des Stiftes Klosterneuburg*, n.f. 9, 1975, 109-138.

Leithe-Jasper, Manfred. "Bronzestatuetten, Plaketten und Gerät der italienischen Renaissance," *Italienische Kleinplastiken, Zeichnungen und Musik der Renaissance, Waffen des 16. und 17. Jahrhunderts*, Schloss Schallaburg, 1 May–2 November 1976, 51-243.

Leithe-Jasper, Manfred. "Inkunabeln der Bronzeplastik der Renaissance," *Weltkunst*, 51, 1981, 3188-3190.

Lewis, Douglas. "Two Equestrian Statuettes after Martin Desjardins," *Studies in the History of Art*, 1974, 142-155.

Lewis, Douglas. "The Washington Relief of *Peace* and Its Pendant: A Commission of Alfonso d'Este to Antonio Lombardo in 1512," *Collaboration in Italian Renaissance Art*, New Haven, 1978, 233-244.

Lisner, Magrit. "Appunti sui rilievi della Deposizione nel sepolcro e del compianto su Cristo Morto di Donatello," *Scritti di storia dell'arte in onore di Ugo Procacci*, Milan, 1977, 247-253.

Mann, J.G. *Wallace Collection Catalogues: Sculpture*, London, 1931; rev. ed. 1982.

Mariacher, Giovanni. *Bronzetti Veneti del Rinascimento*, Vicenza, 1971.

Mariacher, Giovanni. "Unfamiliar Masterpieces of North Italian Sculpture," *Apollo*, n.s. 102, no. 163, September 1975, 174-189.

Mariacher, Giovanni. *Venetian Bronzes from the Collections of the Correr Museum, Venice,* Washington, 1968.

Mastai D'Otrange, M. L. "The Connoisseur in America," *The Connoisseur,* 164, February 1967, 136-139.

Meller, Peter. "Riccio's Satyress Triumphant: Its Source, Its Meaning," *The Bulletin of the Cleveland Museum of Art,* 63, 1976, 325-334.

Mesenzeva, Charmian. "Deutsche Renaissance-Bronzen in der Ermitage zu Leningrad," *Pantheon,* 39, 1981, 247-249.

Middeldorf, Ulrich. "Glosses on Thieme-Becker," *Festschrift für Otto von Simson zum 65. Geburtstag,* Berlin, 1977, 289-294.

Middeldorf, Ulrich. "In the Wake of Guglielmo della Porta," *The Connoisseur,* 194, February 1977, 75-84.

Middeldorf, Ulrich. "Una miscellanea di placchette," *Scritti di storia dell'arte in onore di Ugo Procacci,* Milan, 1977, 326-330.

Middeldorf, Ulrich. "On the Dilettante Sculptor," *Apollo,* 108, April 1978, 310-322.

Middeldorf, Ulrich. *Raccolta di Scritti, that is Collected Writings 1924-1979,* 3 vols., Florence, 1979-1981.

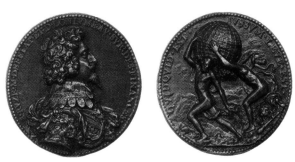

Warin, Antoine Ruzé, *obverse and reverse (see description on p. 211)*

Middeldorf, Ulrich. "A Renaissance Jewel in a Baroque Setting," *The Burlington Magazine,* 118, March 1976, 157-158.

Middeldorf, Ulrich. *Sculptures from the Samuel H. Kress Collection: European Schools, XIV–XIX Century,* London, 1976.

Minneapolis Institute of Arts. *Sculpture from the David Daniels Collection,* ed. Merribell Maddux Parsons, Minneapolis, 26 October 1979–13 January 1980.

Montagu, Jennifer. "*Hercules and Iole* and Some Other Bronzes by Foggini," *Apollo,* March 1968, 170-175.

Montagu, Jennifer. "Some Small Sculptures by Giuseppe Piamontini," *Antichità Viva,* 13:3, 1974, 3-21.

Munich, Bayerisches Nationalmuseum. *Bronzeplastik: Erwerbungen von 1956-1973: Hans R. Weihrauch zum 65. Geburtstag,* Munich, 1974.

Musée de l'Ermitage. *Sculpture italienne des XVe–XIXe siècles,* Leningrad, 1972.

Museum of Fine Arts, St. Petersburg, Florida. *The Bronze Figure in Italy,* ed. John Goldsmith Phillips, 31 January–15 March 1981.

Museum of Fine Arts, Springfield, Massachusetts. *Glorious Horsemen: Equestrian Art in Europe, 1500 to 1800,* ed. Laura Camins, Springfield, 1981.

Museum für Kunst und Gewerbe, Hamburg. *Bildführer II: Ausgewählte Werke aus den Erwerbungen während der Jahre 1948-1961, Festgabe für Erich Meyer zu seinem 65. Geburtstag am 29. Oktober 1963.* Hamburg, 1964.

Museum für Kunst und Gewerbe, Hamburg. *Deutsche Kleinplastik der Renaissance und des Barock,* ed. Jörg Rasmussen, Hamburg, 1975.

Nava Cellini, Antonia. "Note per l'Algardi, il Bernini e il Reni," *Paragone,* n.s. 27, May 1967, 35-52.

Norris, Andrea, and Ingrid Weber. *Medals and Plaquettes from the Molinari Collection at Bowdoin College,* Brunswick, Maine, 1976.

Paccagnini, Giovanni. *Pisanello alla corte dei Gonzaga.* Milan, 1972.

Pechstein, Klaus. *Bronzen und Plaketten vom Ausgehenden 15. Jahrhundert bis zur Mitte des 17. Jahrhunderts,* Kunstgewerbe Museum (Kataloge, III), Berlin, 1968.

Pollard, Graham. "A Document for the Career of Riccio," *Mitteilungen des Kunsthistorischen Institutes in Florenz,* 13:2, 1967, 193.

Pollard, Graham. *Renaissance Medals from the Samuel H. Kress Collection at the National Gallery of Art: Based on the Catalogue of Renaissance Medals in the Gustave Dreyfus Collection by G.F. Hill,* London, 1967.

Pope-Hennessy, John. "A Bronze Satyr by Cellini," *The Burlington Magazine,* 124, July 1982, 406-412.

Pope-Hennessy, John. "Cataloguing the Frick Bronzes," *Apollo,* 93, May 1971, 366-373.

Pope-Hennessy, John, assisted by Anthony Radcliffe. *The Frick Collection: An Illustrated Catalogue, III: Sculpture, Italian,* New York, 1970.

Pope-Hennessy, John. *An Introduction to Italian Sculpture,* Parts 2 and 3: *Italian Renaissance Sculpture* and *Italian High Renaissance and Baroque Sculpture,* London, 1st ed. 1963, 2nd ed. 1970/1971.

Pope-Hennessy, John. "Italian Bronze Statuettes—I," *The Burlington Magazine,* 105, January 1963, 14-23.

Pope-Hennessy, John. "Italian Bronze Statuettes—II," *The Burlington Magazine,* 105, February 1963, 58-71.

Pope-Hennessy, John. "The Italian Plaquette," *Proceedings of the British Academy,* 50, 1964, 63-85.

Pope-Hennessy, John. "The Madonna Reliefs of Donatello," *Apollo,* n.s. 103, no. 170, 1976, 172-191.

Pope-Hennessy, John. *The Portrait in the Renaissance,* New York, 1966.

Pope-Hennessy, John. *Renaissance Bronzes from the Samuel H. Kress Collection: Reliefs, Plaquettes, Statuettes, Utensils and Mortars.* London, 1965.

Radcliffe, Anthony. "Antico and the Mantuan Bronze," *Splendours of the Gonzaga,* ed. David Chambers and Jane Martineau, Victoria and Albert Museum, London, 4 November 1981–31 January 1982.

Radcliffe, Anthony, and Charles Avery. "The 'Chellini Madonna' by Donatello," *The Burlington Magazine,* 118, 1976, 337-387.

Radcliffe, Anthony. "Bronze Oil Lamps by Riccio," *The Victoria and Albert Museum Yearbook,* 3, 1972, 29-58.

Radcliffe, Anthony. *European Bronze Statuettes,* London, 1966.

Radcliffe, Anthony. "Giambologna's Twelve Labours of Hercules," *The Connoisseur,* 199, September 1978, 12-19.

Radcliffe, Anthony. "Ricciana," *The Burlington Magazine,* 124, July 1982, 412-424.

Rome, Palazzo Venezia. *La Collezione Auriti: piccoli bronzi, placchette, incisioni e oggetti d'uso,* Rome, 1964.

Rosati, Franco Panvini. *Medaglie e Placchette italiane dal Rinascimento al XVIII secolo,* Rome, 1968.

Rosenberg, Alexandre P. *Bronzes of the Italian Renaissance: Twenty-Two Unpublished Statuettes,* New York, 1981.

Rossi, Francesco. "Maffeo Olivieri e la bronzistica bresciana del '500," *Arte Lombarda,* n.s. 47/48, 1977, 115-134.

Rossi, Francesco. *Musei Civici di Brescia: Cataloghi, I: Placchette, Sec. XV–XIX,* Vicenza, 1974.

Salmann, Georges. "Les Bronzes de la Renaissance italienne," *Connaissance des Arts,* 278, April 1975, 99-106.

Salmann, Georges. "Florence au XVe siècle," *Connaissance des Arts,* 279, May 1975, 123-128.

Salmann, Georges. "Une méthode d'approche pour les bronzes du 15ème siècle," *Connaissance des Arts,* 283, September 1975, 93-96.

Salmann, Georges. "Padoue," *Connaissance des Arts,* 288, February 1976, 97-104.

Salmann, Georges. "Venise autour de 1500," *Connaissance des Arts,* 298, December 1976, 121-126.

Schlegel, Ursula. *Die Bildwerke der Skulpturengalerie Berlin, I: Die italienische Bildwerke des 17. und 18. Jahrhunderts,* Berlin, 1978.

Schlegel, Ursula. "Riccios 'Nacktermann mit vase' zur Deutung einer Gruppen italienischen Kleinbronzes," *Festschrift Ulrich Middeldorf,* Berlin, 1968, 350-357.

Seelig, Lorenz. *Studien zu Martin van den Bogaert gen. Desjardins (1637-1694),* Altendorf, 1980.

Seymour, Charles Jr. *Sculpture in Italy 1400 to 1500,* Baltimore, 1966.

Sheard, Wendy Stedman. *Antiquity in the Renaissance,* Smith College Museum of Art, 6 April–6 June 1978, Northampton, 1979.

Smith College. *Renaissance Bronzes in American Collections,* Northampton, 1964. Introductory essay by John Pope-Hennessy.

Souchal, François. *French Sculptors of the 17th and 18th Centuries: The Reign of Louis XIV,* 2 vols., Oxford and London, 1977.

Spencer, John R. "Filarete, the Medallist of the Roman Emperors," *The Art Bulletin,* 61, 1979, 550-561.

Staatlichen Museen, Berlin-Dahlem. *Bildwerke der Christlichen Epochen von der Spätantike bis zum Klassizismus,* Munich, 1966.

Staatliche Museum zu Berlin, Skulpturensammlung. *Italienische Bronzen der Renaissance und des Barock; Statuetten, Reliefs, Medaillen, Plaketten, und Gebrauchsgegenstände aus den Museen Berlin, Dresden, Budapest und Prag,* 15 October–31 December 1967.

Summers, John David. *The Sculpture of Vincenzo Danti: A Study in the Influence of Michelangelo and the Ideals of the Maniera,* New York, 1979.

Theuerkauff, Christian. "Eine augsburgische 'Fortuna-Abundantia,'" *The Burlington Magazine,* 124, July 1982, 425-429.

Theuerkauff, Christian. "German Small Sculpture of the Renaissance," *Apollo,* 102, December 1975, 432-439.

Timofiewitsch, Vladimir. *Girolamo Campagna,* Munich, 1972.

Verein Bregenzer Kunstausstellungen. *Meisterwerke der Plastik aus Privatsammlungen im Bodenseegebiet,* Bregenze, 1 July–30 September 1967.

Wark, R.R. *Sculpture in the Huntington Collection,* San Marino, California, 1959.

Watson, Katharine J. "Sugar Sculpture for Grand Ducal Weddings from the Giambologna Workshop," *The Connoisseur,* September 1978, 20-26.

Weber, Ingrid. *Deutsche, Niederländische und Französische Renaissanceplaketten 1500-1650,* Munich, 1975.

Weddigen, Erasmus. "Thomas Philologus Ravennas, Gelehrter, Wohltäter und Mäzen," *Saggi e Memorie di storia dell'arte,* 9, 1974, 7-76.

Weihrauch, Hans R. *Europäische Bronzstatuetten,* Brunswick, 1967.

Weiss, Roberto. "The Medals of Pope Julius II (1503-1513)," *Journal of the Warburg and Courtauld Institutes,* 28, 1965, 163-182.

Weiss, Roberto. *The Medals of Pope Sixtus IV,* Rome, 1961.

Weiss, Roberto. "The Medieval Medallions of Constantine and Heraclius," *Numismatic Chronicle,* 7, 3, 1963, 129-144.

Weiss, Roberto. *Pisanello's Medallion of the Emperor John VIII Palaeologus,* Oxford, 1966.

Wixom, William D. *Renaissance Bronzes from Ohio Collections,* The Cleveland Museum of Art, Cleveland, 1975.

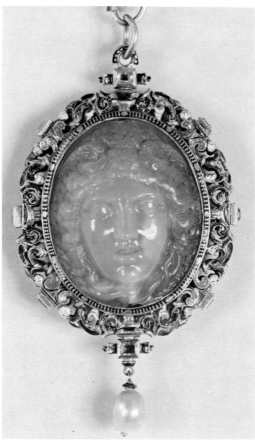

North Italian, probably Milanese, Pendant with the Head of Medusa *(see description on p. 165)*

Sixteenth-Century Decorative Arts

Cora, Galeazzo, and Angiolo Fanfani. *La maiolica di Cafaggiolo,* Florence, 1982.

Conti, Giovanni. *L'arte della maiolica in Italia,* 2nd ed., rev., Milan, 1980.

Dauterman, Karl, James Parker, and Elizabeth Standen. *Decorative Art from the Samuel H. Kress Collection at the Metropolitan Museum of Art,* London, 1964.

Distelberger, Rudolf. "Beobachtungen zum den Steinschneide-werkstätten der Miseroni in Mailand und Prag," *Jahrbuch des Kunsthistorischen Sammlungen in Wien,* 74, 1978, 79-152.

Distelberger, Rudolf. "Dionisio und Ferdinand Eusebio Miseroni," *Jahrbuch des Kunsthistorischen Sammlungen in Wien,* 75, 1979, 109-188.

Distelberger, Rudolf. "Die Sarachi-Werkstatt und Annibale Fontana," *Jahrbuch des Kunsthistorischen Sammlungen in Wien,* 71, 1975, 95-164.

DuBon, David. "A Spectacular Limoges Painted Enamel," *Philadelphia Museum of Art Bulletin.* 76, 329, 1980, 2-17.

Council of Europe. *Firenze e la Toscana dei Medici nell'Europa del Cinquecento: Palazzo Vecchio: committenza e collezionismo medicei,* Florence, 1980.

The Fine Arts Museum of San Francisco. *The Triumph of Humanism: A Visual Survey of the Decorative Arts of the Renaissance,* San Francisco, 1977.

Forman, W. and B. *Limoges Enamels,* London, 1962. Text by M. Gauthier and M. Marcheix.

The Frick Collection. *An Illustrated Catalogue, VIII: Enamels, Rugs and Silver* (Enamels section by Philippe Verdier), New York, 1977.

Giacomotti, Jeanne. *Catalogue des majoliques des musées nationaux: Musées du Louvre et de Cluny; Musée national de ceramique à Sèvres; Musée Adrien-Dubouché à Limoges,* Paris, 1974.

Guaitini, Grazietta. *Antiche maioliche di Deruta,* Spoleto, 26 June–13 July 1980.

Hackenbroch, Yvonne. "Jewelery in the Style of Giambologna," *The Burlington Magazine,* 199, September 1978, 34-37.

Hackenbroch, Yvonne. *Renaissance Jewelery,* New York, 1979.

Hausmann, Tjark. *Kataloge des Kunstgewerbemuseums Berlin: VI, Majolika; Spanische und italienische Keramik von 14. bis zum 18 Jahrhundert,* Berlin, 1972.

Hayward, J.F. *Virtuoso Goldsmiths and the Triumph of Mannerism: 1540-1620,* London, 1976.

Heinzl-Wied, Brigitte. "Studi sull'arte della scultura in pietre dure durante il Rinascimento: I Fratelli Sarachi," *Antichità Viva,* 12,6, 1973, 37-58.

The James A. de Rothschild Collection at Waddesdon Manor: Glass and Enamels (Enamels section by Madeleine Marcheix and R.J. Charleston), London, 1977.

Jestaz, Bertrand. "Les Modèles de la Majolique historiée bilan d'une enquête, *Gazette des Beaux-Arts,* S. 6, 79, 1982, 215-240.

Jestaz, Bertrand. "Poteries de Saint-Porchaire," *La Revue du Louvre,* 25, 1975, 384-396.

Kris, Ernst. *Meister und Meisterwerke der Steinschneidekunst in der italienischen Renaissance* (rev. ed.), Vienna, 1976.

Legner, A. "Freiburger Werke aus Bergkristall: Kristallschliff der Spätgotik und in den Jahrzehnten um 1600," *Schau ins Land,* 75, 1957, 167-198.

Lessmann, Johanna. *Italienische Majolika: Katalog der Sammlung, Herzog Anton Ulrich-Museum Braunschweig,* Brunswick, 1979.

Liverani, Giuseppe. "Ampliamenti al catalogo delle porcellane medicee," *Faenza,* 45, 1959, 6-12.

Liverani, Giuseppe. *Five Centuries of Italian Majolica,* New York, 1960.

Liverani, Giuseppe. "Premières Porcelaines européennes: les essais des Médicis," *Cahiers de la Céramique et des Arts du Feu,* XV, 1959, 141-158.

Mallet, J.V.G. "Maiolica at Polesden Lacey–I," "Maiolica at Polesden Lacey–II: *Istoriato* Wares and Figures of Birds," "Maiolica at Polesden Lacey–III: A New Look at the Xanto Problem," *Apollo,* 92, October 1970, 260-265; 92, November 1970, 340-345; 93, March 1971, 170-183.

Mallet, J.V.G. "The Este-Gonzaga Service, Made for Isabella d'Este, c. 1525 by Nicolò da Urbino (active c. 1520-1540)," *Splendours of the Gonzaga,* ed. David Chambers and Jane Martineau, Victoria and Albert Museum, London, 4 November 1981–January 1982, 175-178.

Mallet, J.V.G. "Mantua and Urbino: Gonzaga Patronage of Maiolica," *Apollo,* 114, September 1981, 162-169.

Morazzoni, Giuseppe. *Le porcellane italiane,* vol. 1, Milan, 1960.

Newman, Harold. *An Illustrated Dictionary of Jewelry,* London, 1981.

Rackham, Bernard. *Victoria and Albert Museum: Catalogue of Italian Maiolica,* with emendations and additional bibliography by J.V.G. Mallet, London, 1977.

Rasmussen, Jörg. "Zum Werk des Majolikamalers Nicolò da Urbino," *Keramos,* 58, 1972, 51-63.

Shinn, Deborah. *Sixteenth-Century Italian Maiolica: Selections from the Arthur M. Sackler Collection and the National Gallery of Art's Widener Collection,* Washington, D.C., 5 September 1982–2 January 1983.

Spallanzani, Marco. "Le Porcellane cinesi nella Guardaroba romana del Cardinale Ferdinando de' Medici," *Faenza,* 65:2, 1979, 41-50.

Stone, Peter. "Baroque Pearls," *Apollo,* 68, December 1958, 194-199; 69, February 1959, 33-37; 70, April 1959, 107-112.

Urban, Stanislav. "Der letzte Edelsteinschneider aus der Familie Miseroni: zum Leben und Werk von Ferdinand Eusebio Miseroni," *Alte und Moderne Kunst,* 21, no. 144, 1976, 11-15.

Verdier, Philippe. *The Walters Art Gallery: Catalogue of the Painted Enamels of the Renaissance,* Baltimore, 1967.

Von Neumann, Robert. *The Design and Creation of Jewelry,* rev. ed., New York and Philadelphia, 1972.

Wallen, Burr. "A Majolica Panel in the Widener Collection," *National Gallery Report and Studies in the History of Art,* Washington, D.C., 1968, 95-105.

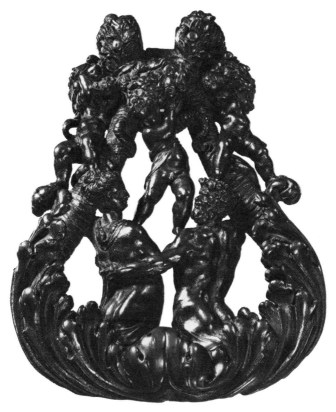

Sansovino, Doorknocker with Nereid, Triton, and Putti *(see p. 138)*